Professional Techniques for the
Wedding Photographer

Professional Techniques for the Wedding Photographer

by George Schaub

AMPHOTO
American Photographic Book Publishing
An imprint of Watson-Guptill/New York

George Schaub is a writer/photographer whose work has appeared in many newspapers and magazines. He is technical editor of *Studio Photography* magazine and a contributing editor to *Darkroom Photography* magazine, *Photographers Forum*, and *Lens* magazine. He is also a frequent contributor to *The New York Times* Arts and Leisure section on photography.

A native of New York City, he holds a Bachelor of Arts from Columbia University and for many years owned and operated a custom black-and-white lab/studio on Long Island, with his wife, Grace, and writes, photographs, and travels extensively.

First published 1985 in New York by AMPHOTO, an imprint of Watson-Guptill Publications, a division of Billboard Publications, Inc., 1515 Broadway, New York, NY 10036

Library of Congress Cataloging-in-Publication Data

Schaub, George.
 Professional techniques for the wedding photographer.

 Includes index.
 1. Wedding photography. I. Title.
TR819.S38 1985 778.9′93925 85-11097
ISBN 0-8174-5600-7
ISBN 0-8174-5601-5 (pbk.)

Manufactured in Japan

2 3 4 5 6 7 8 9/90 89 88 87 86

Edited by Marisa Bulzone and Donna Marcotrigiano
Designed by Jay Anning
Graphic Production by Gladys Garcia

To my beautiful bride, Grace.

ACKNOWLEDGMENTS

My thanks go to the photographers whose efforts made this project possible—their credits appear with the photographs in this book. Also, to Marisa Bulzone who went through a number of changes with me, and to Victor, who, though he couldn't make the trip, gave me a real sense of what love and thoughtfulness had to do with the whole business. I'd also like to thank my father, whom I trailed as a kid, picking up spent flashbulbs as he shot *his* weddings, and who later coached me on my first jobs. To my mother, whose understanding, support, and love have always meant a lot.

Special thanks go to Ken Sklute, whose many photographs adorn these pages, who spent many days choosing pictures to match my sometimes nebulous requests. Ken is a highly regarded photographer in his field, and he's earned the honor of being named Wedding Photographer of the Year by the Long Island Professional Photographers Association, as well as Creative Photographer of the Year for five years in a row. Ken gives lectures and seminars around the country, and the care you see in the work in this book is typical of all his photographic endeavors whether it be in wedding work, portraiture, or commercial assignments.

Contents

Introduction

People who don't like people have no business taking people pictures and, most of all, wedding photography is a people business. In the course of their work, wedding photographers encounter every type of nuptial ritual, from Christian to Jewish to Buddhist to "holistic," and enough characters and situations to fill a book. Sit down with an experienced wedding photographer and talk with him or her about the trade—you'll hear stories both sublime and ridiculous, and about situations that range from high comedy to moments filled with genuine emotion.

But that's what makes wedding photography such a fascinating profession, or avocation. To an outsider, each wedding may look the same, but the seasoned wedding photographer knows better. It's hard work, and the demands made during the course of the day might well leave most mortals exhausted. Yet, with all the labor comes a reward—and that's the knowledge that, as the photographer, you've shared in one of the most intimate and touching moments in people's lives.

How you approach this shared time, and the way you apply your skills as a photographer/artist, will make the difference between a mechanical, and ultimately tedious experience and one that is emotionally and financially rewarding. It will definitely also make the difference between your ultimate success or failure in the wedding photography business.

If you come away from this book with nothing else, it's hoped that you'll leave with this attitude, one that is essential to every successful wedding photographer. Most importantly, the job of the photographer is not only to make copies of faces and record the day's events, but to make *interpretations* and pictorial statements about the individuals involved and the love they share.

While it's true that many wedding jobs are run according to a certain script, it's also true that every job is different because every couple encountered has their own life, their own special story. Every wedding means new people to meet, new stories to tell, and new challenges to face. Placing every job into the same category will result in boring pictures and, within a short period of time, a bored photographer.

Some people feel that wedding photography is a simple task, a rote exercise in shooting a few pictures of a kissing couple and other setup shots. Nothing could be further from the truth. In the course of a day, a wedding photographer will be involved with formal portraiture, commercial design, fashion, glamour, group portraiture, photojournalism, and architectural photography. At the same time, the photographer is also a director, a bridal consultant, and even a referee. Because wedding photography encompasses so much, it is an excellent field with which to start, or to hone your skills.

As those of you who've worked in this area know, the actual shooting of a wedding can be a pressure situation. In most instances, there will not be a second chance to get certain shots. Wedding photographers have to know their equipment and should always be prepared with backups. Also, time is a factor that must be considered; efficiency is of the utmost importance. The photographer has to fit everything into the schedule of the people who hire him or her, and he or she may often run into situations like having to pose a dozen people for a group portrait in five minutes. Within this pressured framework, a wedding photographer has to watch for details, work fast and, most of all, care.

What then, is the real task of the wedding photographer? It's carrying the responsibility of portraying intense emotion through pictures, at the same time telling a story about the day of the wedding. This doesn't mean relying on clichés or putting couples and their families into unnatural positions or awkward poses. Rather, it's taking what is natural to the people involved and refining it with a few simple rules of color, composition, and balance.

There's no one "style" that is right; no one pose that fits a situation every time.

What *is* important is instinct, timing, consistency, and the understanding that every part of a photograph has a reason to exist. This clarity and understanding separates a wedding photographer from a snapshooter and is the reason couples still hire professionals to photograph their weddings. Throughout the book, in text and illustration, this "seeing" will be emphasized—this ability to refine what already exists. It will become apparent how this ability to "see" can become a part of your photography; how light, composition, and posing can be made to yield creative, interpretive images rather than stilted poses.

Although technique is important to successful wedding photography, psychology carries equal weight. The attitude of the photographer will influence the whole feeling of the resultant pictures, just as the attitude of the people being photographed will either enhance, or detract from those pictures. It often becomes the task of the wedding photographer to bring out the love and beauty that exists within his or her subjects.

This love begins with a sense of self-esteem, which means that the subjects must like themselves. This shouldn't be a difficult task because on a wedding day, people will be dressed in their finest and filled with good feelings. Sometimes, words of encouragement can be helpful, as well as projecting a feeling that the people being depicted are beautiful, that they are filled with love.

The point is that beauty is a concept, a mental attitude. Understanding this will not only change the quality of the photographs—it will entirely change the way you as the photographer approach the work. Thus, wedding photography becomes more than just a job—it turns into a sharing of a special nature and can become a very moving experience. It is a difficult concept to teach, but experience has shown that it works.

Even with all the technical knowledge and emotional qualities shared by top wedding photographers, no one can make it in this field without taking care of business. Many photographers consider themselves artists, which they are, but subsequently don't give the facts and figures of running a business serious enough consideration. Without figuring what their time is worth, the cost of film and processing, and other factors discussed in the text, many wedding photographers are actually losing money or, at best, running in place. This is one of the main reasons for the great turnover in wedding photographers.

Also, as artist/photographers, many people find selling an excrutiating experience. The fact remains that if you can't come to an agreement with someone on what's to be done and for how much money, you'll never shoot a single wedding. Although it certainly needn't be of the high pressure variety, selling *is* important to success in wedding photography.

Along with organizing financial matters, a wedding photographer must have an accurate system for filing, storage, and retrieval of negatives as well as a way of presenting final prints in albums. The entire methodology of running a business must be considered. Although each person will find his or her best approach, the signing of contracts, collecting money, making bookings, and completing orders must be run with a sense of order. This emphasis on the "practical" aspects is based upon the experience of many wedding photographers who take great pictures but who are, quite frankly, lousy business people.

The approach of this book, then, is the perception of the wedding photographer as an entrepreneur/artist whose field covers almost all aspects of photography, and who has the rare opportunity to share some very intimate moments in many people's lives. Technical, financial, emotional, and practical considerations in the work are all important. It's hoped that this book will provide you with a guide in these matters, and that you'll use the information as a basis for creating beautiful pictures and prospering in your wedding photography business.

The Business Side of Wedding Photography

The wedding business is a *very* competitive field particularly because of the great number of weekenders, freelancers, and established studios who go after the lucrative wedding market. Whatever category you fit into: whether you're someone who wants to supplement your income by doing weddings on weekends; or you're a dedicated "art" photographer who has to pay the rent while waiting for the grant to come in; or you're part of an established studio doing weddings on a regular basis, you'll have to deal with the shooting of weddings as a *business*.

First, getting involved with wedding photography requires that you make a substantial initial investment of time, money, and focused energy. It's *not* the type of work you can just show up for—you'll probably spend a lot of time going out and booking jobs. Even before you shoot your first wedding you'll need samples of your work (your "book" or portfolio), a prepared price list, a printed contract, and a realistic sense of the type of pictures each individual client wants. This chapter will deal with how to go about getting the jobs, and how to get more and more work as time goes on.

GETTING STARTED

Fortunately for those who are novices, wedding photography is one field where an active apprenticeship program exists. Most photographers and big studios that do weddings are in continual need of assistants. These people accompany photographers on wedding shoots and handle lights, change film, and even shoot candid and vantage point shots. Assisting is an excellent way to begin to learn the trade and to see if you would enjoy doing weddings on your own.

If you do go this route, try to assist for more than one photographer—by working with a variety of people, you'll get a feeling for the approach and style of many different eyes and sensitivities. You'll also get to know and to use various types of cameras

and lights, which will aid you in purchasing decisions once you go out on your own. Although the pay may be low, assisting is one of the best ways to get a hands-on introduction.

Building a Sample Book. One of the wonderful aspects of photography is that no one has yet been able to talk a great photograph into existence. That's the reason why people who look for a wedding photographer usually ask to see samples of his or her work.

You may have dozens of great sunset shots, and even a picture that made the front page of a newspaper, but if you don't have photographs you've done at a wedding, or portraits of a bride, you're going to be less likely to convince people that you're the one to do their wedding. Once you get rolling in business you'll be all set; you can add to your portfolio the best shots from each job. You'll be using samples as calling cards for other jobs, sales tools, and studio decor that will help you sell extra prints and enlargements.

Initially, however, you might have to do a bit of scrambling to build your sample book. If you're assisting, you might ask for copies of the prints you shot as candids. Some photographers might be hesitant to give you permission, but you might be able to trade some of your labor time for admittance to the wedding "theater" and freedom to shoot on your own for a specified period of time.

Another way to build a portfolio is to take your camera with you to every wedding to which you're invited and to begin to shoot pictures like the ones you see in this book. If you've decided to do this always ask the working photographer before shooting, and don't intrude on his or her posed shots. (You'll appreciate this courtesy later when *you're* the one working at a wedding.)

If you don't get invited to many weddings, but you want to shoot samples with professional equipment on your own time, then ask some friends to be models. Rent

or borrow a tux and a bridal gown and spend a day shooting pictures. Follow the poses and lighting diagrams in this book and shoot formals in a house, candids in a park, and even compose photographs using a church exterior.

The idea is to build a portfolio that sells the fact that you know what to do when the bride and the groom are in front of your lens. Remember, *nothing sells your ability more than your wedding pictures.* You may have the smoothest sales pitch, elegantly embossed business cards, and the slickest looking studio space around, but if you can't make the pictures work you won't get the business.

Presentation. If you've seen how commercial photographers show their work, you know that you can't show your carefully composed chromes out of a shoebox—the choice of a handsome case aids the final sale by giving clients the impression that they're dealing with a professional. In the case of wedding photographs, you should show prints in an actual wedding album. This technique accomplishes two things. First, it adds to your image as a professional; and second, it gets the client thinking about wedding albums as the repository of *their* prints.

Of course, handling wedding albums as part of your service as a wedding photographer makes sense. Why give the sale to someone else when it's very easy to buy and fit prints into albums yourself? When putting sample albums together, use a selection of budget to luxury albums. You'll soon learn your market and will find albums to fit everyone's pocketbook. Send away for samples and literature from album companies. (See *Completing the Sale* chapter.)

If you have a studio, or a place in your home where you receive clients, make enlargements of the best of your samples. Have them professionally framed and hang them attractively where they can be seen by prospective customers. While many photographers use metal sectional frames

for their work, wedding work should be framed in a more traditional, painterly way in various style wood frames. Having a print or two texturized will add even more style to your photo decor wall.

Again, having decor prints as samples shows clients you know how to handle the finishing of a picture, *plus* it gets them thinking in terms of enlargements for their own home. In the case of sample enlargements and wedding albums, your samples show your work and act as sales tools. Reinforcement of sales should be a continuing thread throughout your relationship with your clients. Rather than constantly *talking* sales, sales, sales, you can do it more subtly by surrounding the client with your product. From there, the actualization of sales should be a simple matter and will actually spring from their requests rather than from your push.

FORMULATING PRICE LISTS

Before you even make your first sales call, or place an advertisement for your services, you've got to get your price list in order. You can't hesitate when you get an inquiry, or make up different prices for each client. Because pricing is such an individual matter, here are some points you might like to keep in mind when drawing up your price lists.

Estimating Costs. The net costs for shooting a wedding include more than your salary. Add in film, processing, batteries, assistants, albums, enlargements, travel, dry cleaning, insurance—any job related expense. You should consider your base hourly wage for shooting a wedding in relation to what you earn for other weekend jobs. You also must decide if sorting negatives rates the same hourly salary. If you hire someone to sort negatives and put albums together figure in that cost. Figure six to eight hours (including prep time) for the average shoot and the same for sorting.

Components. You have a number of ways to structure your price list. You can go with a package deal or *a la carte.* Generally, a package consists of one 8×10 album of X number of prints, two 4×5 or 5×7 albums with X number of prints (called parent albums), a set number of thank-you cards (wallets of a favorite pose and binders) and perhaps an 11×14 print. Packages are usually worked out so that you have a set profit margin, and very few photographers allow variations once a package (or various packages) is worked out. Of course, extra prints and enlargements should be sold over and above the package, usually at a healthy profit margin.

The purpose of a package deal is to bring in clients at a good base price, with the hopes of selling extra prints later. In a sense, a package guarantees a photographer a "minimum" for the work.

Another way of getting a minimum is to sell a wedding on an *a la carte* basis. With this system, an hourly shooting fee, plus expenses like film and processing, is charged, and the photographer makes out regardless of the amount of prints ordered. Every additional item, such as albums, enlargements, thank-you cards, and so on is then billed on an individual basis.

While the *a la carte* system might seem less expensive to clients, it actually costs them more in the long run for the same services as the package. It does, however, give them a chance to create their own "menu." This method seems to be popular with people who don't want "traditional" coverage, and may be worthwhile as an option that you can offer. Look at what your local competitors charge. You'll notice that this consideration is near the bottom of the list. You *should* know what your competition is up to, but you shouldn't let it be a very important determination when making up your prices. If you're in an area where everyone charges $300 for a basic package, and you come in asking $1000, you'll probably get less work than your competitors.

But, you'll still get work, and if you're really $700 better than the competition you'll get more work than you can handle.

Others might want to catch every fish in the pond by dynamiting the water with low prices or special deals, but you might want to go after a more quality-conscious market. Base your price list on your needs, your attitudes, and the type of clientele you want to attract.

Remember, it's easier to start a little high and adjust to the market later than to raise fees once you've established a reputation of being a budget photographer. In most cases, the market will let you know if you're too high-priced.

Though prices vary around the country, the average minimum asked by most photographers is $350, and the average final sale to the customer rounds off to about $700. This ratio of package price to final sale (1:2) holds true for most photographers with average sales ability. The extra money comes from enlargements, framing, special albums, and extra prints.

One last word about pricing—once you've set a price and a policy, stick to it. There are many shoppers in the wedding marketplace, and many will try to bargain with you. They may promise you big enlargement sales, their second daughter's wedding, or the moon. Experience shows that the bigger the promise, the smaller the delivery. Remember, your prices should be figured according to the way *you* work, not on someone else's calculations of what they think a wedding should be worth.

THE CONTRACT

Because a contract is essential, you must have one prepared before the first client walks through the door. You can make up a simple or an elaborate contract, one with "singing angels" or printed-out from a word processor, but you must have a signed agreement with your wedding client before you even think about taking the first picture. A contract spells out rights and obligations for both parties, guarantees that you'll get paid for the work you do, and limits your liability in case disaster strikes.

Stipulations. A contract should have the following stipulations. (A sample wedding order agreement is included in this chapter. You're free to use the contents in making up your own.)

• Work Order: the who, what, where and when of the wedding, including service and reception.

HOW MUCH IS YOUR TIME WORTH?

Too often, wedding photographers don't make the effort to figure in all their costs, and end up working for less than they should. They add up film and processing, subtract it from their package price, and figure that that's their profit.

Anyone who keeps their own books can tell you differently. You have to include taxes, insurance, depreciation, gasoline, plus overhead on everything from telephone to rent to the electricity to keep the strobes charged. Even with those costs factored in, many wedding photographers fail to take their own labor into consideration.

How much is your time worth—ten, twenty, thirty dollars an hour? How much training and investment brought you to where you can do a *professional* job for your clients? Give this some thought when quoting prices for your next wedding.

- Copyright protection: all the pictures you take, including negatives, proofs, and samples are under your copyright. Never sign a work-for-hire contract on a wedding, unless you get a nice extra fee for surrendering those valuable negatives. Once you have established copyright protection you're free to make prints for samples and advertising, *plus* have the assurance that clients will come back to you for extra prints and enlargements. If a customer of yours tries to bring proofs to a copy studio in order to circumvent going through you for enlargements, they will in effect be violating the copyright law.

- Liability Release: should cover everything from someone tripping over your light cord while on the job to covering yourself should film be mangled by the lab. The lost film clause is very important. Although most professional labs take the utmost care with film, there may be a day (and if you're in this business long enough there *will* be a day) when you walk into your wedding lab and are greeted with a look of dismay on the manager's face. Some professional associations have insurance policies that cover re-rental of tuxedos and even re-catering of a wedding cake, but many shots from the special day simply can't be recreated later.

- Exclusivity Clause: bars any other photographer (pro or guest at the wedding) from taking pictures while you're working. Aside from getting rid of a source of much nuisance, this clause assures that none of your posed shots will be snapped by an uncle, thus depriving you of a possible sale. Of course, this doesn't mean that you'll bar everyone from taking pictures. It just gives you the discretion of asking someone to stop intruding on your work, or making sure that no one starts shooting flash pictures while you're setting up your slave lights.

- Payment Clause: clearly spells out the order and manner of payment. This should include the fact that the client's initial deposit can't be returned due to cancellation or postponement of the wedding. As you get rolling in this business, you'll find that wedding bookings pile up in the late spring and early summer. Once a date is booked, say in May, you'll find that you'll get three or four more requests for the same date from other parties. Unless you have a stable of photographers to handle those dates you'll have to refuse them, and a cancelled or postponed wedding date means lost money.

If you're working a package deal, the entire amount of that deal should be paid prior to the wedding. Split the payment into thirds—one-third on the date of the signing of the contract; one-third two weeks before the wedding (this is also a good time to reconfirm times and dates) and the last part on the day of the wedding itself. Walk away from the shoot knowing that you have the money in your hand—don't be any different from the band, caterer or any other professional involved.

Let the contract become a worksheet that guides both you and your client throughout the actual wedding day. Get the name of the minister or rabbi, the location where the bride will be dressing, and agree upon a time that the picture taking will commence. If you like, you can even include exact hours of coverage, and add an overtime charge for any work done past a certain hour.

In other words, make the contract work for you; add or amend the contract in any way you see fit, but please make sure to keep in the recommended clauses. Also, consult a lawyer if you're drawing up your own contract; don't pretend to be a lawyer, or let anyone else's contract become your sole guide.

FINANCIAL RECORDS

Books, ledgers, and all the financial records necessary for running a business should round out your paperwork. Income from wedding work is taxable income, and you must "pay the piper" even if you work part time. Consult an accountant on the ins and outs of running the business. Take heart—even though the income from the work is taxable, your expenses for film and equipment used on the job are now *deductible*. Traveling expenses to and from the job, interviews, and sales calls, and lots of other expenses you've probably been paying without deducting are considered deductible business expenses. Many pros started photographing weddings and were able to build and deduct their equipment as they built their studios.

However, see an accountant and let him or her guide you through the labyrinth of tax laws as well as advise you on which form is best for your business. Whether it be a DBA (doing business as), incorporation or limited venture, you should consult an expert in the field. Also check with them on tax numbers, sales tax collection, and other necessary forms for your business. All this becomes an important part of your wedding photography business.

BUSINESS CARDS

The next part of the paper chase is the business cards. These cards can be flowered or plain, but they should be direct. Remember, wedding photography is essentially a word-of-mouth business, and a very personal one. Whenever you shoot a wedding, you'll probably be approached for your card by relatives, and friends of the couple, and even band members, at the reception. Have cards handy because most of your business referrals will happen in this fashion. When people notice that you work professionally, courteously, and efficiently, they'll definitely want you to handle their own child's wedding.

If you change your address or phone number after you've had cards printed, spend the few dollars and have new cards printed. Keeping that professional image pays off with the next wedding you book.

MARKETING TECHNIQUES

Now that you have your price list, samples, contracts, business cards, and accounting books in order, you're ready to "sell" your first potential client. How do you find clients? Well, remember those business cards you had printed? It's time to use them as placards in as many places as will have them. Put them up at the local florist, limousine service, in restaurants, and in catering halls. Place them in bars, and on bulletin boards in churches and meeting halls.

While you're making the rounds, let the people in charge know you're out to shoot weddings, and that any leads will be appreciated. Often, local photo and film outlets are good places to leave cards—most will be happy to post business cards for you because they feel you'll be buying film and supplies from them.

Although most photo studios won't recommend you unless they really know you and your work, *and* they have an overflow they can't handle, some may offer to hire you as a candid or day man. On occasion they may have overbooked a date and need someone to fill in. If you're just beginning, take the job because this can lead to referrals while you are at the wedding itself. Once you've built a reputation, many studios may recommend you if they're too busy to take on a particular job. The wedding business tends to be composed of a fraternity of photographers, and sooner or later you'll get to know everyone in your area who's in the business.

You've probably heard of bridal shows, where dress shops, caterers, florists, limousine services, and photographers put on

SAMPLE FORMAT FOR WEDDING CONTRACT

AGREEMENT FOR WEDDING PHOTOGRAPHY

Wedding Date _____

Bride's Name _____Phone _____

Address _____

Groom's Name _____Phone _____

Address _____

Address After Wedding _____

1. This constitutes an order for wedding photographs and albums and prints. It is understood that any and all proofs, sample prints and negatives remain the property of the photographer, _____, and they may be used for advertising, display or any purpose thought proper by _____.

2. Although all care will be taken with the negatives and photographs taken at the wedding, photographer limits any liability for loss, damage or failure to deliver pictures for any reason to return of all deposits made.

3. It is understood that no other photographer, amateur or professional, shall be allowed to photograph at the wedding while photographer _____ is working, and that any breach of this agreement will constitute a reason for non-completion of the job with no liability to photographer _____ and loss of initial deposit by signing party.

4. Upon signature, photographer _____ reserves the time and date agreed upon, and will not make other reservations for that time and date. For this reason, all deposits are non-refundable, even if date is changed or wedding cancelled for any reason.

5. With packages, a deposit of 1/3rd is due at signing of this contract, with 1/3rd to be paid two weeks prior to wedding and the remainder to be paid upon completion of photography.

All terms of this agreement are understood and agreed upon.

Signature of Photographer _____

Signature of Contracting Party _____

Address _____

date _____

Wedding Checklist, as Part of Contract

Name of Bridal Party _____

Address _____

Date of Wedding _____

Where bride will prepare _____

Photography to commence _____

Time for flowers to be at home _____

Ceremony takes place at _____

Address _____Time _____

Name of presiding priest, rabbi or minister _____

Telephone number _____

Reception at _____

Address _____Time _____

Best man _____Maid/Matron of honor _____

Here are a number of suggestions for pictures. Please check off those you desire, plus fill in any special requests you may have. This list helps guide the photographer in making pictures.

At the house:
☐ Mother adjusting veil
☐ Bride putting on garter with bridesmaids looking on
☐ Bride in dressing room with mirror
☐ Bride pinning corsage on mother
☐ Bride pinning flower on father
☐ Flower girl handing bouquet to bride
☐ Portrait of mother and bride ☐ father and bride
☐ Brothers and sisters and bride
☐ Bride leaving house
☐ Father helping bride into car

At the church prior to ceremony:
☐ Groom and groomsmen
☐ Groom with best man
☐ Best man adjusting groom's tie
☐ Groom with best man and minister
☐ Signing marriage certificate
☐ Bride and bridesmaids in vestibule
☐ Bride's mother on usher's arm
☐ Grooms mother on usher's arm
☐ Other people being accompanied down aisle

During the ceremony:
☐ Bride being taken down aisle by father
☐ Father giving away bride
☐ Shots during the ceremony itself
☐ Time exposure of overall area during ceremony

After the ceremony at church:
☐ Bride and groom coming down the aisle
☐ Groom kissing bride at the altar (set up)
☐ Groom putting ring on bride's finger (set up)
☐ Receiving line right after ceremony
☐ Bride and groom on the steps of church
☐ Getting into car or limo
☐ Shot while seated in limo
☐ Mood shots in and around the church or wedding area grounds

Between the ceremony and the reception:
☐ Outdoor shots of bride and groom
☐ Outdoor shots of wedding party
☐ Shots of groom and best man ☐ and ushers
☐ Shots of bride and maid of honor ☐ bridesmaids
☐ Suggested location for outdoor shots _____

At the reception:
☐ Receiving line
☐ Wedding cake (prior to being cut)
☐ Guests signing book
☐ Introduction of the wedding party
☐ Wedding party toasting bride and groom
☐ Closeup of bride and groom toasting
☐ Dances: Bride and father ☐ Groom and mother
 ☐ First dance
☐ Bride showing rings to bridesmaids
☐ General dancing shots
☐ Candids of wedding party
☐ Flower girl and ringbearer together
☐ ☐ Group family portraits (please be specific) _____

☐ Table shots (done on a sales-guaranteed basis only)
☐ Bride throwing bouquet
☐ Groom and garter
☐ Cutting the cake
☐ Bride and groom feeding cake to one another
☐ Bride and groom's hands with rings and flowers
Special Requests _____

a mini-trade show for potential customers. Bridal studios with years of experience and excellent samples usually work these shows. The first time around attend *incognito* and see what it's all about. If you develop the samples and the pitch, by all means try these shows out. They're an excellent way to meet others in the business (again, a way to get referrals) and book some weddings to boot.

Another good form of advertising is a listing in the local phone book. You'd be surprised at the number of people who let their fingers do the walking when searching for a wedding photographer. You can start out with a bold letter listing, progress to a reprinting of your card, or a more elaborate advertisement as business increases. Local papers and "shoppers" can also be good advertising forums, but they're certainly not as effective as word-of-mouth or phone book listings.

THE APPOINTMENT

When people follow up on referrals, or call you "cold" out of the phone book, the conversation will inevitably revolve around the cost. It's up to you, but it's probably best to defer giving prices over the phone. If the caller insists on prices take the approach that your prices are quite reasonable for the coverage and options you offer, but price isn't the only consideration here. Stress that you always think it's best for all if you meet to discuss the plans for the wedding and find out exactly what they're looking for. Then ask, "When can we set up an appointment?"

Discussing a price on the first call is pointless. You really *do* have to sit down with the bride and groom to find out what they want, and you have to know that you and the contracting party can work together as people. Weddings are a very personal business, and the chemistry between you and the clients will have a lot to do with how the pictures and the experience, turn out. If a caller does insist on getting a price, you can either let them go or give them one of your package deals. Experience shows, however, that price shoppers can be more trouble than they're worth.

Once you get to sit down with potential clients, make the appointment a low-key affair where business is accompanied by personal courtesy and curiosity. In some European, and many Asian, countries, this way of doing business is still the custom.

The appointment should be the time when you formulate your plans for the wedding shots. In your role as director, you've got to begin to conceptualize your script. A wedding picture checklist is included in this section—you can make copies of this and show it to the bride and groom, or whoever is booking the wedding, at some point during the interview.

Obviously, the couple won't know every shot they want taken, but the checklist will help you know the people you'll be working with and the type of wedding coverage they desire. As the people look over the list you may get comments like: "My uncle is making a special wedding cake for us, and we'd really like a shot of him with us and the cake"; or "We've seen those special effects shots, and we really think they're stupid"; or "My father can't stand my aunt, but she's invited to the wedding."

All of this leads you to a better understanding of people's lives, and lets you know directly or indirectly what shots will and will not sell. Let clients fill in any special shots they want that might not appear on the checklist. Prior to the job, you can refresh your memory with the list, and let it become as much of a worksheet as the contract is.

You'll notice that one area *not* given special attention on the checklist is table shots. Because of the difficult and time-consuming nature of these shots, many photographers shoot them on a "sales-guaranteed" only basis. You can make this a rider to the contract, or have it on the checklist in a special section.

As you see the types of pictures that are checked off, added on or left out, you'll begin to see the type of albums and coverage the couple is hoping to have as their final memento of the wedding. The point is that knowledge about your clients leads to a better coverage of the wedding and, hopefully, to more print sales.

THE SALE

The first phase of booking a wedding involves informal conversation and the showing of sample prints and albums. The beginning of the close of the sale starts with a discussion of prices and options. By this time, the couple knows whether or not they want you to be their photographer and, perhaps more importantly, you know if you want to handle their wedding. It's useless to talk price before this is established.

Usually price is *not* a major consideration for couples looking for a photographer (of course, it must be in their ballpark), though it may be a consideration if someone other than the bride or groom is shopping for a photographer. If at all possible, you should have at least one of the couple at the initial appointment.

Don't bargain with people, or listen to promises of high print sales if you keep the initial package price low. If you've done your homework, you know how much profit you'll make on each job. But you really won't know how much work you'll be putting in for the money. Some weddings are easy; others can be very difficult, and it's usually the people who have bargained you down who cause most of the problems in the long run.

Once you've arrived at an agreement on price and/or package, go over each clause of the contract and make sure they fully understand its terms. Have them sign and give you a deposit.

If, after your presentation, a client will not sign the contract because they want to shop around or aren't certain about the facts, offer to help them gain a better understanding of the way you work. If they still won't sign, apply a little pressure. Inform them that wedding dates fill up quickly and you can't promise to hold a date without a contract and a deposit.

On the other hand, if you go through the whole appointment and find that you absolutely can't work with the people (and this happens—listen to your instincts), just "find out" that the date they're having the affair is already filled on your calendar. This may sound like a harsh way of doing business, but it's much better than trying to shoot a wedding of people you can't stand. This may never happen to you, but not doing the wedding in these cases is better than having you, the wedding party, and the pictures suffer.

You may find that your first few wedding sales are difficult, but if you approach them as "people events" as well as business deals you'll be much better off. After you've shot your first few weddings, you'll begin to appreciate the importance of that initial appointment and how it, and subsequent meetings with the bride and groom, affected both the final pictures and the final print sales. You'll also see that handling yourself as a professional at these meetings means being treated like a professional the day of the wedding.

The Formal Portrait

Before going into the actual scripting and shooting of the wedding day, you should meet the two people who are the leading man and woman in the story you're about to tell, the bride and groom. The majority of the photographs you'll be taking at the wedding will involve these two people. All of the activities revolve around them and all of the energy comes from them *and* towards them. While everyone else plays a supporting role, these people are the stars, and should be revealed as such in your photographs.

Because the bride and groom are the center of attention, and are constantly being pulled this way and that, there's often little time to make formal portraits of them during the course of the day's events. If at all possible, try to book the formals a week or two before the wedding. You can take them in your studio, their homes, or another appropriate location. In this way, you can get your formals *plus* have the newspaper announcement shot done at the same time. (Black-and-white prints for newspaper reproduction can be easily made from color negatives.) This may be impossible, however, as the bride's gown or the groom's tux might not be ready in advance of the wedding day. In that case, make the formal of the bride at her home before the service, of the groom at the church before the service, and formals of both of them together either right after the service or early on in the reception.

Formals are based on classic studio portraits. Studio props, such as elegant chairs, couches, or posing stools can be used, along with very simple or quietly hand-painted backdrops. Though props can be helpful in posing, keep them to a minimum and remember that formals are quite different from environmental or more candid photographs of the couple. In these photographs, you'll rely on simplicity and elegance in design, posing, environment, and lighting.

Natural or artificial light can be used for these portraits but, as with the posing, simplicity should be the watchword. Window light through sheer curtains can give a soft, even glow to your subjects. Strobes add an element of control, and though many beautiful portraits can be made with one light, a key, fill, and background kicker light will certainly do the job. Whichever light source you use, keep the lighting simple and have it follow a consistent, natural path toward and around your subjects.

It's quite natural for people to feel awkward during a formal sitting. As the photographer, you can either aggravate or alleviate your subjects' nervousness by the way you treat them. Reassure the bride and groom that you won't do anything to embarrass them. Begin the rapport by sharing your feelings, and set up channels of communication as you go along. The stiffness of many formal shots often results from the photographer having a preset notion of what the people should feel or look like, and he or she pours the couple into a mold that has nothing to do with the individuals themselves. Be confident of your own photography to allow people to be themselves.

Once you feel a sense of ease, bring the couple, or individual, into the shooting space and let them go into their own pose. You'll find that many people know what to do in front of a camera, and all you'll have to do is refine their natural pose for them. The refining process means watching for lines, shadows, and body language, as well as facial features that should or shouldn't be emphasized. Take the time to look at who and what you're photographing.

Follow the general rules of portraiture—don't let the nose break the line of the face, don't let shadows fill the eye sockets, and have a maximum of a 1:3 lighting ratio from one side of the face to the other. Pay attention to the eyes. They are, as the cliché goes, the windows on the soul. One technique for getting effective eye contact is to have the subject look down right before the shot and then look up into the lens the instant before the picture is taken. Of course, not all your formals should have direct eye contact.

Looking at lines means that you move arms and shoulders so that they create a flow throughout the picture, rather than a series of choppy horizontal lines. Think of your composition as a diamond rather than as a series of blocks and rectangles, and visualize S curves in and around your subjects. Use the bridal veil as an object that creates an aura, not one that obstructs or makes hard vertical lines cutting through the face. Notice how the hands are placed. Go for a graceful look and make sure the fingers don't look like a pile of sticks.

The key words in formal wedding portraits are simplicity and elegance, sprinkled with a sense of intimacy. If the stance of your subjects is too stiff and haphazard, help them by showing them how to place themselves, rather than trying to talk them through it. Don't be afraid to touch and guide (though you should always ask permission to do touch posing). Once they're in the general pose you want, go back to your camera position and begin refining.

Formals are the part of wedding photography where your studio skills are put to greatest use. Use the time available to look carefully at the design elements in the viewfinder and watch for the small details that can make or break a picture. Formal doesn't mean stiff; think of it more in terms of a classical approach to your subjects. Don't ignore the special character of each of your subjects, but also don't forget the lighting and lines that make these portraits popular for album and wall enlargement sales.

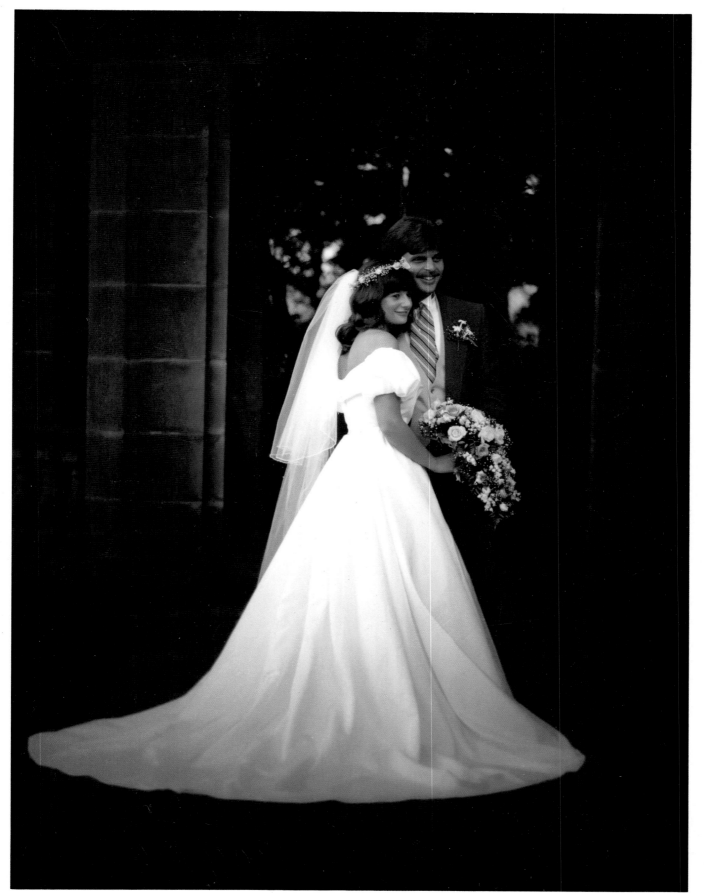

The Bride's Elegance

The elegance and style of bridal portraits should evoke the natural beauty of the woman in the bridal gown, rather than have the look of a replaceable head pasted on to a wedding dress. Capturing detail in the gown is important, but it shouldn't override the person wearing it. With this in mind, approach the bridal formals by doing a number of poses, including a full-length shot (showing the flow of the dress), a medium shot with and without bouquet, and a head and shoulders shot with the veil.

When doing a full-length shot, pick up the train of the gown slightly and let it fall naturally. Don't cut the gown off at the bottom of the image—let it be a curving design element in the print. Also, don't fuss with the gown other than giving it a delicate flow; too many times gowns are made to look like elaborate braids that twist and snarl around a bride's feet.

The bouquet is an excellent prop for bridal formals. It should be held slightly above the waist in a natural, graceful way. Remember to have flowing lines in both the body and the dress, and to have the arms bent in such a way that no hard angles or horizontal lines intrude on the grace of the picture. If the hands are showing, "break" the wrist for a flowing look. Also, don't have the bride standing flat-footed, facing the camera squarely. Instead have her bend her body naturally, shifting her weight to one or the other leg.

Avoid the "passport" look and watch for a diamond design created by head, body, and arms. If you use the bouquet in a medium distance or closeup shot, put it in focus if the bride is looking at it. Let it go slightly soft if it's just being used as a design element or splash of color in the lower part of the frame.

One of the chief sources for an unacceptable bridal portrait is the burnt-out look created by the gown reflecting too much light in comparison with the rest of the tones in the picture. This may cause underlighting on the subject's face, but in order to get good skin tones in printing, the detail in the dress is lost. Be very careful with your lighting ratios.

One way to avoid this problem is to keep the main source of light away from the front of the bride's gown. Have the woman turn to the side and have her head turn in toward the light source. If you're using artificial light, feather the light across the subject rather than have it blast directly onto the gown. Feathering means that the light is pointing across the plane of your subject, resulting in a skim effect. Use of a soft box or diffuser on your light source will also yield a mellower light. The point is that you should pay close attention to the contrast in your bridal lighting, and to try to keep the lighting as soft and low key as possible.

Most bridal formals benefit from the use of a light vignetter or diffuser on the lens. The veil at the top of the frame and the gown or bouquet at the bottom serve as beautiful borders. Slight diffusion might also be desirable, depending on the light source and the subject. Natural light through diffusing curtains can create an excellent light in which to shoot bridals, although you should be careful of too strong a light source. If the scene seems too contrasty, move the bride further away from the window, thus decreasing the intensity of light striking the gown.

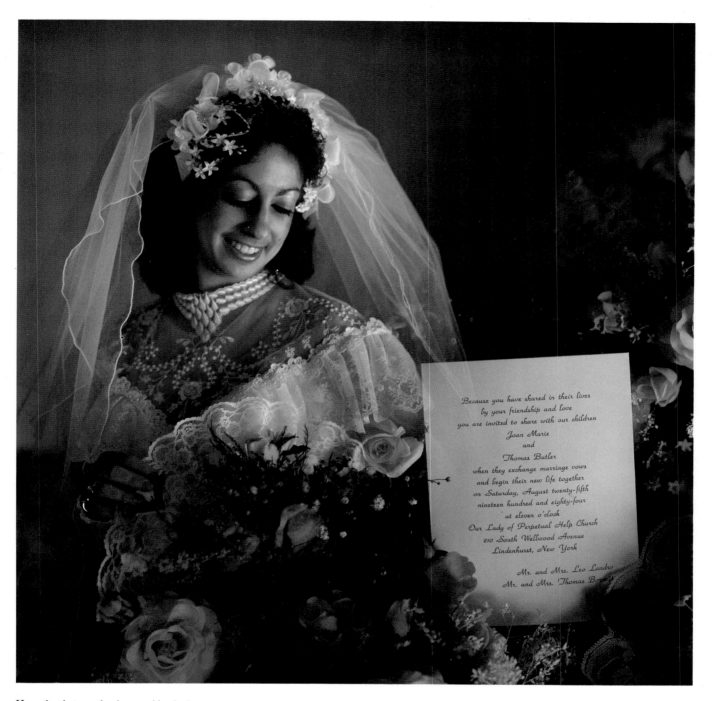

Because you have shared in their lives
by your friendship and love
you are invited to share with our children
Joan Marie
and
Thomas Butler
when they exchange marriage vows
and begin their new life together
on Saturday, August twenty-fifth
nineteen hundred and eighty-four
at eleven o'clock
Our Lady of Perpetual Help Church
210 South Wellwood Avenue
Lindenhurst, New York

Mr. and Mrs. Leo Landro
Mr. and Mrs. Thomas Butler

Here, the photographer has combined a happy bridal portrait with an insert of the wedding invitation done with a matte box effect. Though either shot can be done solo, the combination of the two tells a story plus sets the time and the place. (Photo: Ken Sklute)

This formal portrait of the bride is greatly enhanced by the creative use of the veil. The light spills through the veil and the whole effect is one of gentleness and beauty, with the single splash of color from the rose adding just the right touch. A single strobe mounted in a large soft box created this effect. A white reflector card was used to balance out the left side of the frame. (Photo: Bob Salzbank)

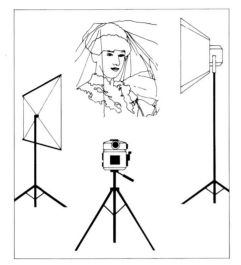

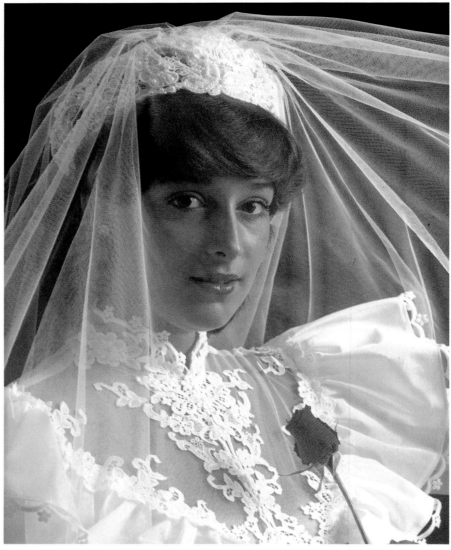

ARRANGING THE BRIDAL VEIL

The bridal veil is a wonderful prop that, when used correctly, creates a soft halo around the bride's face. When used incorrectly, it can throw distracting shadows, accentuate harsh lines, and distract the viewer by its "heavy appearance." It *isn't* mosquito netting on a pith helmet. Think of the veil as an arrangable vignette that surrounds the bride's head.

When setting up the veil, make sure that there are no hard, straight lines. It should be "fluffed out." Its stronger creases shouldn't cut into the eyes, nose, or chin line of the bride. Be especially watchful of shadows thrown by the veil, and be particularly careful that the web-

bing doesn't make a net-like shadow across the face.

Use the veil's lines as part of the flow of the whole picture, and let it lead the viewer's eyes from the bride's head to her shoulders and downward to the edge of the gown. See the veil as the top of a diamond that continues through the rest of the composition.

The veil can also serve as a diffuser, and as you experiment with different forms of lighting (backlighting and sidelighting can be particularly dramatic) you'll see all the soft effects you can create with this gauze-like material.

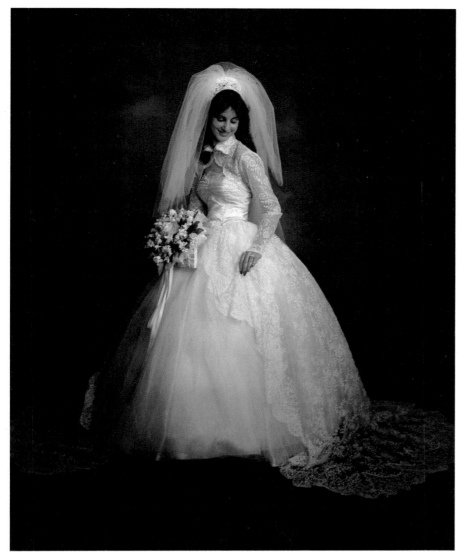

Painterly effects for bridal portraits can be attained simply with the right background and simple lighting technique. Add to this proper posing and a medium-to-low camera angle, and a classic portrait emerges. (Photo: Ken Sklute)

POSING TECHNIQUES

When doing formals and candids where you have some control in the situation, there are three ways to pose—talk, touch, and show. Talk posing involves giving verbal directions to your subjects, requesting them to move their hands slightly, or tilt their head. This is fine after you've set up a pose and are at the camera making the final adjustments to the picture. Touch posing is refinement by physically moving a person with your hands. When your verbal instructions would be too confusing, or the subjects themselves do exactly the opposite of what you tell them, use this method. Always ask before you move someone physically, as some people are, well, "touchy" about being touched.

Show posing is the quickest way to get subjects into the position you want because you actually assume the pose you desire and then ask them to mimic your stance. Once you show pose, you can then further refine the picture with touch and/or talk instructions. Show posing is ideal for weddings because it gets the job done fast, and helps you get the people in position in an often time-pressured situation. It also can break the ice; it can make posing a game rather than a stiff, strenuous exercise for all concerned.

The Groom's Style

(Photo: Ken Sklute)

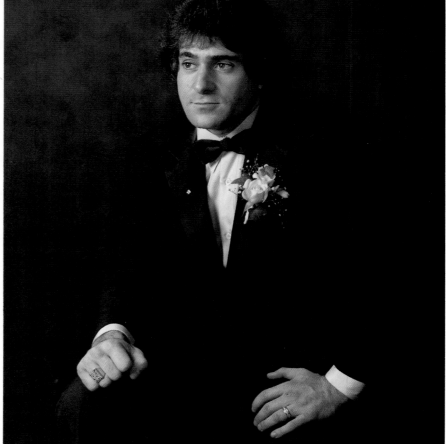

While the bride's portrait is usually bathed in soft light, or has an almost mystical quality about it, the classic shot of the groom is one that's more defined, and has a somewhat darker tone. The photograph certainly shouldn't be hard, or moody, and it should be a reflection of the man's character. Too many photographs of the groom are heads and shoulders, with a broad smile or caricatured, serious look that more often than not resembles a grimace. Aim for a natural look, and be aware of the small details that go into the making of any formal portrait.

Because the groom's clothes are much "straighter" than the bride's, and can't be fluffed out to create paths of design and light, you'll have to be much more conscious of how the lines of the jacket, vest, or waist band fall. Watch for the jacket riding up over the shirt collar and make sure the cuffs of the shirt come out from the sleeves of the coat. Even though the facial expression in the shot might be great, a portrait can be badly hurt by your missing any of these seemingly inconsequential details.

It's rare to see or sell a full-length formal of the groom, so concentrate on medium distance shots. Using a lighting setup similar to the one for the bridal portrait (skim of softbox) you can have the groom lean in slightly, one foot on a stool and an arm resting on the knee, with the other hand in a pocket. Remember to watch for lines by making sure that the groom's shoulders aren't parallel to the top of the frame, and have the head turned to one side or the other so the shot doesn't look like a wanted poster.

It's okay for the groom to have one or both hands in his pockets as long as the hands fit. Some formal wear is very tight or just has decorative pockets, so hands may seem bulky if shoehorned in. If the hands are left out of the pockets, do something with them. Don't just let them dangle in space. Putting hand in hand is better than interlacing fingers. You can also have a thumb hitched into a pocket or belt, creating a more jaunty pose.

Many male portraits seem stilted when compared to those of women. This may be caused by the photographer and subject feeling as if they are trapped into portraying the "male image." Go with your feelings about the individual and don't get caught in stereotypes. This will make your subject more comfortable and allow for a more honest photograph to be made. Look for motion, movement of lines, and dynamism as a way to break any stiff, visual looks. Once the subject has posed himself, or you've helped him find a comfortable position, request an extra lean in towards the camera—this extension does wonders for male portraits.

Use of a dark vignetter is popular for portraits of the groom because it will blend the corners of the frame but won't clash with the generally darker clothes worn by the man of the day. Use your judgment about diffusers with the groom because some benefit by its use and some don't. Though these filters aren't in general use for pictures of the groom alone, they can help create an idealized rendition of the subject.

Smiling is not against the law in the portrait of the bride or groom, but it's rare to see a full, toothy grin in any formal portrait. A bright, open smile is great for candids, but will not sell as the shot chosen to hang on the living room wall. Yet, the demeanor of the groom's portrait needn't be serious or moody. There are expressions where the face is lit up by a happy joy without the showing of teeth. This shine and glow is what you should aim to bring out.

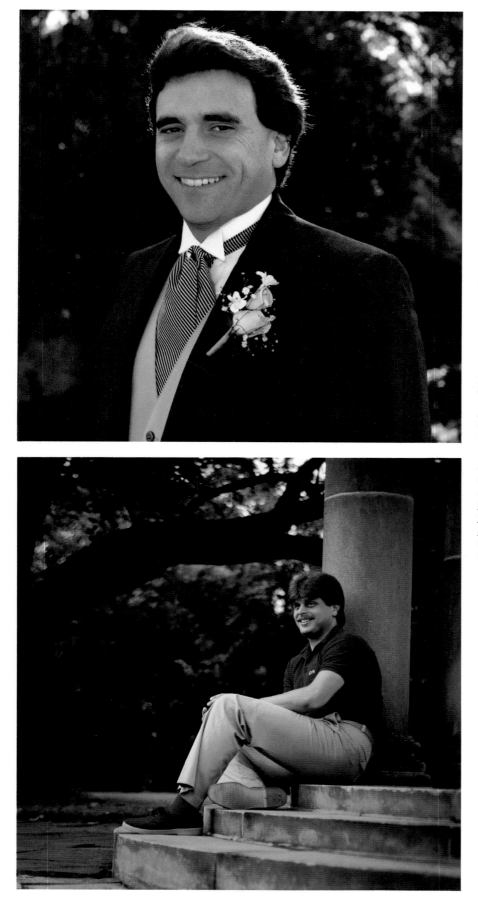

Not every shot of the groom has to be elaborately produced as this straightforward picture illustrates. When the groom is dynamic and well-groomed, your job will be easier. All you'll have to do is induce a winning smile. (Photo: R&R Creative Photography)

In this portrait of the groom prior to the wedding day, all the compositional elements of the tree, the column, the steps, and even the placement of the groom's body fall together to yield a pleasing picture. This casual pose is probably truer to the individual's character than any formally posed picture could be. (Photo: Ken Sklute)

The Couple's Affection

People in love are the easiest people to pose in the world. They want to touch, to be close, and to share their happiness with others, all in a natural way. Most wedding couples *want* their pictures taken together, and their individual shyness is usually overcome when they pose together. Most of all, they're eager for the shot to turn out well, and it's up to you to help them.

Skim lighting should be used for the bride and groom shots, with the main rule being that the bride should be furthest away from the light source. In this way, the dress doesn't become a hot spot, and it also serves as a natural reflector bouncing light back to the normally darker groom's clothing. This same rule holds when shooting the bride and groom in natural light. If you're shooting the couple near a window, put the groom closest to the light source. When taking a light reading in either situation, meter for the shadow area where you want detail, and watch out for too deep shadows falling across the faces.

Though the bride and groom want to be close, initially pose them so that they're standing slightly apart, then have them lean into, or toward each other when you're about to take the picture. This creates a dynamic motion, and a final lean in toward the camera finishes the pose.

Use hand in hand rather than interlocking fingers for your medium distance shots or closeups. The other hands should be entirely visible or entirely out of view. The bride may have two hands on the groom's shoulders as she stands to his side, but make sure that her hands are placed gracefully and that no fingers are "amputated" out of the picture. Don't let a stray thumb spoil an otherwise flowing composition.

Too many photographers place the bride and groom next to each other and snap "lineup" shots. This is a terrible waste of a wonderful portrait opportunity. Seek a dynamism by creating different levels of motion, have the groom sitting and the bride leaning in from behind, or the bride standing in slight profile with the groom looking on with affection, and so forth. You needn't have the couple do gymnastics, but you shouldn't have them pose statically either.

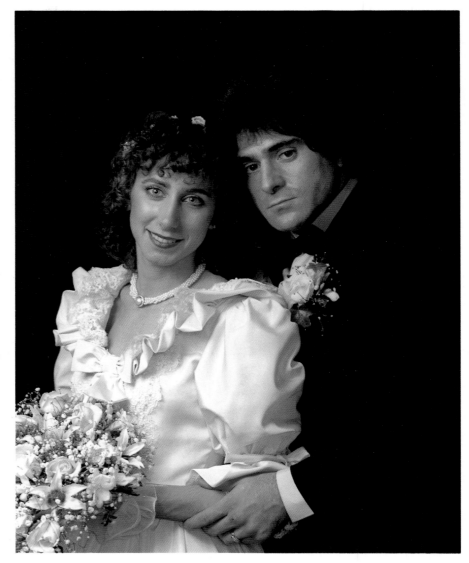

When shooting bride and groom formals, have them give an extra lean in toward one another for the finishing touch on the picture. This is particularly effective with face-forward shots; the pose helps display the natural affection they feel for one another. (Photo: Ken Sklute)

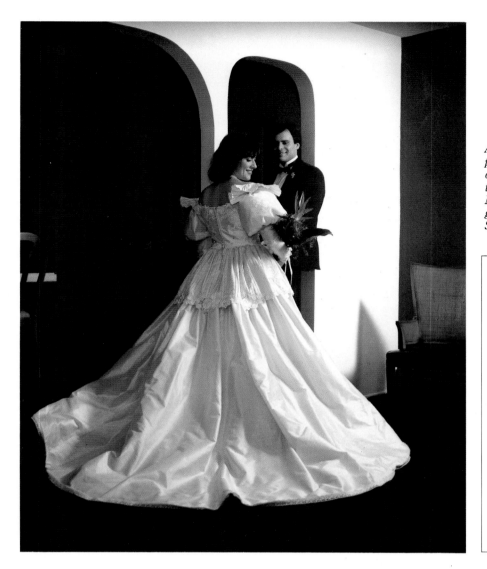

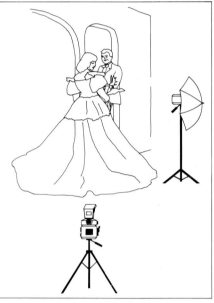

A single umbrella with a 200-watt strobe is placed on a plane with the couple. A bounced on-camera filled strobe (again at 45°) created this modeled portrait of the bride and groom. Note how the fill helps to bring detail to the gown on the left side of the frame. (Photo: Ken Sklute)

ENHANCING THE PORTRAIT WITH LIGHT

Portraiture is a subtle art that requires the eyes to see light and its effects on the subject portrayed. You must utilize the light so it enhances the subject in a way that brings out that character and beauty to their best advantage. Whether the light be natural or artificial, or a combination of both, it should follow the lines of the subject and create a sense of restfulness in the final print.

One of the main ways of enhancing with light is having it create a natural blend of highlight and shadow. No lines on the face should be too deep, or highlight on the wedding dress too burned up. While a high contrast image may be appropriate to certain character portraits, wedding portraiture should, in general, have a soft contrast and an open look.

This "look" is created by using light and knowing how to place subjects in that light. Just as we're asked to "previsualize" how the tones on a landscape picture will fall, the wedding photographer should realize the implications of his or her composition and realize the direction of the light effects the final print. Light can be dramatic without being harsh, soft without being flat. A study of the masters of light, for example, Rembrandt and Raphael, will illustrate this point. Every wedding photographer should be required to spend a month in a museum studying paintings before he or she goes into the field.

So play with light to create the mood and control it so it expresses your feelings. The mastery of light is a major part of your life's work as a photographer. Knowing how to use it well will do wonders for your work.

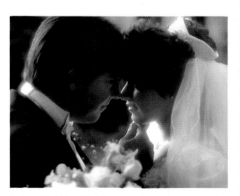

Natural light backlighting was the sole source of illumination for this intimate portrait of the bride and groom. The photographer metered for the faces of his subjects, allowing the backlight to glow slightly around their head and shoulders. The bouquet in the center foreground adds another touch of softness and serves to cover any awkwardness of the man's arm. (Photo: Ken Sklute)

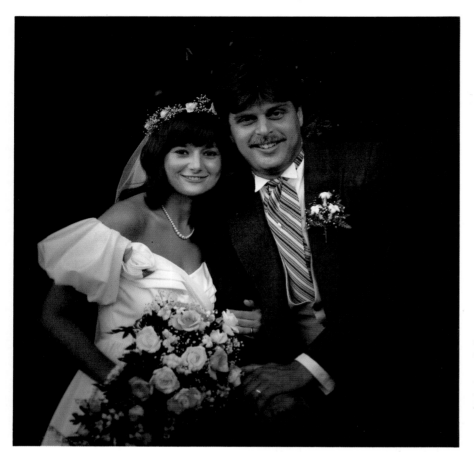

The warmth and happiness that surround this couple is evident from the posing, the couple's expression, and the direct camera-to-subject view. Though elaborately produced bride and groom shots can be successful, the simple elegance of this shot proves that sometimes "less is better." (Photo: Ken Sklute)

In this pre-wedding day portrait of the bride and groom, the photographer used an outdoor location and asked the couple to dress in dark clothes, all for the purpose of making their faces the center of light in the pictures. A dark vignette on the lens adds to the feeling of closeness of the couple. (Photo: Ken Sklute)

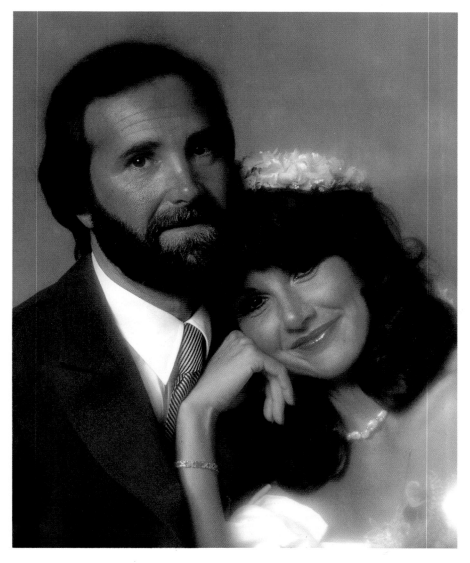

This gentle studio portrait shows the warmth and caring shared by the bride and groom. Though a more casual pose, it still has the attributes of a quality studio shot. Two strobes were used, one a key with a soft box, and one a fill light (f/11) with the fill light set one stop lower than the key. (Photo: David McHugh)

Always strive for a genuine expression in your portraits—contrived shots look forced and rarely sell. A picture that involves direct eye contact between the bride and groom can be great because in the midst of posing the couple just might want to kiss. Hold them in this pose a little longer than usual, and let them move their faces closer and closer together. This creates a wonderful sort of tension that is resolved by the click of the shutter, and the kiss. The idea isn't to keep the couple from kissing, but to help set up an emotional, real pose.

A light vignetter is good for bride and groom pictures, and a diffuser can be helpful for creating a romantic mood. Many times you can work with a posing bench, and by arranging the train of the bride's gown on the platform you can create a naturally soft border that also throws beautiful highlights into the rest of the picture. Backlighting can also be utilized for the creation of mood. Meter for the faces so that important details aren't lost, and allow the backlight to spill through hair and over shoulders to create an aura. You may need a brief fill flash or reflector card to help light the faces, but be careful not to overlight and watch for flare in your lens.

The key to bride and groom formals is the connection between the man and the woman—their love, caring, and shared humor. To capture this is a challenge, but it's made so much easier by the fact that it's their wedding portrait. It's an emotional time, one filled with anticipation and affection. Make your pictures so that those feelings are shared with future viewers.

Before the Ceremony

The time before a wedding is one of hurried preparedness, when the bride and her family are preoccupied with the endless details of the coming day. The mood in the household is similar to that backstage before a play, where the actors are hurriedly getting on their costumes, makeup, and rehearsing their lines. The scene is usually emotionally charged and nerves can be high strung, to say the least.

During your initial appointments with the client you should agree upon the time when you'll be arriving at the house, that the flowers will be ready when you arrive, and that most everyone will be ready for taking pictures at a certain hour. Coming three hours early, when everyone is still drying their hair, will be a waste of your time and make everyone else more nervous than necessary. Most photographers plan to arrive at least two hours before the bride is to leave for the wedding ceremony.

The first task you'll have is to take a few minutes to scout your location. Find an area where you can take bridal and family portraits, one that doesn't have too busy a background or clashing colors. If you can combine this with an area that has a nice fall of natural light, so much the better.

If the light isn't right in any area of the house, choose an open space where you can set up your strobes. While you're doing this, check to see if there are exposed staircases, easy chairs, bookcases, mirrors, and other items that can serve as posing props. If there are lamps in your posing location, leave them turned on except, of course, if they're harsh spots or fluorescents.

Many people may be coming in and out of the house during this time. Don't push them out of the way for your pictures, but make sure they don't serve as distractions either. Once you set up the shooting area (and this may entail moving furniture, opening blinds, or drawing curtains) make it off limits. You're creating a set, and once it's prepared don't let others disturb it.

While you're acting as stage designer, it's a good time to enlist the aid of someone who will become your assistant director in all matters having to do with the bride and her family—the maid (or matron) of honor. It's her job to help the bride throughout the day, and she'll serve as an excellent go-between for you and everyone else who's part of the festivities. Many things will be going through the bride's head before the ceremony—don't add to her preoccupation by making too many direct demands. The maid of honor can help you organize the people for the pre-ceremony pictures since she often knows the extended family and where the veil, flowers, and other necessary items are located.

Start shooting a minimum of two hours before the bridal party leaves for the service. This will mean that you have at least one hour in which to get your pictures, and will give the bridal party an hour after you leave to make their final preparations. Any time less than this will result in rushed shots and possibly poor pictures. Give yourself and the subjects enough time to relax into their poses. As it is, you'll have to work hard and fast—you always have a deadline in these situations. Allow for time to shoot, pack your gear and get to the church to do some shots of the groom, his ushers, his family, and his friends.

The order of shooting will depend upon who's ready once you're set up. Since the bride is the key subject in most of these pictures, try to arrange with her to be ready first; discuss this during your pre-wedding day appointments. It is a good idea to get shots of the ringbearer and flowergirl early on; the children may become restless if they have to wait around for a picture. After this, do shots of the bride in her room or dressing area, posed shots of the family, and finally some outdoors shots.

This is the first contact you'll have with the bride and her family on the wedding day, and the rapport you establish at this point will set up the relationship you have together for the rest of the shoot. Regardless of the ease of your prior appointments, this is pressure time, and your behavior during these moments establishes the mood for all concerned.

Blundering around the house, barking orders, is not a good idea, no matter how nervous and pressured *you* feel. It's unfortunate, but some wedding photographers are too callous, or unsure of themselves, to handle people gently during the wedding day. It's gotten to the point where some people *expect* wedding photographers to be bullies. Don't live up to people's worst expectations, treat them with care, and they'll probably return the favor.

If all is chaos and confusion in the household, at least get some shots of the bride getting ready and a few pictures of her and her close family. Quite frankly, you never quite know what you'll be walking into on the actual day of the wedding. So don't worry if you miss some of the shots mentioned in this section while you're at the home. You can always get them later at the reception. Don't put the shots off if you do have the time and the people are ready. It's always best to make the most of picture opportunities and get the main shots out of the way when you can.

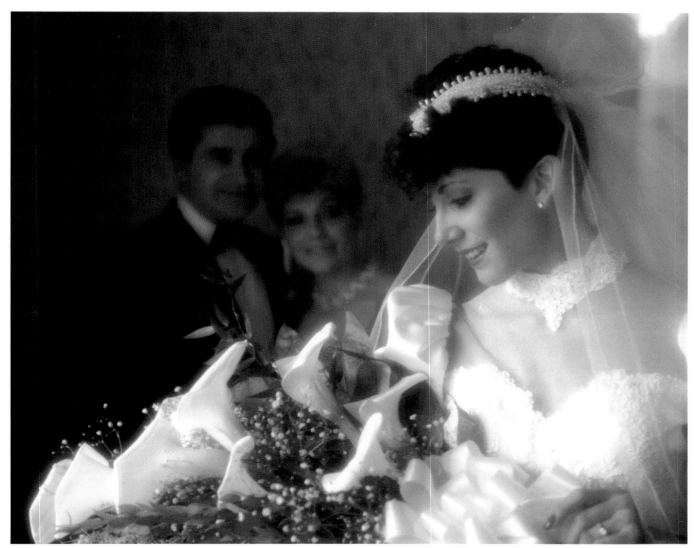

(Photo: Ken Sklute)

The "Dressing" Shot

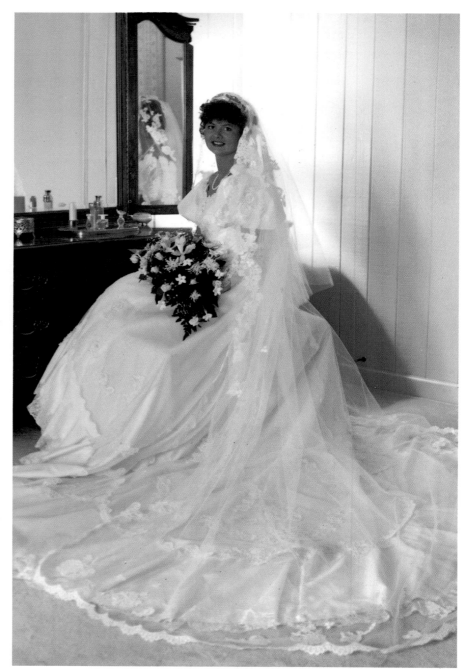

A classic shot for any wedding album is one of the bride getting ready for the wedding, usually called the "dressing" shot. This doesn't mean that you burst into her room and get shots of the woman drying her hair. Generally, these shots are made when the bride is ready and are setups showing her putting on the finishing touches or arranging her veil.

The pictures should convey a sense of intimacy, and are made alone with the bride in her room or dressing area. They're usually dreamy or contemplative, and should tell the story of her preparing for her new life. Among popular shots in this series are those using a mirror as well as pictures of the bride looking out through a window.

The mirror shot can be particularly evocative because it portrays the bride contemplating herself and this special moment in her life. Doing a straightforward shot of just the mirror with the bride's face reflected in it would be like taking a picture with the bride holding a picture frame around her face. For that reason, most of these shots are made over the bride's shoulder, including some details of the dressing table. Lighting is accomplished with a bounce flash, which eliminates glare from the mirror and fills the room with a soft glow. Don't just have the bride staring into the glass, create some movement by having her applying some makeup or arranging a part of her dress or veil.

Natural light can be used to good effect in the "getting ready" shot, and a vivid picture can be made of the bride looking through a curtained window, with her hand gracefully parting the material to let a shaft of light fall upon her face. Not only does this yield a good light to work in, it also tells the story of the bride looking toward the future. This is a preparatory moment; don't have the bride wear a veil, but photograph her in her gown as if she's taken a break from dressing and is giving a moment's thought to the day ahead. Keep in mind that all the shots you take during the day should be in the context of the story you're telling.

Other shots you might consider include the bride contemplating her bouquet, sitting in an easy chair, and relaxing in her room. None of these should be "formals", and the light should be kept as soft and warm as conditions allow. Available light is always the illumination of choice, so scout the house for a relaxing area that will enhance the mood.

In the "dressing" shot, include the dressing table and other details of the room. If a mirror is present, use it to reflect a part of the scene hidden from the camera's view, but take care not to get hot spots from your flash reflecting back into the camera lens. (Photo: R&R Creative Photography)

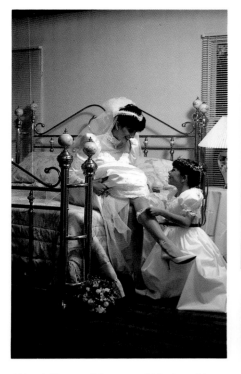

DRESSING FOR THE OCCASION

An important aspect of handling a wedding as a professional, and being treated as same, is appearance. Along with mental attitude and technical expertise, the way you look can definitely effect the way people relate to you and the comfort you feel with them. You don't have to be a clothes "horse", or have your nails manicured everytime you go out on a job, but you should have an appearance in keeping with the occasion. "Dress like a guest" is the way most professionals handle the question of what to wear. Slacks, sports coat, comfortable dress shoes, and a tie are fine for men. Some photographers dispense with the problem altogether and create a fine impression by having a tailored tuxedo ready for all wedding jobs. For women, tailored slacks or a "business" dress work well with either a smart blouse or suit top that matches. Formal gowns are unnecessary, and will probably just get in the way of working efficiently.

Running sneakers, designer jeans, or casual knit tops might be fine for location work, but rarely fit in the more formal atmosphere of a wedding. Of course, if the wedding is a beach party, you'll look silly in a tux, so check with the bride and groom about attire and setting. Sloppy clothes, poor grooming, and an indifferent attitude to appearance are never in order, especially if you hope to build clients with each wedding you shoot. You'll want to blend with the surroundings, not stick out and embarrass the people who've hired you, or yourself.

(Above) The candid nature of this shot of the bride and the flower girl is enhanced by the "peeking around the corner" camera angle. The light source is in the room (an off-camera strobe) and the whole composition is balanced by the bouquet resting at the foot of the bed. (Photo: Ken Sklute)

(Right) Using only the natural light cast through a set of sheer curtains, the photographer has added a very light diffusing screen to his lens to enhance the natural light. Locations like this are a natural for bridal portraits in the home. (Photo: Ken Sklute)

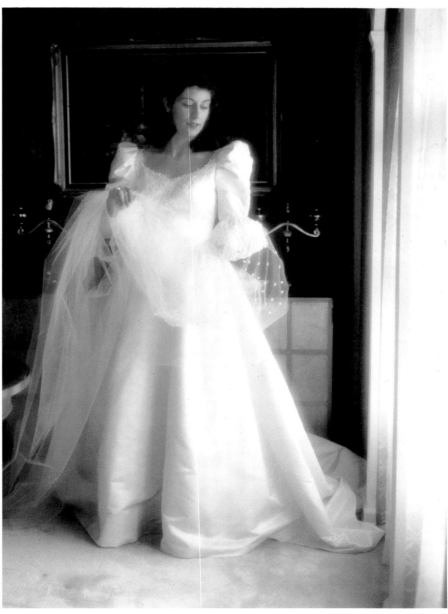

The Bride and Her Mother

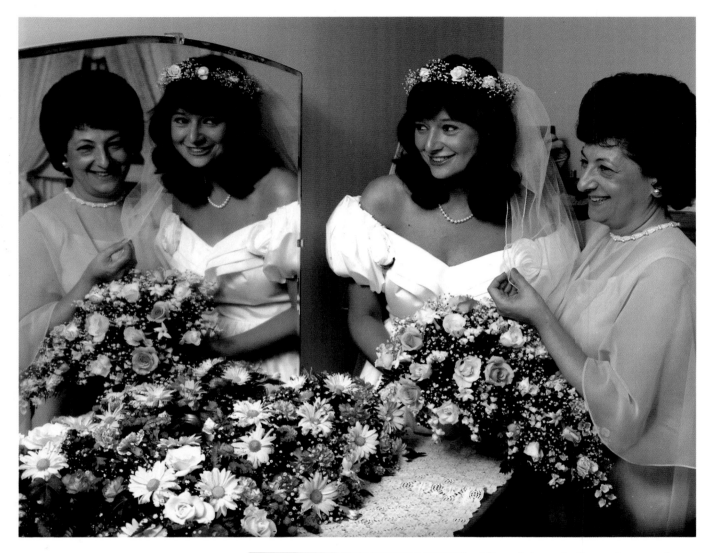

Mirror shots require that you be aware of reflections from the strobes, and here the photographer used two lights. The umbrella strobe on the left is set up to avoid mirror reflections, and the other is bounced off the ceiling (at a 45-degree angle) from an on-camera strobe to add details to the subjects. (Photo: Ken Sklute)

Tenderness, affection, and caring are the emotions you should seek to portray in the photographs of the bride and her mother; therefore posing becomes very important. If the shots can be taken in natural light, so much the better, though mood can be created with artificial light.

How do you portray the emotions mentioned above? By touch, by the motion of the hands and bodies, and by eye contact. When you request that the mother and daughter stand together, they may go right into the pose you want, or you may have to explain or actually help them pose. If you have a definite shot in mind, such as the daughter seated in a comfortable chair and her mother next to her on the arm of the chair, have the bride take her place. Then, act out the pose you want the mother to take. Showing is so much easier than talking subjects into a pose.

Avoid the lineup type of shot where the mother and daughter stand side by side in the middle of the room. This may show off their fancy gowns, but it does little to express the feelings between them. If you photograph them standing have the mother doing something, fussing if you will, or have the bride pinning the corsage to her mother's dress.

After the pose is set, start talking and enhance the mood with your words. It isn't necessary to resort to baby talk, but generate or reveal feelings by talking about the affection you feel coming from the two of them towards one another. Bring them closer with your words. Watch for the special moment when both forget that they're having their picture taken, and when they connect with their eyes and touch. When you feel that moment, refine the shot quickly by having them move closer, look into each other's eyes, or move their hands so the composition is tighter. It's okay to have them hold the pose you think communicates best as long as you don't have them stand in the same place and pose for minutes at a time.

You have the advantage in these situations because you see the subjects through the viewfinder, and you should work to enhance what you see with a few small adjustments. Rely on your instincts for the right shot, but remember to look carefully at the whole effect. Always keep in mind what you want to say, but also keep a parallel thought as to how you're saying it. Awareness of technique is important, but it shouldn't be the overriding matter in your pictures.

The caring and warmth shared by these two people is evident in the posing and touching of heads and hands. (Photo: Rhonda Wolfe Vernon/Artography)

ENHANCING SUBJECTS THROUGH POSING

As we get on in years, life gives our faces certain character, such as smile lines, furrowed foreheads and, unfortunately, double chins.

Double chins can be eliminated, or at least not exaggerated, by having the subject jut, or extend, their heads and necks just prior to the photo being taken. Be aware of your subjects when taking a picture, and have them extend each time a shot is made. It's impolite to say, "Extend your neck so I don't get your double chin," but phrases like, "Okay, move in towards your daughter, but only with your head and neck," or, "Look up with your whole head" can be diplomatic ways of solving the problem.

If a person is much taller than their picture partner, and you have them looking down at their partner in the shot, just have them extend their head or turn it slightly to the side when you take the picture. This care also should be taken with other features that you enhance through posing, such as exaggerating or diminishing noses (by changing head, camera, or light position); creating a slimmer figure (by shooting from a lower angle or with a longer lens), and de-accentuating baldness by avoiding a glaring top-light. People look the way they look, but we all know a camera can glamorize or make more harsh the less than perfect features we all have.

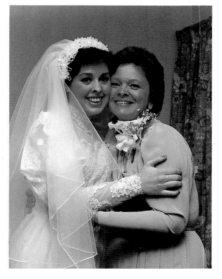

A slight projection of the heads of the mother and daughter toward the camera helps enhance their features plus gives that extra touch of intimacy to the shot. (Photo: David McHugh)

A Portrait of Father and Daughter

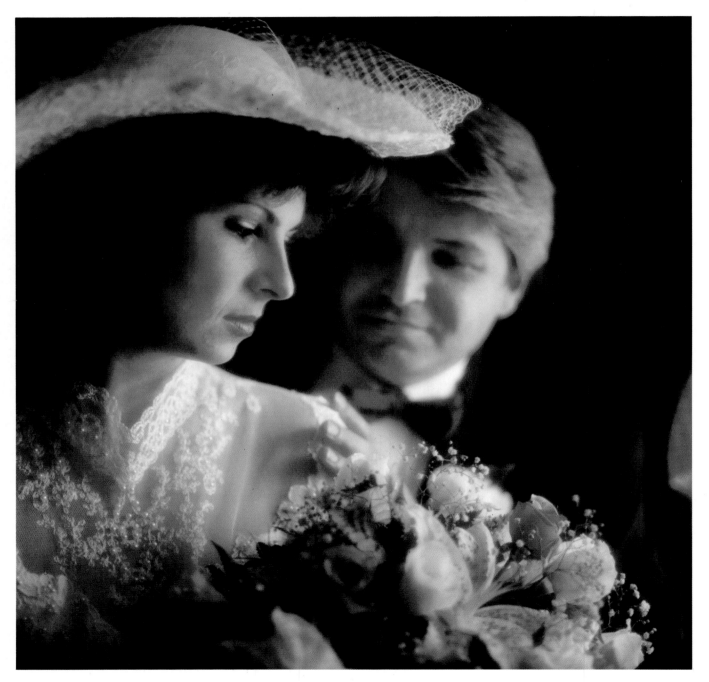

Depth of field has been used in both the foreground and background to enhance this picture of a bride and her father. While the father is in the background and slightly out of focus, the touch of his hand makes the visual connection with the bride. The bouquet has been allowed to go slightly out of focus in the foreground, adding a balance and splash of color to the scene. (Photo: Ken Sklute)

The emotions between father and daughter on the wedding day are strong, and your photographs should convey the feelings of warmth and affection they share. Though it seems traditional that these statements are less intimate than those of mother and daughter, there's no reason to have the poses seem stiff and proper. While many people may take a natural pose for this shot, you may have to work harder to get the feelings into the picture.

You can approach this shot from a number of different angles. If the father seems particularly nervous, you can have the bride helping him get ready for the day. She can be posed straightening his tie or putting a flower in his lapel. If he's calm and collected, you can pose them together arm in arm, hugging or sitting quietly with one another.

Though shots portraying the dependent, protected daughter looking up to daddy may still be popular, the roles and attitudes of society have changed. If you force people to adopt a pose that is unnatural to their lifestyle, you'll not be doing your job and get a false picture in the bargain. Rather than fall into a clichéd pose, try to get a real sense of the father-daughter relationship and use your posing ability to express it.

One of the emotions you may find present is the pride the father has in his daughter. You can express this pride by having the father relating strongly to his daughter's presence, by the look in his eye or the stance he takes next to her. Like the mother-daughter shots, have the two relate strongly through their looks and touches. Having them stand squarely next to each other, looking and smiling into the camera, communicates nothing but the fact that they got dressed up that day.

These are people who've shared a good part of their lives together, with all the time and emotions that implies. You might find an area in the house where they've shared much of that time, or an activity that has helped them bridge the gap between them. You might inquire about these matters, and ask them to help you tell the story in a way that only they can know. These details can help you express the story of these two people, and put real meaning into the pictures made on a very important day in their lives.

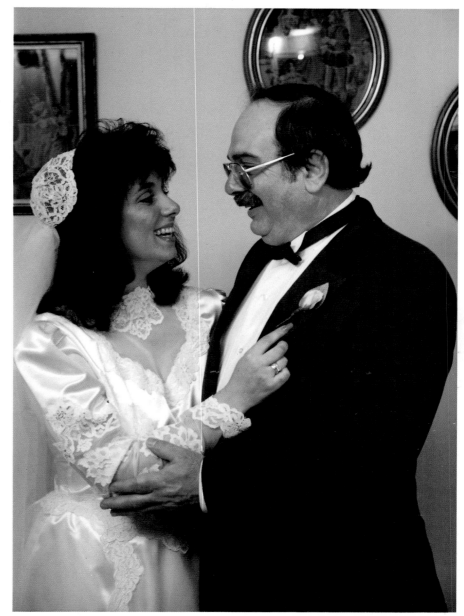

The affection shared by father and daughter is self-evident in this candid photo taken at the house. Variations on this shot might include the bride adjusting the flower in her father's buttonhole or the father helping his daughter down the staircase. (Photo: Ken Sklute)

Highlighting the Family's Closeness

Photographing the trio of bride, mother, and father allows you many posing choices, and all should feature the love and caring that makes this group special. Since this is a special day for all concerned, capturing their emotions, particularly through touching poses, is important. Because you have a threesome, you can use a diamond style setup, with two people seated and the third standing behind them. Add the bouquet or train of the gown as the bottom tip of the compass.

One pose that's very popular utilizes depth of field. The mother and father stand behind the bride, slightly out of focus, while the bride stands sharply in focus in the foreground. To get this shot, have the parents stand slightly to the side so they are in a corner of the frame. Set your lens at $f/4$ or $f/5.6$, check the scene with your depth-of-field preview button and focus right on the bride's nose.

If you're doing a straight-forward picture, shoot a waist-up shot with the trio arm in arm, and have them snuggle in together. Don't revert to a stiff pose, rather talk them into the pose that conveys a feeling of closeness. Although most people will fall into a natural pose in this situation, keep your eyes open for refining touches such as a flow of lines.

Using props can be extremely helpful with a small group such as this, and staircases, arm chairs, and couches should be used to the fullest. Whenever you have people seated, make them sit "on the edge of their chair" so to speak, or have them sit laterally across the seat of the chair. Don't allow them to plop back into the seat, and be aware of how jacket and/or dresses ride up when they're seated.

Hands can become a problem in small groups, and a general rule to follow is either show all the hand or none of it. Don't have a thumb sticking up over a shoulder (if they're in a "huddle" shot) or two fingers coming

out from a waist. Be aware of these distracting elements, and make it a part of your visual once-over before you snap the shutter.

This will be the last picture of the bride and her mother and father before her marriage. To say that emotions are strong at this time would be an understatement. Don't get in the way of those emotions, and don't pose the people unnaturally so they feel confused by your directions. Get them together for the picture, help them pose in a comfortable way, and you'll get all the pictures you need for a successful take.

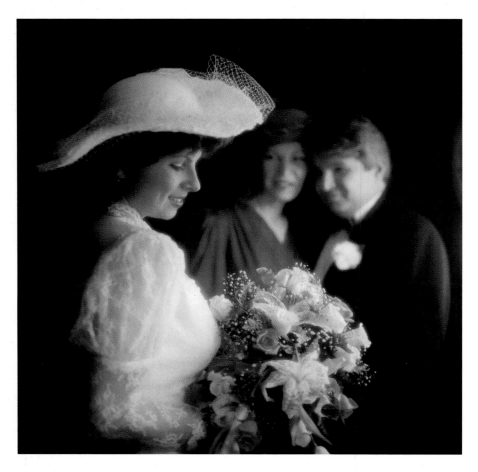

A popular method of portraying the mother and father with the bride utilizes depth of field to have the bride in focus and the mother and father slightly out of focus in the background. A setting of $f/5.6$ was used in this exposure. Also, two panels of windows were used to light this scene, one with light falling on the bride and the other with light falling on the parents. (Photo: Ken Sklute)

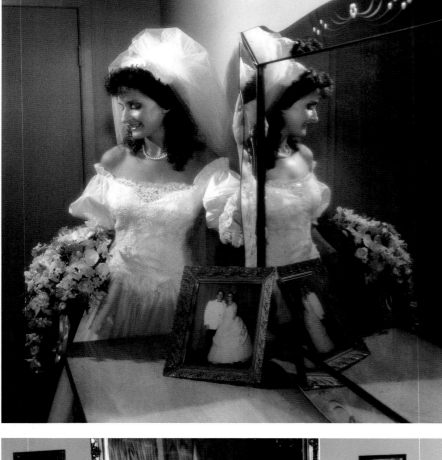

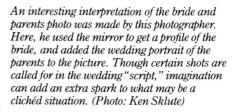

An interesting interpretation of the bride and parents photo was made by this photographer. Here, he used the mirror to get a profile of the bride, and added the wedding portrait of the parents to the picture. Though certain shots are called for in the wedding "script," imagination can add an extra spark to what may be a clichéd situation. (Photo: Ken Sklute)

A single 200-watt strobe off-camera was used to illuminate this group. An exposure time of one second was used to bring up the ambient light in the room behind the columns, thus providing a balanced background to the shot. (Photo: Ken Sklute)

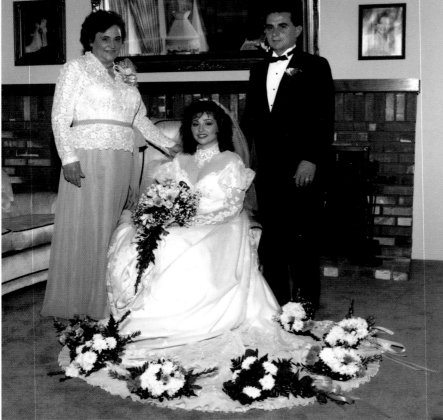

This "classic" shot of the bride surrounded by mother and father, and bordered with bouquets, is one solution to the family shot at home. Having the parents lean in a bit more toward the bride would have added an extra touch of intimacy to the scene. (Photo: R&R Creative Photography)

Posing the Bride and Her Attendants

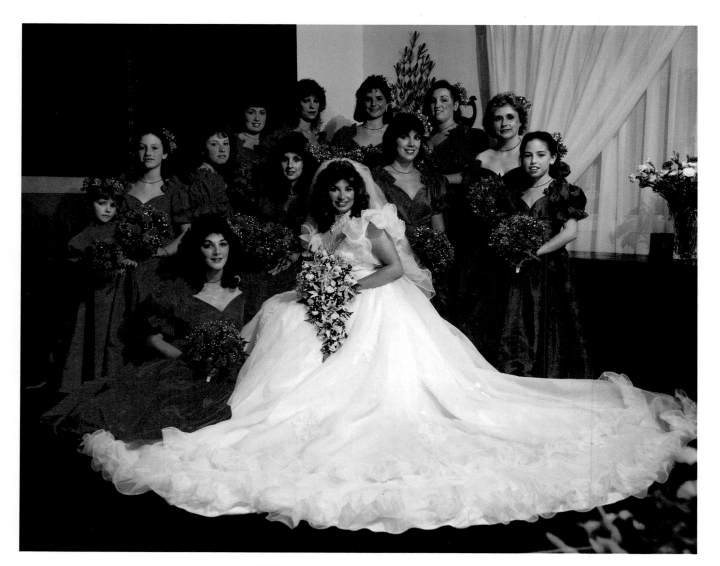

Simplicity in lighting is often the key as illustrated in this group shot made with a bounce-fill technique. Here, a single umbrella/fill strobe is burst from a 45-degree angle on the left side of the group. An on-camera strobe is bounced off the ceiling at a 45-degree angle to provide a frontal fill light (Photo: Ken Sklute)

Often group pictures of the bride and bridesmaids are stiff, and the resultant shots look like high school yearbook material. You may have a small party of four, or as big a group as ten. The type of posing will, to some extent, be determined by the size of the bridal party. Small groups lend themselves to more intimate settings, such as around a chair or couch, while larger groups may require that you step outside for the shot (depending, of course, on the size of the shooting area in the home and the weather.)

The bridal party consists of friends, contemporaries, and honored guests of the bride. They're usually attired in the same color, or type, of gowns. Though the bride almost always wears white, the bridal party may wear pastels, dyed lace, or other "party" style dresses. Always consider your backgrounds when shooting the bridal party, making sure you don't have color clashes. Purple drapes and bright orange dresses can make for a visually alarming photograph.

In all shots with the bridal party, the bride should be the center of attention. This can be accomplished by posing her in the middle of the group, with the bridal party arrayed around her, or by having the group arranged so their motion is toward the bride. With a small group you can have the bridesmaids around the bride's head like a halo, or have some sitting with her on a couch and the others leaning in from behind.

For larger groups, you can line the group up, but only if there's a sense of motion involved. Turn each person three-quarters facing the bride, with the dresses fully flourished, or have the bridal party arranged in groups of diamonds with the bride in the center. (A diamond group is composed of four people, or three people and an implied fourth; this shot has to be taken from the front, at a high angle.) Watch for flowing lines throughout the group, just as you would in a closeup of the bride herself.

It's okay to have fun with this shot, and not every pose has to be a setup shot. You can have the bridesmaids crowding around admiring the ring, or each taking a part in arranging a part of the bride's attire. Get one or two formals, but don't be afraid to get loose with this group shot. Never be afraid to experiment with the group personality, as you may end up stifling the good times that are a part of the day.

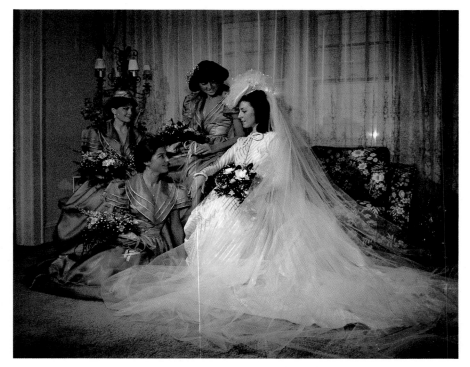

The tonal consistency in this picture makes it very pleasing to the eye, and the lightness of the bride's dress serves as a natural reflector to make her the center of attention. Too many light sources would have thrown off the mood of this group shot. (Photo: Ken Sklute)

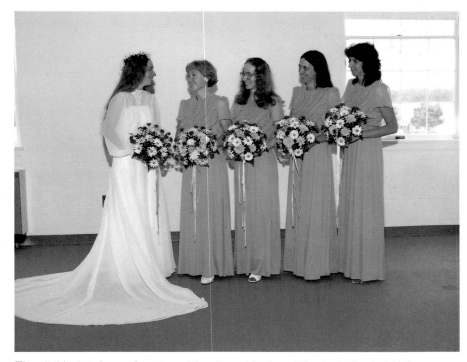

Though this shot gives an inventory of those present in the wedding party, the straight line approach to groups leaves something to be desired in the posing. Perhaps the window light could have been used to good effect, rather than as a distraction in the background. (Photo: Rhonda Wolfe Vernon, Artography)

The Bride and Her Maid of Honor

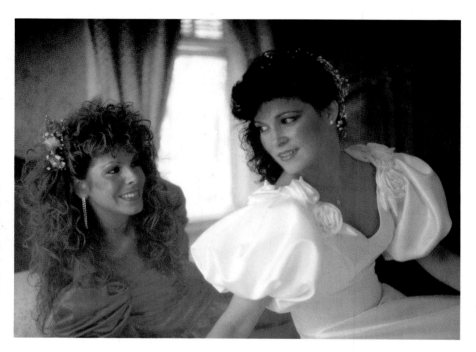

As mentioned previously, the maid of honor has a special place on the wedding day. She's there to make sure everything runs smoothly, to serve as stylist, to do errands, and even to occasionally hold the bride's hand. Being maid of honor means that the woman is one of the bride's best friends and confidants. Therefore pictures of the two of them together should express this closeness and intimacy.

Many picture opportunities of these two people will present themselves during the course of the day. You can capture them together during the preparation at home, at the church, or at the reception. Effective shots include the maid of honor helping the bride with her veil, helping the bride with her train, or even sharing a quiet moment or a laugh together.

In what appears to be a candid picture, the photographer has set up a shot that speaks volumes about the relationship between the bride and her maid of honor. Note how the spilling backlight and split frame of the curtains mirror the pose of the two women. Their crossing bodies at the bottom of the frame enclose the composition. (Photo: Glenmar Studio)

DEALING WITH THE NERVOUS BRIDE

Nervousness on the part of the bride is a natural reaction to the heightened state of emotion on the wedding day. Sometimes this nervousness can spill over into fits of giggling or even near-hysteria. Trying to pose someone in that condition can be, to say the least, trying, especially when you're attempting to attain a particular elegance or expression in the photograph. Don't panic; making demands or becoming hyper yourself will only increase the state of the bride's nervousness.

If you can, calm the bride with your words and gentle actions. There's no sense trying to posing her in this state, so take the time to work with her without applying any pressure. The bride may be hyperventilating, and deep breathing is a way to help her calm down. Sit with the bride and talk slowly, then ask her to join you in a minute or two of meditation. This may sound a bit foolish, but it really works.

Reassure the bride that there's plenty of time for her to get ready after the pictures are done, and that whatever happens you're there as a friend as well as a photographer. The bond between photographer and client can become very strong as the day progresses, and allying yourself with the bride early on helps to alleviate tension.

If none of this works, and the bride continues to be nervous or agitated, pictures may be impossible to take at this time. Don't keep banging your head into the wall. Tell the bride that everything is okay, and that you'll get the pictures later in the day. Accept the fact that the situation is sometimes out of your control, and know that the bride will calm down considerably after the ceremony is completed.

All this is part of the wedding photography game, so be prepared for all sorts of people and reactions. In many cases, your presence at the bride's house actually provides some structure to the hectic time before the ceremony. Remain calm, project a friendly and professional manner, and most people will welcome the one organized person in what seems to be a scene of chaos. That person should be you.

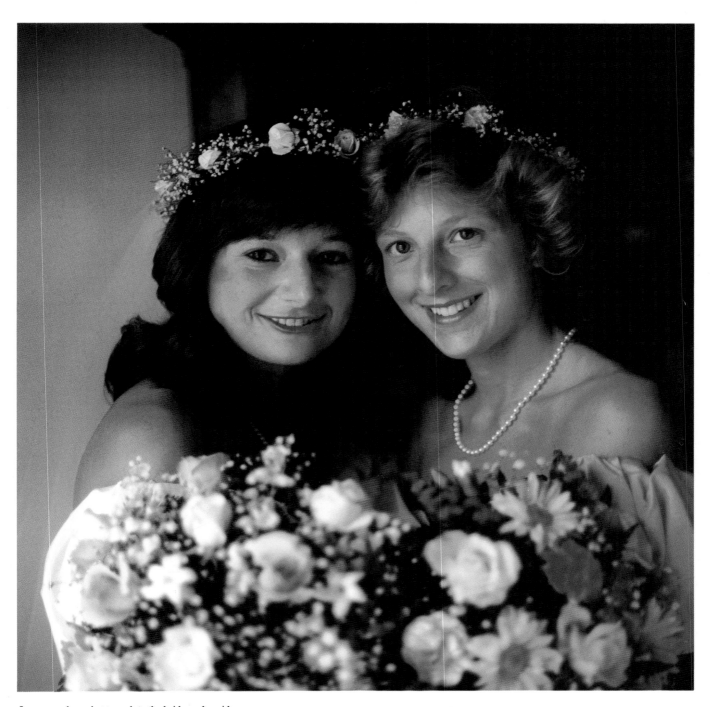

In a more formal approach to the bride and maid of honor picture, the photographer has used the bouquets as a lower border, and put them slightly out of focus to add a splash of color to the scene. The fact that the two women are touching heads lends more intimacy to the scene than if they were standing next to each other with their heads apart. (Photo: Ken Sklute)

Focusing on the Ringbearer and Flower Girl

A source of some very precious photographs, and ones guaranteed to be good sellers, are those of the ringbearer and flower girl. Seldom are children so charmingly dressed, and well-behaved, as when they appear in these roles. Children tend to take these jobs very seriously, and the attention they're given makes them feel very special during the day.

These shots may be made with each child separately, with the children together, or with the children with the bride and/or groom. Usually, the flower girl will be in attendance at the bride's home, so take shots of the bride and her together at that time. The child can be posed next to the bride who is seated in a chair. They can be exchanging a flower, relaxing together, or admiring the bouquet.

As the flower girl is usually the picture of innocence, shots with her and the bride can be made even more ethereal with the use of a light vignetter or soft-focus attachment. Center the two in the middle of the vignette, and use a soft backlight to add a halo to the scene.

Pictures of the girl and boy together can be very charming. You may have little luck making them stay in a preconceived pose, but don't worry—kids being kids, they'll give you plenty to shoot. The little boy may have never dressed in such a tailored fashion, and in an almost mock gravity, he'll walk around with a sense of importance modulated by a great deal of shyness. Asking him to hold hands with the flower girl, or to stand still for a kiss from her, may be too much for his dignity, so just put the two together and get ready to shoot.

Shots of the ringbearer with the groom can also be special. Although this will have to wait for later, you can have the boy sitting on the groom's knee or holding the ring out for both to admire. The boy will probably be taking the job quite seriously, so don't pose him in a way that will be embarrassing. He will probably be blushing enough already.

One word of advice: get the shots of the children early; as the day passes they may become tired and cranky. They'll certainly become more precocious. While this also holds true for adults, the older folk generally don't act it out as much as children.

This shot of the ringbearer and flowergirl is interesting because they're children posing in a very "adult" way. The flower in the young man's lapel adds a balance and a touch of color to the right side of the composition. (Photo: Ken Sklute)

Designing with Diagonal Lines and Curves

In each picture you take there should be a reason for every form, every fold of fabric, and every line in the frame. While this may sound like nit-picking, it's important that your composition be tight and disciplined. The same holds true for every other form of expression. In music, a piece loses its flow if the drummer falls out of rhythm; in ballet, a dancer is careful not to waste a move. The pleasure a viewer derives from a photograph comes from more than just the subject matter; it's determined by the subtleties such as where the center of light falls and how the eye is moved through the frame.

One of the most visually captivating techniques photographers use is provoking the eye through the use of diagonal lines, lines

The use of sweeping lines and diagonals in this group pose makes for a very strong composition. Note how the bridesmaids form two triangles around the flowing pose of the bride. One flaw in this picture is that the lamp on the left is on and the one on the right is off. (Photo: Ken Sklute)

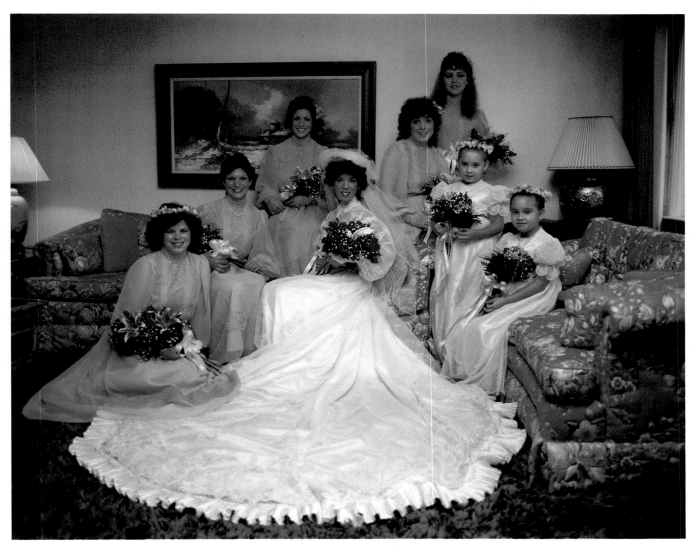

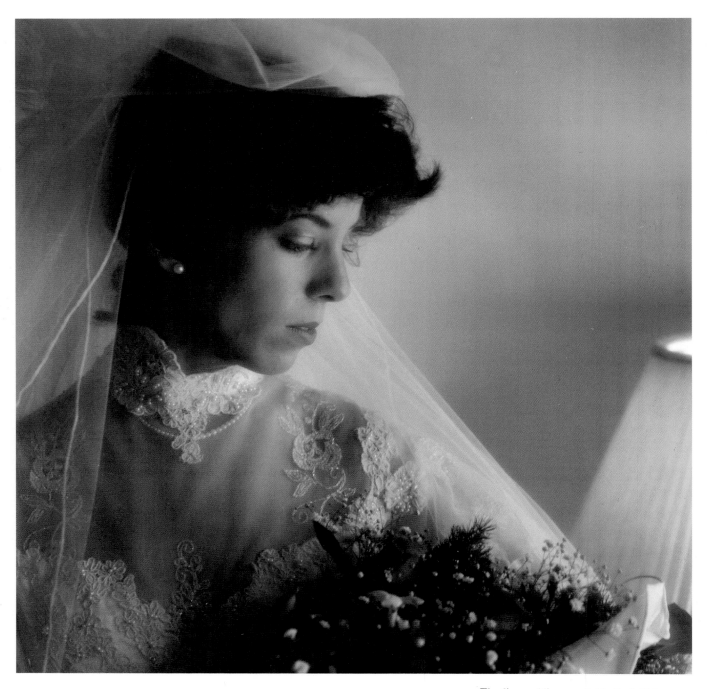

The diagonal lines created by the bride's arm and the arrangement of her veil help to make this a strong composition. Imagine the picture without the echo of line created by the veil, and you'll see that's it's still a good portrait, but that the presence of the reinforcing diagonal makes it even better. (Photo: Ken Sklute)

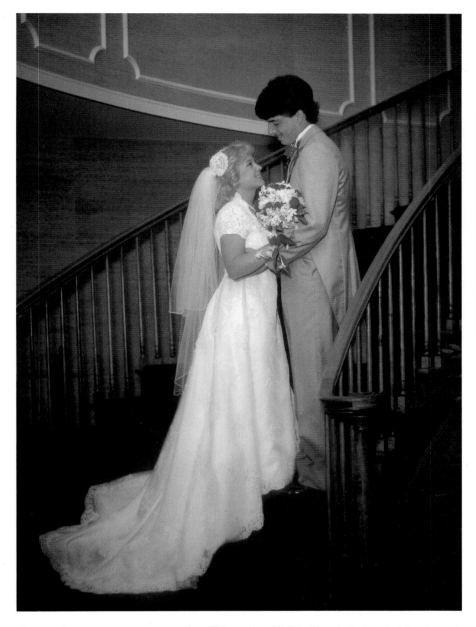

The soft, diffuse light, the diagonal line formed by the staircase, and the touch and eye contact between father and bride would make this a good candidate for an album, but the light fixture that juts from the man's head hurts the overall composition. You must watch backgrounds in your shots. (Photo: Ken Sklute)

that run from one corner to another. This needn't be an obvious line or object that crosses through the frame; diagonal lines can be induced by having a hand and the head held at a certain angle or by a prop, such as a staircase, that leads the eye through the frame.

A variation on the diagonal line is the S curve, another way of leading the eye through a print. Here, posing is enhanced by visually superimposing this graceful sweep of line onto the picture. By removing the burdensome horizontal composition, or breaking it up with diagonals and S curves, you create a flow and rhythm in your work. You, therefore, entice the viewer to linger a bit longer with the image. Don't let subjects get too loose, or have them bend in uncharacteristic fashion, but just keep these

visual "tricks" in mind when looking through your viewfinder.

When composing, attention should be paid to your background as well as your main subject matter. A strong horizontal, such as a straight-backed chair or even a fence post, will detract from even the most graceful pose. If you do make a shot with a fence in the picture, consider making it a diagonal line rather than a straight horizontal. You'll notice a dynamic difference in the composition.

The most obvious example of strong vertical or horizontal backgrounds detracting from a picture is the classic telephone pole emerging from someone's head. You've trained your eye to look out for that problem; now go one step further and keep a flow and sweep in your images.

Using Existing and Artificial Light

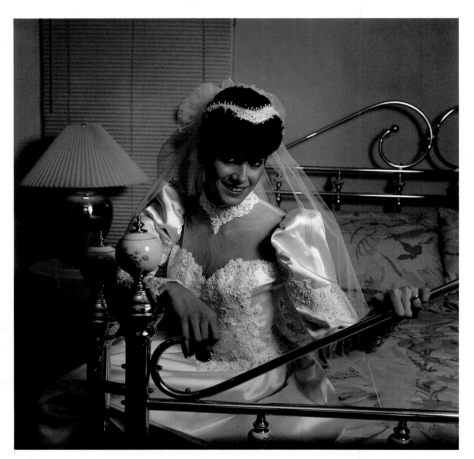

Using and controlling light is the key to making good pictures. During the wedding day you'll be confronted with both natural and artificial light, and combinations of the two. Knowing how to read light, and make it a tool of expression, is important to all types of photography, and wedding photography is certainly no exception. In fact, utilizing light during a wedding can often be more demanding than in any other type of photography. You can return to a landscape picture if conditions on a particular day aren't favorable. You can take hours setting up studio lighting for a commercial shot. No such luxury exists on the wedding day—you have to work with what you've got, and make the best of it. That's why you've got to be flexible, be able to think on your feet, and be able to manipulate the light you've got to best advantage.

Natural light is preferable to artificial light, especially when doing portraits in the home. Large bay windows, lightly curtained, yield a soft, rich light that makes any strobe seem harsh in comparison. But once you have this light, how can you make the best use of it?

The first step is in knowing how to read the light. Let's say you want to make a portrait of the bride using the light coming from a window. In posing, keep the front of the bride's dress away from the strongest point of light. The white field may throw off your exposure, resulting in a harsh looking dress and an underexposed face. Turn the bride's head toward the light, letting it model her features as it skims over her face.

Take a reflective reading from both the highlight and shadows in the scene (that is, the shadow area in which you want to show detail). If these two readings yield more than a three stop range (*f*/4 and *f*/16), you're getting too much contrast. You'll have to adjust your pose. You can do this by either moving the bride further from the window (thus decreasing the intensity of the light falling on the subject) or by setting

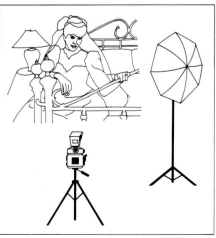

An umbrella strobe was set up to the right of the bride to bring a light to the scene, and an on-camera strobe was bounced off the ceiling (45-degree angle) in order to add detail to the opposite side of her face. Notice that the lamp is turned on in the background; a one second exposure assures that light from the lamp records on the film. (Photo: Ken Sklute)

up reflector cards on the shadow side to fill in the darker areas.

Take readings after your adjustments and look for a range of two to three stops between highlight and shadow (*f*/5.6 and *f*/11). Expose for the shadow reading, or a half stop above the shadow, and you'll get a rich negative that can be printed perfectly by your lab.

On the other hand, if you want to use contrast for effect in your pictures, set the shot up where the highlight-to-shadow detail ratio on your subject is over three stops. Expose one stop below the highlight reading and have the lab print for detail in the highlight area. For a silhouette effect, have the background read three stops over the *entire* main subject, such as a profile. By modulating this technique you'll be able to use available light to its fullest potential, and have expressive pictures in the bargain. The intimate pictures in the home are easily done when you have a good, filtered source of natural light. This light will give you portraits and group shots that have a quiet, elegant look to them.

You may, however, have to deal with a heavily overcast day, or find yourself in a situation where no natural light finds its way into the scene. This won't stop you from having full and expressive control over the lighting. Artificial light has come a long way from the size 25 flashbulbs, and modern studio strobes have elaborate fixtures, from umbrellas to "soft boxes" that yield light that approximates a natural, "northern" illumination. Soft boxes are sheets of translucent material that strap over strobe heads. They're available in oval, square, rectangular, and even star-shaped configurations. One of the most popular ways of dispersing studio strobe light is with an umbrella, an attachment in which the light is thrown and subsequently reflects the light back on to the scene. When using umbrellas, use a matte rather than a super silver variety.

Creating even, modeled light or high contrast scenes is done in a similar fashion to the method with natural light, except with strobes you create highlight and shadow by using of two light sources, and sometimes a third kicker, or background light. Set up your lights so that they skim across the picture plane (from the sides) rather than have them punching directly at the subjects. Too strong a light bouncing directly back from a wedding gown can cause problems.

Your two lights will consist of a key light and fill light, much like the sunlight and natural reflector card setup described before. Set the key light for full or half power,

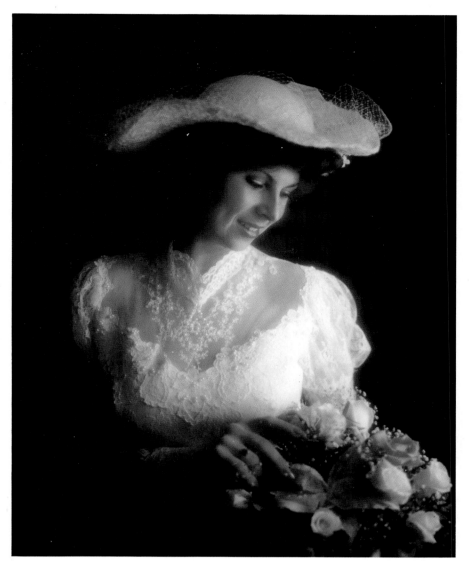

and the fill light for a quarter power setting below the key light. This has the effect of yielding one less stop of light from the fill, thus providing a shadow and highlight to your scene. Use the modeling lights in the strobes (preview lights that show the ratio, though not the intensity, of your lighting setup) to help set up the lighting, and move the lights around until you get the look you want.

Always have the brightest light source coming from the darkest part of the scene. For example, if the groom is in a dark tux put him on the side of the key light. In this way you avoid harsh reflections from the bridal gown, which will throw off your exposure, and it allows the gown to serve as a natural reflector into the groom's darker clothing.

For scenes where you want high contrast, you can either turn off the fill light completely, have it two steps below the key

The light from a single window was enough to provide ample illumination for this portrait of the bride. The white dress acts as a natural reflector into the bride's face. (Photo: Ken Sklute)

or use a background slave to throw glowing highlights around your subjects. Another popular use of strobes is directional lighting, where the strobe is off to the side of the subjects and is definitely "off-camera." This is great for pictures of singles or couples, but isn't recommended for group shots.

Strobes can also be used as a way of lightening or darkening areas in the scene. If you have a room where there's a certain amount of ambient light created by lamps or a brief shaft of sunlight, expose at 1/15 second. This will illuminate the subject plus allow the glow of the lamps to record on the film. If you want to isolate the subject in the room, expose at 1/250 second. This will darken the surrounding area and allow little, if any, ambient light to be recorded. Of course you'll have to compensate your exposure by changing *f*-stops.

Combinations with two, or even a single strobe, creatively used, are endless depending on the power at which you use them, and where they're placed in relation to your subjects. Practice with your lights, learn how to read strobe output with a flash meter, and be able to predict the effect you achieve with each variation.

When using a mix of artificial and natural light sources, keep an eye out for the balance of light and the way it falls in your pictures. Here, a distracting highlight glows from an artificial source behind the man's head, while light from a window falls across the bride. (Photo: David E. Ross, R&R Creative Photography)

USING A LIGHT METER

Whether it be in natural or artificial light, correct use of a light meter will determine how you translate mood and feelings in your pictures. Professional meters have the capability to give you readings for the various types of information you need by yielding reflective, incident, and strobe light. Reflective measurements read just that, light reflected from a subject. To take a reflective reading, bring the meter right into the area you're shooting and hold it off the subject, with the meter head pointed towards the subject. For example, if you're reading a face that's side lit, take a measurement off the shadow side of the face *and* one off where the light is falling strongest. You can then check your lighting ratio by comparing one reading to the other.

Incident meters measure overall lighting conditions, and are excellent for general shots, such as those made outdoors. With incident readings, you point the meter in the direction of the camera, making sure your shadow doesn't fall across the meter globe.

A flash meter measure the light from your strobes, and generally reads out in *f*-stops. Place the meter next to your subject, pop the strobe, and note the reading. Walk around and make several readings, making sure the light is balanced the way you desire.

A special adaptor can be put on professional strobes to give spot readings. Here, the meter yields a very selective measurement of 1–10° of your subject, though it can only be used for available light readings. It's a very accurate way to measure light, but it's really more useful for landscapes than weddings. Whatever type of reading you take, make sure the meter is consistent and accurate. A faulty meter can be a disaster. A good meter is as important a tool as your camera on the wedding day.

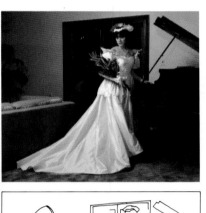

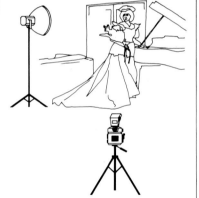

Photograph of a bride in her living room was made with a bounce-fill technique. An off-camera strobe was placed at a 45-degree angle from the bride and to the side. An on-camera strobe was bounced off the ceiling (45-degree angle). The meter was read off the light side of the bride's face so some modeling would occur in her features. (Photo: Ken Sklute)

The "Final" Farewell

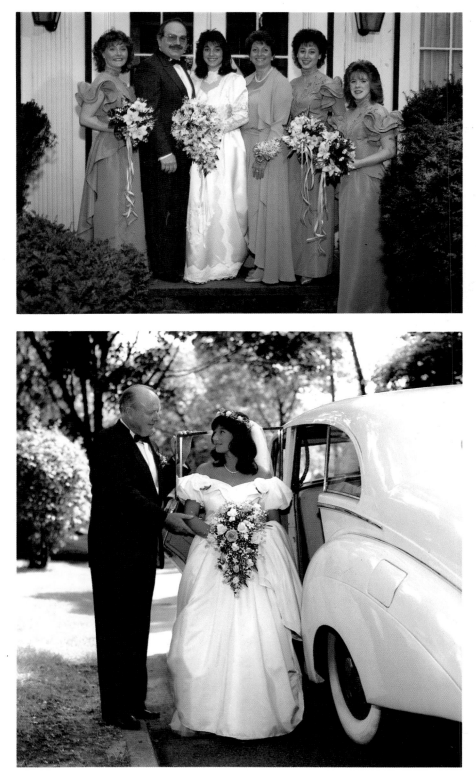

The farewell to hearth and home is a traditional shot requested by many couples, and although it's chronologically the last shot in the home "script," you should try to set it up prior to the actual departure to the ceremony. If you wait around until everyone is ready to go, you'll have to race to the church to get the shots you want there before the ceremony. Once the bridal party arrives at the church everything goes into motion. Besides, you'll have to give yourself time to pack your gear and reload your camera for the next series of photographs.

The departure shot is what's called a "grabshot," so it shouldn't take more than a few minutes of everyone's time to set up. An easy way to pose this shot is at the front door or steps of the home. Have the bride and the bridal party at the bottom of the steps and the family at the top waving good-bye, or have the father open the front door for the bride while the mother looks on or waves so long. If the limousine or bridal car arrives early (don't count on that happening) you can get a shot of the father opening the car door for his daughter with mother helping her with the gown. Another option is to have the mother and father at the bottom of the steps, with the bride descending the staircase helped by the maid of honor.

As this is a staged shot, any of these variations will do, so let your directorial spirit take over and design new setups on this basic scenario. The idea is to get the shot and get moving because the next hour or two of your life will be very busy. Make sure that you get to the church *before* the time of the ceremony.

(Top, right) A grab shot that can be set up even before the limousine comes to the house is a group picture of the bride, her parents, and bridal party at the front of the house. Time may be of the essence here and may preclude any elaborate posing. (Photo: Ken Sklute)

(Bottom, right) The father helping the bride into the limousine prior to the ceremony is a classic shot in most wedding albums. Note the low angle-of-view in this photo, the quiet demeanor of the subjects, and the way they connect both visually and physically. (Photo: Ken Sklute)

Photographing the Ceremony

The pictures described in the following sections all take place in and around the church or synagogue before, during, and after the ceremony. When they take place is often out of your control, as some churches allow pictures to be taken during the ceremony; some allow a few discreet shots during the service; while others absolutely forbid any pictures while the wedding is taking place. In order to help smooth the way, it's best to check out a few things before the day of the wedding itself.

Soon after the wedding is booked (or at least a month before the service, as some weddings are booked a year in advance), call the priest, minister, or rabbi and inquire as to the institution's policy on photography during the service. This indicates that you're willing to respect the church and its policies, gets a spirit of cooperation moving between you and the minister, lets you know what you can and cannot do, and subsequently helps you plan your shooting stragegy for the day.

If you get permission to shoot at will during the service, it still doesn't give you license to blunder about the altar with whirring motor drive and popping strobe. Discretion is always the name of the game so consider using a moderate telephoto lens and standing back a bit for the service. Some photographers spend so much time on the altar that one would think that they're getting married.

If you get permission to take a few pictures during the ceremony, such as the "giving away of the bride" and the ring ceremony, honor that understanding by getting those pictures and then moving out

of the way. You can also get good pictures from the back of the church or the balcony, should the building have one. Ministers have been known to stop in mid-service and order an over-enthusiastic photographer to stop shooting pictures. Save yourself, and your clients, this embarassment by respecting the presiding minister's wishes.

If no pictures at all are permitted during the service, request that the minister stay a few minutes after for a reenactment of a few scenes from the wedding. Although this may sound a bit artificial, it's really a successful method of obtaining the best possible pictures from the key points in the proceedings. In fact, it may be the best and most discreet way of getting the pictures you want from the actual service since you have absolute control over posing and camera angle. You certainly can't be calling out directions for posing during a service. Also, by getting permission to shoot in the church after the service (you should get permission regardless of whether you've been able to shoot during the ceremony or not), you'll have an opportunity to make great portraits of the couple and the whole bridal party in the context of the church.

Another way of preparing for the shots in and around the church is to scout the location before the day of the actual shooting. Not all churches are alike, and some will offer advantages and others disadvantages in your shooting script. See if you can move around the altar, or if it's right against the back of the church. Is there a balcony, or choir loft, for long range shooting? Will it be available to you during the ceremony? Again, talking with the minister beforehand

can get a door opened that might otherwise be locked. If possible, visit at the approximate time during the day when the ceremony will be taking place in order to get a feel for the light. This will help you preplan some shots.

An optional preparation is to attend a rehearsal of the service itself. More and more couples are structuring their own ceremonies to their own lifestyles. Some have chamber orchestras performing, guitar solos by younger sisters, or even friends reading passages from favorite works of literature. Knowledge of these, or any special events, will help you become a better visual storyteller. If you can't make the rehearsal, at least get a good idea of the script of the wedding beforehand. Don't miss those moments which make every ceremony unique.

When you finally arrive at the church or the synagogue after your shooting session at the bride's house, find and enlist the help of the best man to act as your liaison. He can help you identify those important people that need to be photographed as they are escorted down the aisle. He can also gather the rest of the wedding party for the various shots you'll want to take prior to the ceremony.

If you're doing exterior shots of the groom, or the groom and the ushers, don't stray too far from the grounds of the church, and make sure there's some line of communication between you and what's going on inside. If you really have a good set of legs and a reliable communications network set up, you can be at the front of the church for a grab shot.

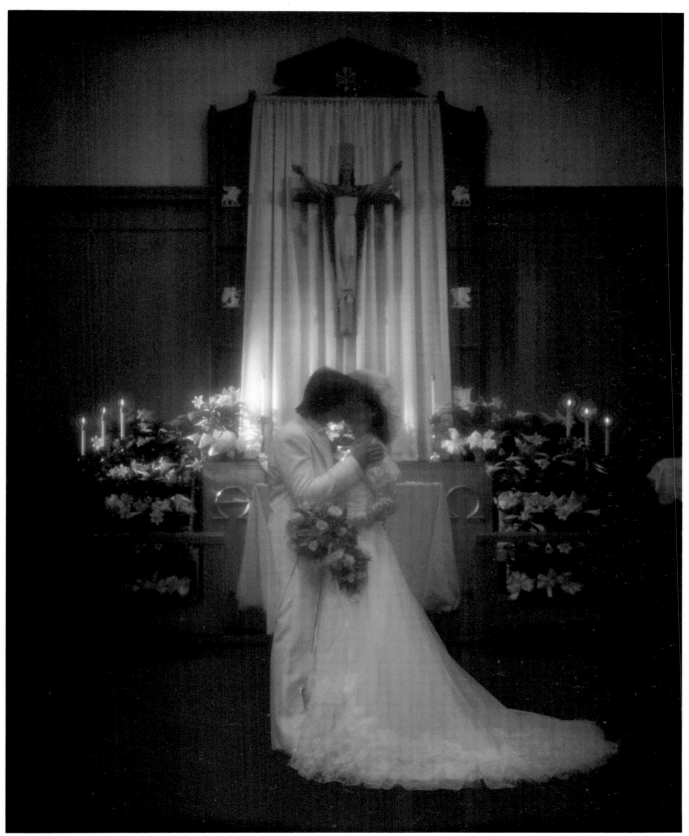

(Photo: Ken Sklute)

The Groom's Reflections

The final moments of bachelorhood are an interesting time in a man's life. Even if the couple's been going out for years, lived together prior to being married, or are getting married after being swept away, the man always has a few moments of thought before the wedding. These thoughts may result in a transformation of spirit, accompanied by a twinkle in the eye and a certain look that some might describe as happiness. Your being present at this time gives you a unique opportunity to record and interpret these feelings. Rather than look for formal poses, choose more candid ones that capture the natural, and spontaneous, emotions of the groom.

Just as the bridal shots often mirror a contemplative soul, the shots of the groom can be made with him looking out a window, awaiting the arrival of the bridal party, or just wistfully thinking of his wife-to-be. Since he may feel a bit awkward in front of the camera at this time, help with some verbal encouragement and touch posing.

Unlike the bride, who is wearing a beautiful dress with ruffles and flourishes, the groom is clad in the somewhat austere fashion of a tuxedo. This clothing is meant to accentuate line and angles and offers little of the visual play available with the bridal gown. For that reason, you'll have to be more conscious of posing and helping the groom appear less stiff than his clothing makes him out to be. Having him turn his head or lean against a support can give motion to a potentially straight line shot. Be aware of the collar of the coat riding up over the neck, the sleeves coming out from the arms of the coat, and other details that can turn a well-tailored look into a poorly worn garment. Many tuxedos are rented and aren't always tailor-made for the groom.

Posing should be casual, and a good source of ideas for shots is men's fashion magazines—emulate the "look" you see there, or design your own to fit the individual. Resting a leg on a chair or other prop, with an arm across the knee, and head and shoulders leaning in towards the camera can yield a very dynamic look. Hands can be in the pockets or thumbs hitched in the

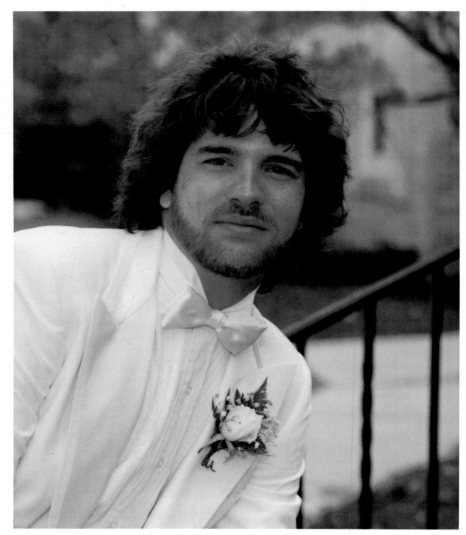

pocket or waist band to convey a relaxed, confident mood.

A dark vignetter can be put to good use at this time because it helps to eliminate a less than staged background plus it focuses the light and attention on the groom's face. If you use this filter, you can shoot from a low or medium angle to give a sense of presence to the subject.

Too often, shots of the groom before the ceremony make the man look like he's waiting for a bus. Use motion and dynamism in the shots to reveal the sense of heightened awareness that is so much a part of the individual at this time.

This shot of the groom prior to the ceremony makes use of available light. The blossoms of the tree serve as a natural background and border to the picture. (Photo: Robert R. Decker, Artography)

(Right) This photo of a handsome groom before the ceremony makes good use of the props at hand. Note how the photographer has placed the groom's head against a dark background yet his dark clothes are not lost because of the balancing white of the steps. Hitching a hand in a pocket is a good way to pose what might be an awkward limb. (Photo: Ken Sklute)

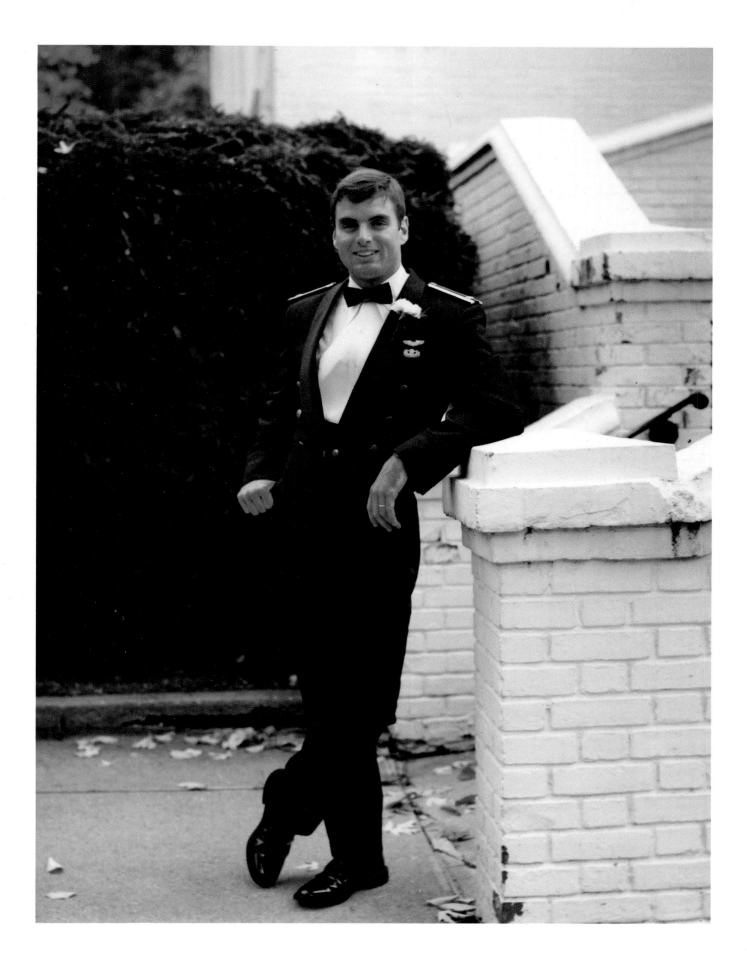

The Groom and His Best Man

The best man is usually the groom's best friend or closest male relative, and as such is valet, bodyguard, and confidant before and during the wedding ceremony. A bond exists between the two men that is certainly an important part of the wedding story, and it should be a part of your photo record. Stress this bond in your pictures, and make images that show the camaraderie and caring the two men share.

The easy way to handle this shot, though a poor excuse for a picture, is to either line the men up against a wall for a double "passport" photo or have them standing next to each other for a long shot in the context of the church. Actually, done properly, this shot has the potential to be a very warm, and sometimes humorous photo. Encourage the men to interact, and interject some comments about the impending wedding.

Popular shots include posing the best man looking at his watch, informing the groom that the time for the wedding is drawing near. With the camera slightly behind the best man, his profile and hand with watch showing, position the groom on the right side of the frame. Other set shots include the best man offering a handkerchief to the groom, or the best man giving him a heart-to-heart talk on the facts of life.

Perhaps the best shots are those depicting the real friendship that exists between the men. Hugging, clasping handshakes, or shots of the men with their arms around each other's shoulders are effective. These shots allow them to show affection without the need of a setup. Encourage this sharing, and get shots that are spontaneous without being affected. The days when men had to be stiff and formal with each other are, hopefully, over. While you're picturing these spontaneous moments, always keep an eye for the details that can make or break the shot. Having people pose informally doesn't mean that you can take sloppy pictures.

The best man is usually a close relative or friend of the groom, and shots of them together should communicate the bond between them. Express the feelings between your subjects in your pictures, don't just line them up and take a snapshot "photo of record." (Photo: Ken Sklute)

The Groom and his Ushers

(Photo: Ken Sklute)

If you get to the church early enough before the ceremony, you'll have time to get a few shots of the groom and his retinue. Although you can get shots later in your environmentals, or even at the reception, this is an opportunity to get a fairly formal portrait of the group. After the ceremony, the group may be much less serious about getting their formals done. At this point they are still involved with the task at hand, they'll be on their best behavior, and they'll still be impressed with themselves and their outfits.

Even though this shot may be in a more formal vein, it's still no excuse to just line up the group and make a "team" picture. Scout locations in and around the church, and find the architecture and landscaping that lends itself to posing. Arrange the group in and around the environment, and have the best man serve as your assistant director.

A number of poses are possible in this situation. You may line the men up with their bodies at a three-quarter angle and shoot from a low vantage point—about waist-high. This camera angle lends strength to their stance and makes everyone look taller and quite "formal." Another poses places the best man shaking hands with the groom in the foreground with the ushers arrayed behind them, or to the right side of the frame. Set your aperture so both the foreground and background are in focus. You can also use the church steps as a posing area, and have the men forming a *V* with the groom in the center. You needn't rely on stock poses here, although you can't take all day posing the group either.

For interiors, you can have the groom sitting in a chair and the ushers leaning in towards him from behind, all with a hand on his shoulders, thus showing a feeling of support. Also, you can pose the entire group each with one leg up on a bench and one arm resting across a knee; the other hand can be hitched in a side pocket. Have them lean in toward the camera.

After the ceremony is complete, you will have time for more relaxed, informal, and even humorous shots of the groom and ushers. Take advantage of the time before the ceremony to get strong formals, but pose as quickly as you can because everyone has many details on their mind.

Arriving at the Church

Stationing yourself in front of the church prior to the ceremony, and getting shots of the arriving bridal party and/or the father and the bride can add a number of good pictures to your coverage. It can also be a way of getting pictures of these groups should you not be able to go to the bride's home prior to the service or if time didn't permit the pictures to be made. Often, not all of the bridal party is dressed and ready for pictures when you're doing the pictures at the bride's home. These shots can also be effective in that the context of the church gives further meaning to the photographs, and convey more of a "real time" sense of the event.

From the moment the bride leaves her home, the father is usually by her side. He ushers her into the church, down the aisle, and finally "gives her away" at the altar. Though you'll probably be getting a shot of the accompaniment down the aisle, a good shot, and one that gives you a bit of insurance, is one of the father escorting the bride from the car into the church. Here, use the limousine as a prop, and have the father help his daughter take the first steps towards the ceremony.

As most churches have steps that lead to the entrance (and you'll be using these later for a group shot after the ceremony) you can use them to get a good vantage point for this picture. If the steps are too high or too far away from the curb, get closer and shoot a full view of the action.

Depending upon the time of day, you might need a fill flash to help balance your exposure, especially if you choose to take the shot with the bride just emerging from the car. Pay close attention to shadows and the high reflectivity from the gown. Also try to click the shutter when the bride and her father are moving gracefully.

If the bridesmaids happen to be in the same limousine, or close behind, you may have time to get a quick shot of the group on the steps of the church. Gauge your time carefully here, as the participants may be concerned with final preparations. Whatever shots you take at this time, be aware that they'll have to be of a candid nature.

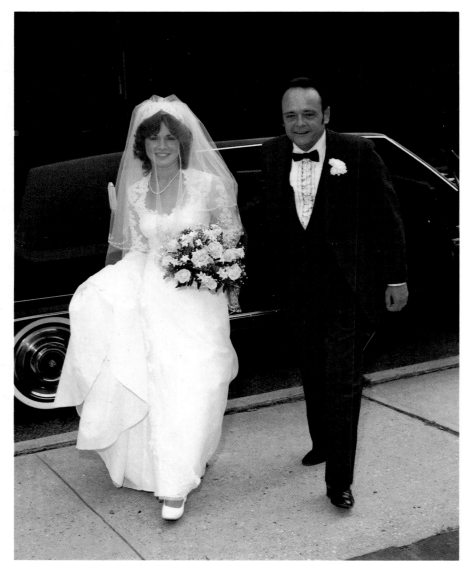

Part of your job as wedding photographer is to tell the story of the day's events. Here, in a transitional moment, the father escorts the bride from the limousine into the church for the ceremony. You needn't pose shots such as this—just rely on your instincts and make these photos part of the wedding diary. (Photo: Harold Snedeker)

The Marriage Documents

Prior to the Jewish ceremony, a ritual takes place in the rabbi's office wherein the marriage documents are signed. This event is witnessed by the key members of both families, and is officiated by the rabbi who will conduct the service. This event, which is as important as any that takes place during the wedding ceremony itself, should definitely be part of the wedding coverage.

Because the office or quarters are sometimes cramped, you should switch to a wide-angle lens, such as a 50mm, and use bounce or bare-bulb flash illumination. These bounces of light fill the room and help you avoid harsh shadows or overexposed faces that could result from direct strobe. If you don't have an automatic strobe, be sure to calculate the distance formed by the triangular path of light with bounce technique, and make a quick reading of the scene with your flash meter for insurance.

This is recognized by all as an important picture, so you'll be able to do posing either during or immediately after the documents are signed. You can group the participants around the desk, or get a shot over shoulders of the bride and groom as they're facing the rabbi.

Have action and involvement in the shot by posing your subjects so their eyes and motion are directed towards the matter at hand, rather than have them relate directly to the camera's presence. Respect the importance of the occasion by telling a story of the events, not by having a staged shot where everyone is playing toward the camera. Pose the shot, but do it in a way that allows the camera full view of the participants and the events that are occurring, so that the viewer is not even aware of the photographer's directions.

After the documents are signed by the couple and the witnesses, the bride's mother will place the veil on the bride's head, signaling approval and commencement of the rest of the ceremony. Take this shot either in closeup or including other members of the family, but don't pose it as a formal, camera-conscious group. Although these are setups, shoot them as if they're candids of the action taking place.

The signing of the wedding documents in the Jewish ceremony takes place prior to the service itself. Here, the photographer has taken a unique point of view of the event. Although the bride and groom's profiles are not in focus, this point of view tells the story of what's happening. (Photo: Robert Salzbank)

Coming Down the Aisle

Before the actual ceremony starts, guests arrive and are led down the aisle by the ushers. This standard ritual has the well-dressed retinue of the groom leading both families to their appointed sides of the aisle. Though shots of this procession are optional, clients may want pictures of relatives being escorted by brothers, uncles, and other family members or friends. Also, mothers who rarely see their sons so well-groomed may want a shot of the two of them coming down the aisle.

If these shots are requested, you'll have to find a way to determine who's who in the group being led into the church. Enlist the aid of a family member or the best man to serve as spotter for you. Station your contact person at a strategic point on the aisle and have them signal when the important people are being escorted. Place yourself at the bottom of the aisle (most times these key people will sit down front) and get ready to shoot.

Focus your camera and set flash distance on a seat or pew that's about ten feet from where you're standing. Snap the shutter when they reach that point. One shot is all you'll need at this time—if people want a more formal shot, you can take it later on location at the reception.

While you're there, and when everyone is seated, take a shot of the bride and groom's families. You certainly won't have time to pose the picture, so just make a shot of record. Some people may be craning their necks toward the back of the church or nervously fixing their hair—this is all part of the story of the day and may sell as a candid shot later. These are transitional moments in the day. While they certainly don't represent key pictures, they're all part of the thread that keeps the whole story together. The bridal party procession usually begins with the ushers and bridal party, interspersed with the ringbearer and flowergirl, followed by the groom and best man (unless they are already at the head of the aisle) and the bride and the man who is "giving her away," usually the father.

If shots of each couple in the procession are requested, arrange beforehand that

they maintain a certain distance in their march. Many times they'll bunch up together and a decent picture becomes impossible. Sometimes, in their nervousness, they'll bunch together anyway, so do the best you can.

Inexperienced wedding photographers, often out of shyness, sit themselves in a seat along the aisle and expect to get a clear shooting angle of the couples in the procession. The best bet is to stand at the end of the aisle near the altar, right in the middle of the path. Here, your view won't be obstructed by the inevitable cousin who's decided to try his hand at taking pictures.

Two techniques can be used for these shots. Try both and see which is the most comfortable for you. With the follow-focus technique you keep the on-coming couple in the viewfinder and rack your focusing knob back as they approach and fill the frame. This is good when couples are of greatly

Though not every shot of the processional prior to the ceremony will be a seller, this precious photo of the ringbearer and the flowergirl would seem to be a guaranteed sale. (Photo: Glenmar Studio)

varying heights or when they're moving at a measured, predictable pace.

Another, and probably easier technique, is to again focus on a point on the aisle, set the aperture at $f/8$ (which gives you some leeway), and snap the shutter when the couple reaches that point. A drawback of this technique is that when they reach the predetermined point one or both may have their eyes closed, one may be tripping over a fold in the runner, or they may have their heads turned in the wrong direction. Experience will help you choose the best way of handling this shot.

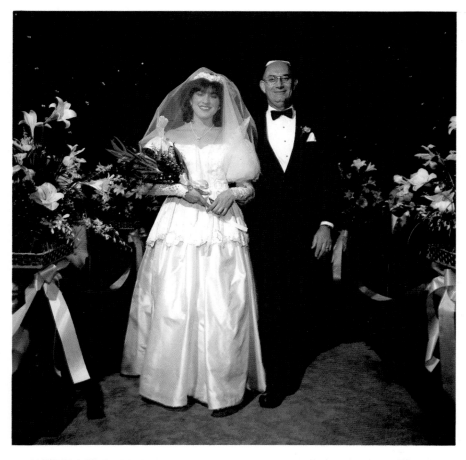

One shot you should always get during the processional is the father and the bride coming down the aisle. Look for expression and be sure to pinpoint focus before you shoot. However, don't hinder their progress to the altar. (Photo: Ken Sklute)

You are free to make pictures in any area of the church, but some locations will be natural "picture points." During this procession, each group made their way through a floral arch, a perfect "interior frame" for the photos. (Photo: R&R Creative Photography)

The Father Gives Away the Bride

Once you've photographed the key people in the procession, move down the aisle toward the back of the church, turn, and get the shot of the father giving away the bride. This sequence will happen fairly quickly, so set your lens and flash as you move. Prior to the ceremony, you should pick a spot from where this shot can be made and figure the distance to the head of the aisle where this action will take place. Be sure to refine your focus right before making the picture.

Be ready to shoot two or three shots in this sequence. The first action is the man (usually the father) lifting the veil of the bride. He then kisses her, takes her hand, and puts it into the hand of the groom. Key moments are right before the kiss and the moment the three people have their hands together. Try to angle in so each face can be seen, and be especially aware of the beautiful moment when they are are all touching.

Sequences such as those in church require that you keep an accurate count of exposures left on the film in your camera— you don't want to be caught short just as the action reaches a peak or a unique moment occurs. While you're shooting the procession, give a glance at the frame counter and note where you stand. In the heat of shooting you may lose count, or find that you have taken more pictures than you thought you would.

All this emphasizes the importance of having extra film backs loaded and ready to go, or having an extra camera body for those models that won't take auxiliary backs. Keep at least one extra back in your pocket, and gain practice exchanging backs on the run. With 220 film you'll have 16, 24, or 30 shots per roll, depending on the format, so keeping track should prevent you from running short.

At the point where the father gives away the bride, and other moments within the ceremony, you won't be able to stop the action and reset your subjects' poses. Position is all-important, and instinct should get you where you need to be. After your first few weddings you'll gain that instinct, so don't kick yourself too hard if you miss the occasional shot. Know your territory, move easily to find your spot, and shoot from both high and low angles. Keep loose, and don't let one error throw off the rest of your rhythm.

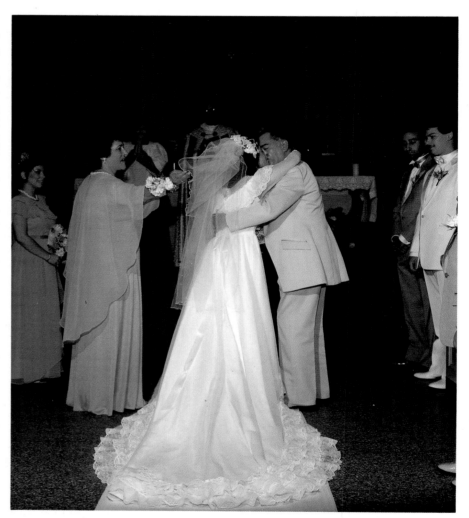

After the bride and her escort have come down the aisle, the man (usually her father) will give her a kiss before "giving her away" to the groom. Stand back enough from this shot to include some of the wedding party, especially the groom, in the picture. (Photo: Ken Sklute)

Exchanging Vows

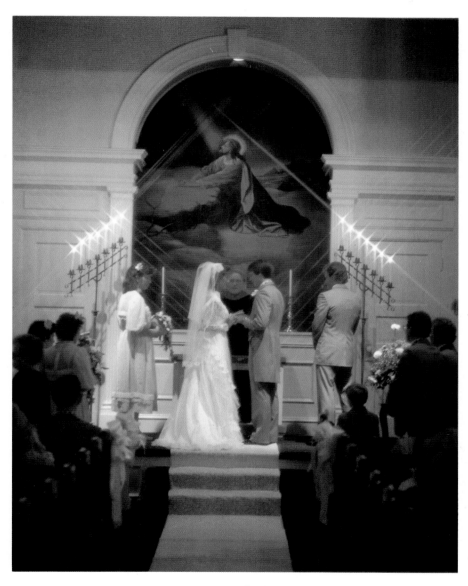

During the exchange of the vows, this photographer stood at the back of the church. With a telephoto lens and a cross star filter, he created this warm "during ceremony" shot. By picking your spots, you can get photographs during the ceremony without intruding. (Photo: Robert Decker, Artography)

The exchanging of vows is one of the high points of the wedding ceremony, and if you're cleared to shoot during the ceremony this is a moment you should record. After the service, mass, or whatever procedures that make up the middle of the wedding ceremony, the bride and groom move close together in front of the presiding minister. This is your cue to also move in and be ready to take pictures.

Hopefully, you've scouted the area upon arrival in the church and know where your vantage point will be. Shooting from behind the service, among the guests, may be of little use. All you may get are the backs of the bride and groom, and the pictures will resemble those you made from the back of the church earlier. The bride and groom may turn and face each other during the vows, but don't count on it. If you do shoot from the front of the altar, kneel down between shots so you don't obstruct the view of others in attendance.

If you can, position yourself behind, or to the side of, the altar and make use of your telephoto lens. Make an incident light reading, and shoot with a high enough shutter speed so the picture is steady (usually 1/60 second is the minimum speed for handheld, telephoto shots.) Get as close as possible while still maintaining a discreet distance. Move around until you get a profile of both the bride and the groom, and include the priest or minister in the frame. Shoot a medium shot of the couple holding hands, and then wait for the priest to make some use of his hands, such as a blessing, before taking another picture.

If you must, move in closer for the picture. But once you've made it get right back to the side. Don't hang around waiting for the next picture, or start rewinding film in the middle of the altar. Though you're an important part of the wedding, you're not the one getting married. Your continual presence on the altar can only serve as a bothersome distraction to the gathered wedding participants and observers.

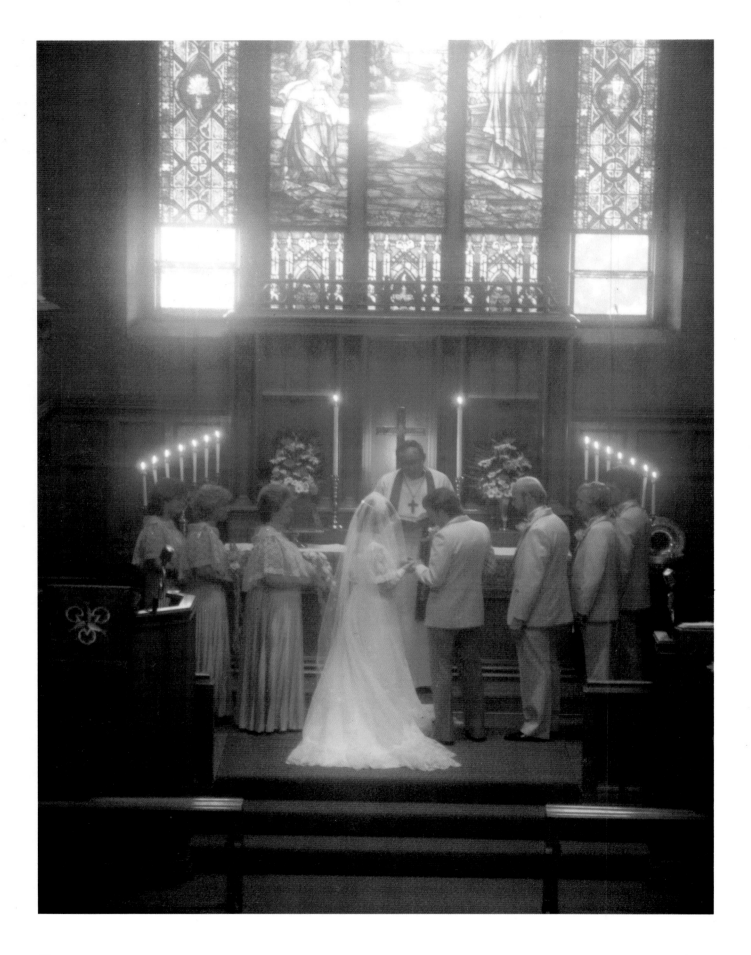

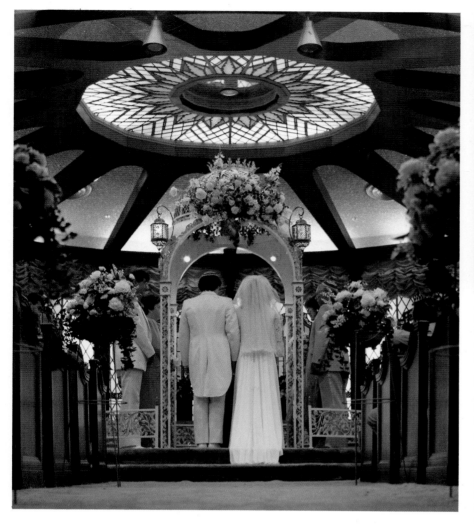

(Opposite page) A diffusion filter can add a soft, warm glow to many scenes and is particularly effective when you have a strong backlight in the picture. (Photo: R&R Creative Photography)

(Left) Color correcting filters can accentuate tones or make them appear more neutral. A warming, or slightly yellow filter, can add a touch of beauty to intimate scenes and highlight the feelings you wish to depict. (Photo: Robert Salzbank)

(Above) Matte boxes can be used for more than just double-exposure effects, and many come supplied with cutouts and shaped vignettes. Here, the photographer used a heart shaped mask to make a statement and to focus attention on the action.

Using Filters Effectively

Various filters can be put to good use throughout the wedding day. Among those you should carry in your kit are vignetters, diffusers, cross-stars (and other light diffracting filters), and color-balancing filters. Vignetting filters can be purchased, or easily made by putting vaseline or clear nail polish around the edges of an old UV or skylight filter. The vignetter can be used to good effect in bridal portraits or in closeup couple shots. Always remember to remove the vignetter when going from single to group portraits. Soft diffusers are also good for portraits, for helping to improve the complexion, removing lines from the face, or whenever a dreamy look is desired.

When highlights are prominent, in such instances where candles are used in the scene, a cross-star or other diffraction filter can break up the light in dramatic fashion. These filters can also be used for church shots to convey a sense of magic, and outdoors if highlights are playing off wood and metal, and you want to continue the mood.

Color-balancing filters or, conversely, ones that accentuate the ambient light, can be used to add either warmth or coolness to a scene. They should be used sparingly, if at all, since the lab can print toward warm or cold tones. Once you've used the filter, you'll have a heck of a time if you want to get a normally balanced tone from the negative. Remember, too, that if you don't have a camera with a through-the-lens metering system, you'll have to figure the filter factor into your exposure.

Whenever you use special effects filters (such as vignetters or cross-stars), you should expose at f/8 or f/5.6. Too high an f-stop will give a hard edge to diffracted highlights or make the soft vignette effect look like the smear on the glass it really is.

Also, please don't overuse filters. Too many albums feature shot after shot of special effects, with the result that the pictures get lost in a mist of haze and twinkling highlights. Don't use the filters as a crutch for poor imagination or clumsy posing. They do have their place, and one or two shots in the album using special effects can really stand out—overuse can make an album look like a catalog of tricks.

Exchanging Rings

Perhaps the most symbolic part of a wedding is the exchange of rings, and with the words, "With this ring I thee wed," or something to that effect, the bonds of matrimony are complete. Both bride and groom say a few words while they're holding the rings and the words are spoken while they're looking into each other's eyes. These can be very meaningful pictures.

You have a number of options with this shot. If you can get behind the priest, you may be able to get off a few pictures, but generally the moment is so sacred and climactic that any movement on the altar can be distracting. Shooting from the side with a telephoto can result in a nice profile/full face couple shot. This shot is taken with a camera angle that reveals a profile of, say, the groom, with the full face of the bride shining her eyes into his. If you can get to a level higher than the altar, you can shoot down over one of the couple's shoulder into the other's face.

Most times you'll be on ground level at this point in the service since you'll have to get ready for the shot where the couple comes back down the aisle after they're married. Because the couple always turn toward each other for the exchange of rings, you can get a good shot of them from the front of the altar. Use a moderate telephoto to get a close shot, and then move back and capture the moment in the greater context of the church. Don't be afraid to include some of the guests in this shot; the picture will show their involvement.

Compose the picture so that the eye contact of the couple is evident, and include the priest, minister, or rabbi if he or she isn't too highly elevated above the couple. An incident meter reading should give you the proper exposure, and if you have time slip a vignetter or diffuser over the lens to add to the pictoral magic of the moment. Some photographers shoot all their ceremony shots with diffusers, and although this creates a nice effect it can be overdone. You might also have time to do some matte box effects, though once the rings are exchanged the couple may spin and move back down the aisle quickly, so don't get caught with your equipment down.

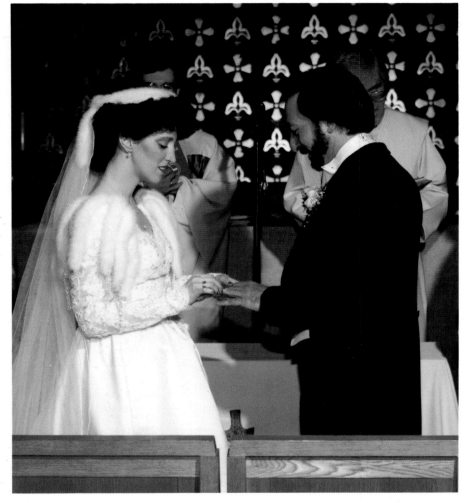

This shot was taken during a key moment in the ceremony, the exchange of rings. (Photo: Rhonda W. Vernon, Artography)

Using Available Light

Some of the best wedding photographs made during the ceremony, and certainly some of the most evocative, are the result of creative available light photography. Available light work has two advantages: it eliminates the use of intrusive flashes during the ceremony and, because of the naturally warm light in most churches, evokes a mood which can only enhance the feelings of the occasion.

Of course, not every wedding location lends itself to this type of shooting. Some halls are lit with fluorescents or are walled with paneling. But the vast majority of sanctuaries are built around a concept of and appreciation for light. In some religions, light is symbolic of the word of God, and many structures pay homage to this wondrous gift of the senses.

In some churches, large windows let in abundant quantities of side and back light during the day, while the nights see altars filled with candles or have elaborate chandeliers that fill the hall with a warm, dazzling brilliance.

To let these great locations go without a number of shots during the ceremony would be a shame. You needn't have a tripod to make these exposures, though it certainly can be used to advantage. If you can, leave the tripod at the back of the church and bring it to the center of the aisle once the initial part of the ceremony is over (after the bride's been given away). Mount the camera on the tripod (you can get a quick release mount on pro models), put on a moderate wide-angle lens and expose at around $f/5.6$ at ⅛ second. Take a reading to verify the light, or bracket up and down a few stops for insurance.

If the church has a balcony, bring your rig upstairs and cover the scene with both wide-angle and telephoto lenses. Split frames or montage effects are popular from this angle. You can get a shot of the wedding party in the lower part of the frame and an overall shot of the church, or just a stained glass window, in the upper part. (Use of matte boxes will be discussed in detail in another section.)

Lack of a tripod doesn't preclude these shots either. When you go to the back of the

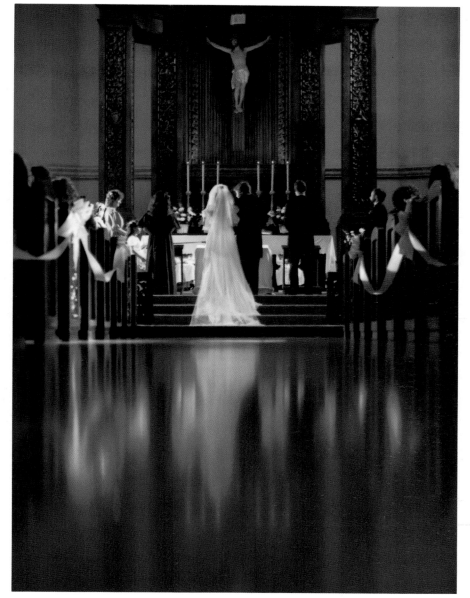

church, set your camera on the floor propped up slightly so the lens is inclined upward and encompasses the scene at the altar. Likewise, the balcony shot can be made by resting the camera on the railing. Expose at the setting prescribed above, and use a cable release to prevent any camera or hand shake. With tripod or without, these available light shots are always effective, and are excellent sellers for both album and photo decor sales.

If you can't use flash during the ceremony, make use of available light for a few "mood" shots. Going to the back of the aisle and propping the camera on the floor can yield a good ceremony shot. Generally, an exposure of f/5.6 at ⅛th second will give a proper exposure, though making a light reading for exact exposure settings is recommended. (Photo: R&R Creative Photography)

Using a Matte Box for Special Effects

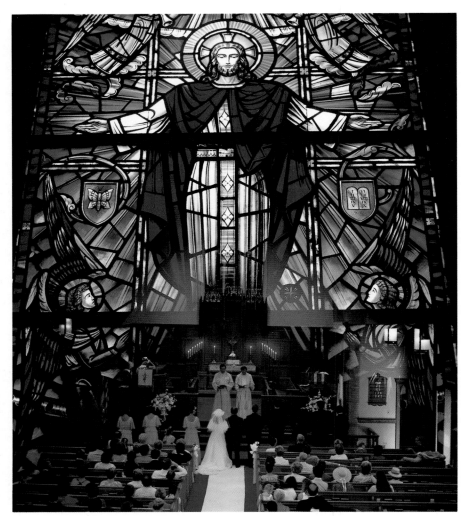

The use of the matte box in wedding photography continues to be popular, and like any effect it should be used when the purpose fits the need, and not gratuitously. In order to make use of this tool, you'll have to have a double-exposure mechanism on your camera. A matte box is a simple bellows attachment that fits over the lens, and it is composed of two or more removable pieces of plastic or metal that block out a portion of the frame when left in the holder. Removing one of the block-out masks allows a portion of the frame to be exposed; replacing it and removing the other block-out mask allows the remainder of the frame to be exposed. Though some of the effects produced with the use of a matte box can be done in-lab with two negatives and special printing techniques, the box allows simple, in-camera montages to be made.

Because the block-outs are interlocking, blending of subjects is mechanical. The art comes in when the choice of subjects to be montaged is made. Putting clashing colors together, or mixing exposure and light sources, can lead to trouble and are a real danger with this tool. Too many montage shots are made for their own sake, without regard of how the final effect will look in the album.

One of the most popular uses for a matte box is during the wedding service. Shots often include the bride and groom at the altar in the lower part of the frame with the architecture of the church or a stained glass window in the upper portion. This condensation of space can be very dramatic, and is almost a guaranteed seller for the church album picture.

The mechanics of this shot are quite simple. Leaving the upper portion of the block-out mask in place, position the bride and groom at the altar in the lower part of your viewfinder (reflex cameras will show all this through the viewfinder, as the mask will blot out the view on your focusing screen) and make your exposure. Then switch to a location in the church that you think will make an effective surround, such as the back of the altar or a beautiful stain glass window. Replace the lower mask, remove the upper and make your exposure.

The variations on the block-out setup are endless, and as you begin to work with it you'll see other picture opportunities. You can even take a picture of the bride and groom before the services, remove the back from the camera, and then replace it during the service and expose the same frame with another portion of the mask in place.

Creative use of a matte box yielded this dramatic scene of the ceremony in progress. For the upper portion of the picture, the photographer exposed for a stained glass window. He covered half the box, then composed the ceremony in progress on the lower half of the frame. Balconies are excellent vantage points for ceremony pictures. (Photo: Ken Sklute)

Masks come in all shapes, sizes, and configurations including stars, vignettes, and multiple screens. Similarly, the double-exposure switch on your camera can also be used for creative effects, though here you'll have to pay close attention to the exposure of each part of your picture. Overexpose the principal subject by one stop, underexpose the "ground," and then have the lab make a "deep" print. Double exposure requires that one aspect of the print dominates another, otherwise the image will be weak and no real sense of what's being communicated will emerge. Don't overuse either effect, or get seduced into endless camera tricks. Pick your spots, and the montage effect will add something special to your wedding coverage.

(Top, right) In this matte box shot of the rings, the photographer has mirrored the pose of the hands in the second exposure. The white of the gazebo matches the cloth of the gown and tuxedo. Have the couple hold their hand pose for the second shot and move right in for the picture. (Bottom, right) Sometimes the matte box effects don't come out quite the way we want them to. Here, aside from the background and the stray figure in the corner the "swooping" hands detract from the effect. (Photos: Ken Sklute)

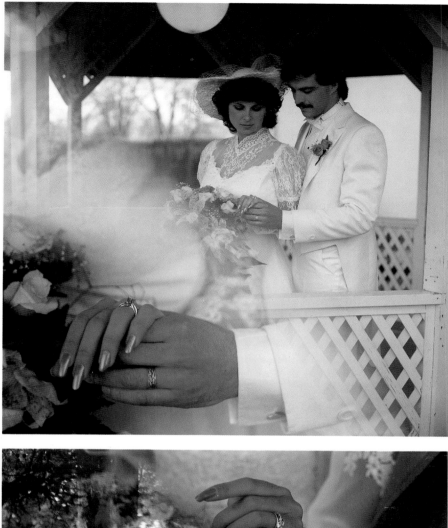

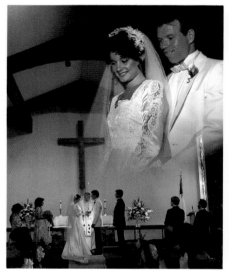

A popular matte box effect has the bride and groom looking down on the ceremony in progress. This is where an extra camera back comes in handy. You can shoot the ceremony on the lower portion of the frame, remove the back, and then add the bride and groom to the picture later. (Photo: David E. Ross, R&R Creative Photography)

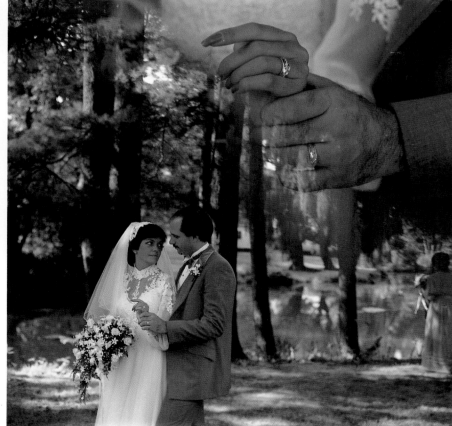

Capitalizing on Candid Moments

The light and heightened emotion evident in a wedding ceremony all make for excellent picture opportunities. Because of the atmosphere of the occasion you won't be able to be as freewheeling in your shooting as you will be during the reception, but this shouldn't stop you from making candids as you go along. Some services go on for a long time, or have a celebration of mass attached to them, so you'll often have time to make quite a few pictures. During shooting, move around the church on cat's paws, and refrain from overshooting or bursting your flash continually. A few select candids will tell the story.

The bride and groom, as the stars of the show, should be the focus of your shooting activity. During the course of the ceremony they may be seated on opposite sides of the altar, giving each other warm looks. A long lens can capture the profile of the groom and have the bride slightly soft in the background, or vice versa. Sometimes, during the ceremony, the couple will be at a kneeler together, and this is an excellent time to get tight profiles of them together. A long lens will flatten perspective and yield interesting effects.

Also, when the couple are at the kneeler they may hold hands, another source of some beautiful images. Move behind the couple, and wait until they turn their heads toward one another. Move back and switch to a normal lens so that you can include the full play of the altar in the picture.

The flower girl and ringbearer are also good candid subjects during the ceremony. The children will be very spontaneous in their reaction to the unfolding events. Capture them as they relate to individuals and the situation, particularly when they're called upon to perform in the service. Their demeanor alone is worth a few pictures.

If there are readings, performances, or special moments, such as a candle lighting, make sure to include them in your ceremony coverage. Don't isolate the individuals involved when making these pictures,

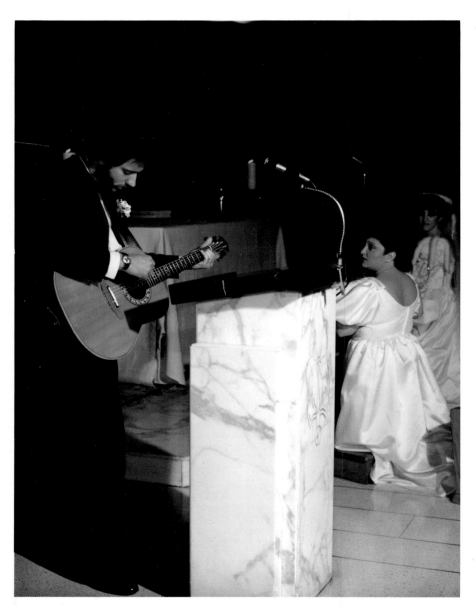

but include either the church or the bride and groom in the shots. If a brother is reading from the Bible, for example, have the bride and groom listening intently in the background, even if they'll be slightly out of focus on the print. This sense of involvement makes the picture much more meaningful to all concerned.

Part of your job as visual storyteller of the wedding day's events includes capturing those moments of sharing between friends and the bride and groom. This candid was made during a musical presentation during the service itself. Note the connection between listener and musician caught by this photo. (Photo: Ken Sklute)

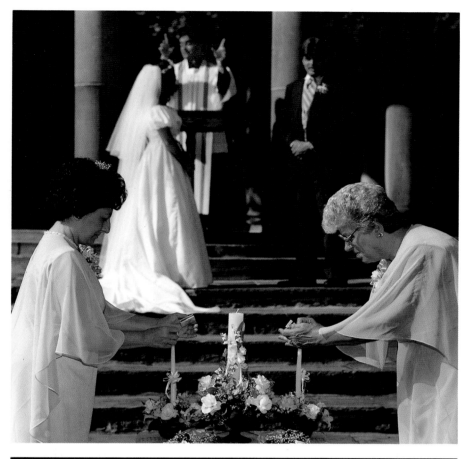

Many ceremonies have special events such as readings, music or candle lighting by family and friends, and these should be part of your weddig coverage. Here, the photographer has captured the event plus included the bride, groom, and priest in the background, thus giving a context to the goings-on. (Photo: Ken Sklute)

Here, the bride and groom take part in a candle lighting ceremony during the service. In this shot, the photographer has chosen to use a dark vignette to center the light on the couple. If you can't get this shot during the service itself, you can always recreate it later. (Photo: Ken Sklute)

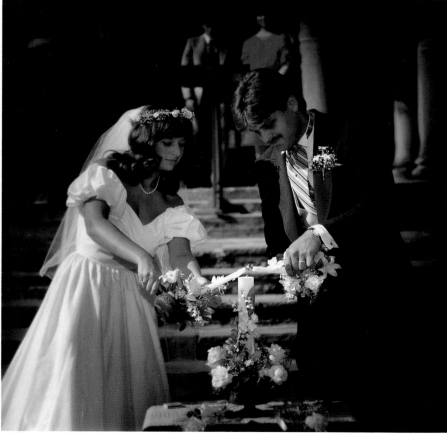

Capturing Special Traditions

In the course of your wedding career you'll come across many types and styles of ceremonies, some unique to the people getting married and others to the religion to which they belong. In these ceremonies, certain moments and customs are as important as the exchange of rings, and failure to photograph them could leave a real gap in your wedding coverage. A procession, a walking around the bride and groom, a sharing of a cup of wine, or other movements and moments steeped in history and tradition may be included. Every wedding ceremony is a little different.

For example, one shot that you shouldn't miss in the Jewish ceremony is the breaking of the glass (or lightbulb). A wine glass or other fine glass is wrapped in cloth at the end of the ceremony, and the groom is supposed to break the glass with the heel of his foot. The gusto with which this is carried out is usually accompanied by a cheerful response from the congregation.

Watch for this moment, and when it occurs, have yourself in a good position for the shot. Take the shot as the groom's leg is raised, and infer the motion that follows with the sense of balance in his stance. Take another shot once the glass is broken, moving back to include the faces of the wedding party assembled under the hupah. Most rabbis appreciate the importance of this picture, and will allow you time to set up the shot and a good position from which to take it. Confer with him prior to the ceremony.

A Jewish wedding is usually conducted under a hupah, a trellis-like arch that shelters the couple, the rabbi, and other close members of the family at one point or other during the ceremony. This framework may prevent telephoto shooting from the sides, so be sure to confer with the rabbi before the service as to your best behavior during the ceremony. All weddings are intimate affairs, and the Jewish service is particularly so. But you may find yourself right in the middle of the ceremony making pictures.

As with all services, check carefully with the rabbi before assuming that you'll be able to take pictures during the ceremony. Some congregations allow and encourage it, while others strictly forbid it.

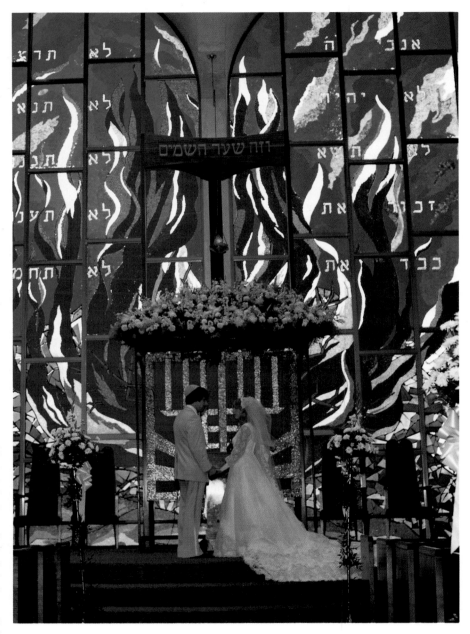

The hupah may be bedecked with flowers so use its structure and decorations as counterpoints in your pictures. Definitely have a wide-angle lens with you if you're to shoot under the hupah during the service because you'll be right on top of the action. Care must be taken not to have your flash work against you. Remember that you're close to your subjects, so be sure to check in the viewfinder for objects that may reflect harshly back into the lens.

The wedding business is a wondrous one because of all the walks of humanity photographers get involved with over the years. Learn the basic about each type of service, and remain open to variations on the theme.

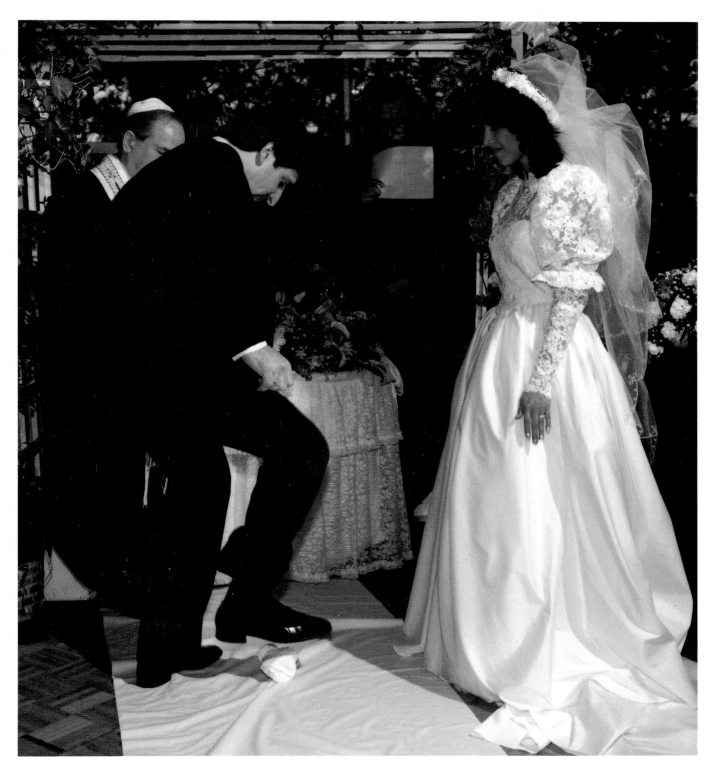

(Opposite page) This spectacular temple wall was a natural for a portrait of the bride and groom. Though not every interior will be as dramatic as this, use the architecture of the church or synagogue for portrait settings. (Photo: Harold Snedeker)

One of the most important moments in the Jewish ceremony is the ritual breaking of the glass. The decisive moment is captured here just as the foot of the groom is coming down on the wrapped glass. (Photo: Ken Sklute)

Leaving the Church

Once the ceremony is over, most couples will turn quickly and make a mad dash down the aisle. Be prepared for this shot—as it can be over in an instant. While the minister is giving his final benediction, station yourself at the end of the aisle, or nearest to where the last row of people are sitting. Set your focus for a particular point in front of you. Don't expect to be able to follow focus, or back pedal as they come racing towards you. This is like sports photography, and you've got to be quick to get the shot.

Once the couple reach the appointed spot, take a picture, then move back and see if you can get another. If you can't, follow them into the vestibule and get one or two *candids* of them—don't even consider posing them at this moment. Their excitement is running high, and they probably would ignore you anyway. These candids can be great, however, and you may even get people rushing out after them and hugging them.

The aisle shot is one that definitely can't be repeated, particularly if you happen to capture some of the happy faces of the congregation as well as the bride and groom themselves. Don't stand in the way of their departure, but shoot away and hope for the best.

After this, a reception line may form and, unless specifically requested, refrain from shooting at this time, as shots of this look confusing and rarely sell. You may be requested to get some quick candids of people who attended the wedding but who can't get to the reception with the bride and groom. These should be simple on-camera flash shots of handshakes and hugs. The time is better spent checking gear, reloading film, going back into the sanctuary, and getting things ready for the next phase of shooting.

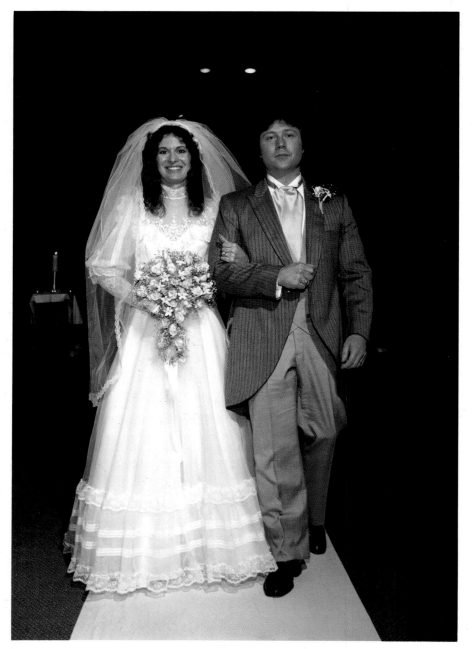

As the bride and groom leave the altar, be prepared to backpedal and take more than one shot. Some will leave in an orderly fashion, while others may make a mad dash for the exit. Pick a spot where the picture should be made and make your exposure when they reach that location. (Photo: Ken Sklute)

(Right) This silhouette was taken after the ceremony as the wedding guests waited outside the door. It portrays a quiet moment of intimacy between the couple just before they enter the "outside" world. Though there are no identifying features lit by flash, the outlines of their faces are distinct against the white sky. Choice of the right camera angle made this picture work. (Photo: Ken Sklute)

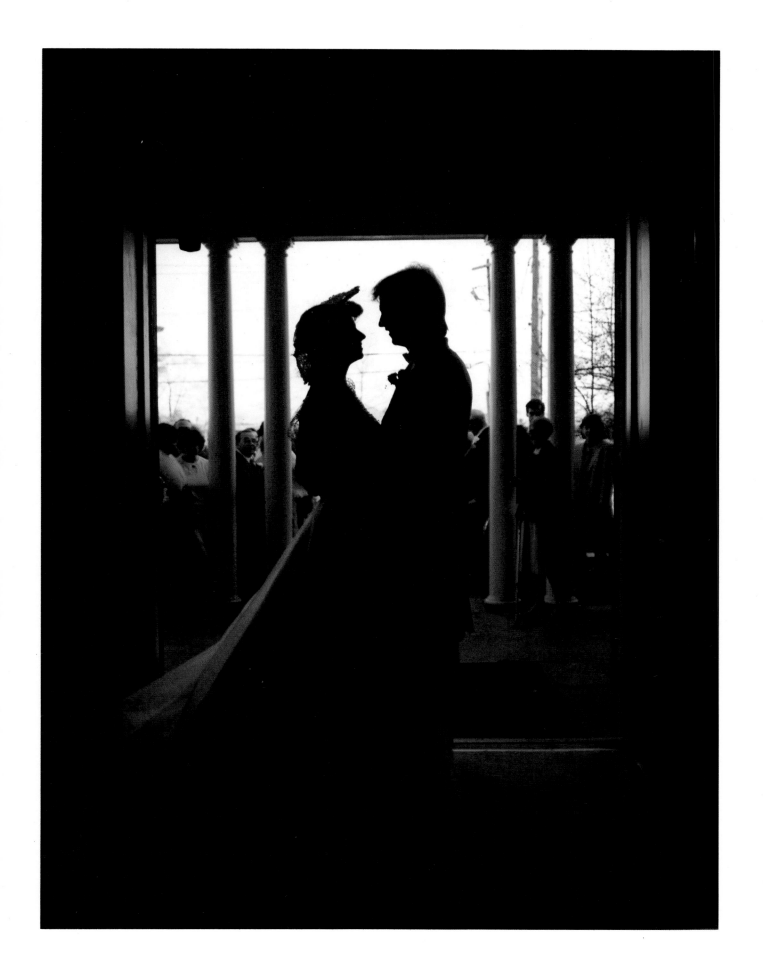

Showcasing the Rings

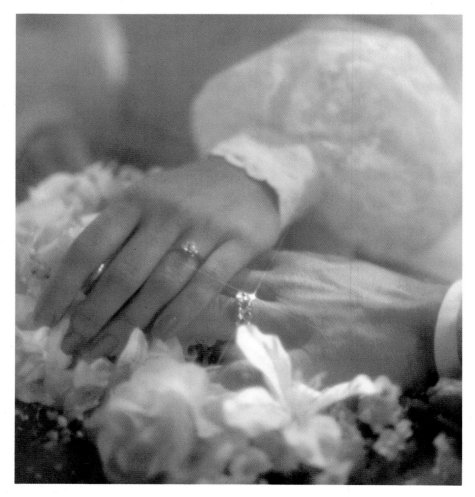

The ring shot is made softer and more sentimental by use of a diffusion and even a cross star filter. Note flash settings when shooting close, or better yet, try to set the scene up so its illuminated by natural light. (Photo: Lorraine Carini Meek/Impressions by Carini)

The first page of many wedding albums features a gracefully posed picture of the couple's hands sporting their rings, usually with a floral surround. A good time to get this picture is right after the ceremony, when the bridal bouquet is still in order, although it can also be made during the reception. This picture is in the still-life realm of the craft. Color, balance, and design are all factors that make it succeed.

The ring shot can be set up right in the bride's lap, or on a table where the couple's hands can rest comfortably. Set the bridal bouquet down and arrange the flowers so they provide a wide enough base for the photo; add flowers from the altar floral arrangements or centerpieces at the reception as necessary. Do this in a place where natural light is falling, or where you can have shadowless light from your strobe.

Have the couple put their hands on top of the floral arrangement—one hand in the other—so the ring fingers face the camera. The bride can lay her hand flat on the bouquet, and the groom's hand can rest across and on top of hers, or vice versa. Observe how the hands rest in one another. Don't have one hand blocking off the other's fingers, or have it look like they're engaged in a game of slapjack. Have both raise their ring finger slightly so the rings are more prominent.

This should be a graceful picture, so experiment a bit before you snap the shutter. Don't hesitate to move the hands yourself, and arrange them as you would elements in a still-life photograph. Talk posing this shot can be difficult, so have the couple relax and move their fingers and hands gently.

A diffusion or vignetting filter will add to the softness of the background and smooth the look of the hands. You may want to add a cross-star filter if the rings are throwing highlights, but don't make them look like items from a cheap mail-order catalog.

Flash requires a filter because you must make this a warm, soft shot, and the glare from the flash may cause deep shadows to form between the flowers.

A variation on this shot uses the wedding invitation instead of the hands with rings, and in this case you lay the invitation on the bouquet, observe all the elements, and expose as you would for any closeup shot. Don't diffuse this shot too heavily; you want the words on the invitation to be legible. If you're using flash, angle the invitation so glare is not thrown back into the lens.

Highlighting the Minister's Contribution

The first pictures you should make in the reenactment sequence are those that involve the priest, rabbi, or minister. Assure the person that you'll only be taking a few minutes of his or her time, and be respectful of the fact that they may be very busy people. To the couple, and perhaps to you, the wedding is a very unique event, but to someone who does four or five a week it's not a matter to dawdle over once the service is finished. Some may outright refuse to cooperate if asked on the day of the wedding (due to prior commitments or objection to the whole process), so arrange the time beforehand. Also, when setting the appointment up with the minister, assure him or her that you'll be respectful of the church and the objects in it. Some ministers have banned photographers from shooting after the ceremony because of the mess they've left behind.

A good selling point in convincing the minister to hang around for a while is that this will eliminate the need for you to shoot during the service itself, or that any shots you will take won't interrupt the mood of the ceremony. If you treat the minister with respect, you'll make it easier on yourself (and all your brother and sister photographers who'll be working in that particular church in the future).

Once you've got the bride, the groom and the minister together on the altar, request that certain parts of the ceremony be acted out. This may be a benediction or blessing, a passing of a cup of wine, or any actions that caught your eye during the original service. You may be surprised at how helpful the minister may be in this process; many seem to be potential movie directors, as they'll suggest shots and angles that may not have occurred to you.

Arrange the group so the angle of view gives a clear picture of everyone involved while it depicts an implied motion. There's no sense to having the pastor there if everyone stands around like they're made of wood. Shoot over the couple's shoulders with their faces inclined towards the cam-

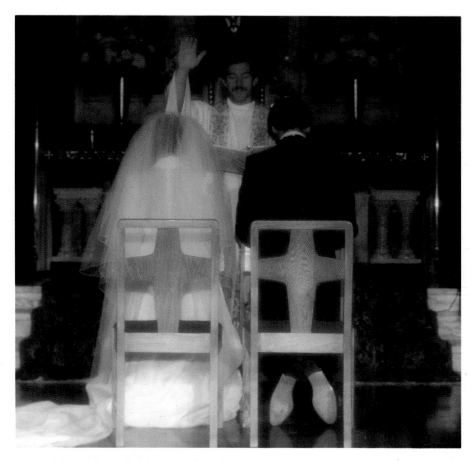

era, and the minister slightly out of focus in the background. Or have the couple exchanging rings, with the pastor's hand extended in a blessing motion. If you have a slave strobe on a pole, use the second light to add drama to the scene, or just rely on the natural light to give a warm glow to the occasion.

Try different angles on the basic themes of the ceremony, and don't be afraid to get in close and use a wide-angle lens. This reenactment allows you an intimacy that's often barred during the actual wedding, so take advantage of this situation to get some special shots. If the minister and couple are close, as often happens in smaller parishes or congregations, pose them in a gentle group shot, perhaps with the minister's arms around the couple.

Whenever you include the minister, priest, or rabbi in a scene, show activity and involvement rather than just having him or her standing around like another guest. Get shots of them blessing the couple, performing some part of the service, or relating strongly to the action. (Photo: Ken Sklute)

Using Candlelight for Atmosphere

Candlelight is very beautiful, and if they're available, candles make great props for portraits in the church. Many services feature a candle lighting sequence. The flame from candles held by the bride and groom are used to light a third candle which signifies the one light that they create with their bond from the separate lights of their lives.

Candles, though beautiful, can't be counted on to provide the sole illumination in a scene, so natural or strobe light will have to be used to fill in the picture. Care must be taken not to overwhelm the flame from the candle, or have the scene too bright because the entire effect will be lost and the illusion shattered.

Long exposure time is the key to having the glowing flame from the candle record properly on film. This can be done in natural or artificial light. If you're shooting in natural light, pick an area where there's sufficient illumination to light the scene, but avoid direct, hard sunlight. Set your camera on a tripod and expose at 1/8 second. This "shutter dragging" will allow the flame to etch on the film. When shooting with a strobe do the same, although you should make sure the flash is bounced or softened by having it reflect off a top-mounted reflector card. Don't blast the scene with light; give minimum flash power required and have the burst come in the midst of your long exposure. You might even consider underexposing the frame a half or a full stop to add to the illusion.

Filters are very useful in candle pictures, and their purpose is to transform the flame into a glowing halo (diffusion filter), a spiraling rainbow (diffraction filter), or even to add a warm glow to the subjects you're portraying (a light yellow or warming filter). The warming filter can be put over your camera lens or strobe light.

If you're doing a candle lighting shot, have the couple lean in toward the candle as they light it, so the warm glow partially illuminates their faces. Take care that the bridal veil doesn't get near the flame. You might consider using a moderate telephoto lens for this shot; it will remove the strobe further from your subjects and give you more control over the light.

Candelabra, or long rows of candles, make great props, and you can use them for backlighting or as balancing elements in one side of the frame. Pose the bride and groom with the candles, step back, and use a telephoto to shorten perspective. Again, this gives you more lighting control, and avoids too close a brush with the flames. Use depth of field creatively and have the candles sharp or soft, depending on your taste. Use the candle light as an allegory for warmth and love, and let the flame light up your pictures. Don't however, use the candle for the sole source of illumination, otherwise the resultant scene may resemble a still from a mystery movie.

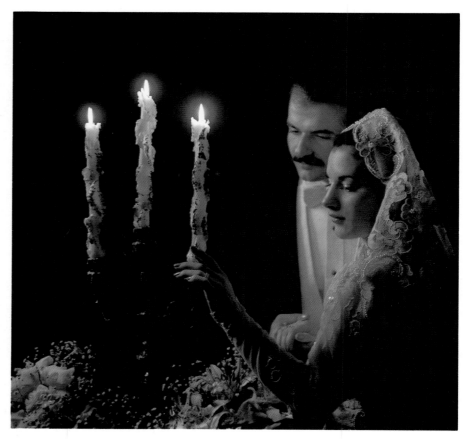

You can't rely on candles alone to provide enough illumination for mood shots. Here, the photographer used an off-camera strobe covered by an amber gel to recreate the soft brown light thrown by candles. The floral arrangement at the bottom of the frame helps create a flow throughout the picture. (Photo: Ken Sklute)

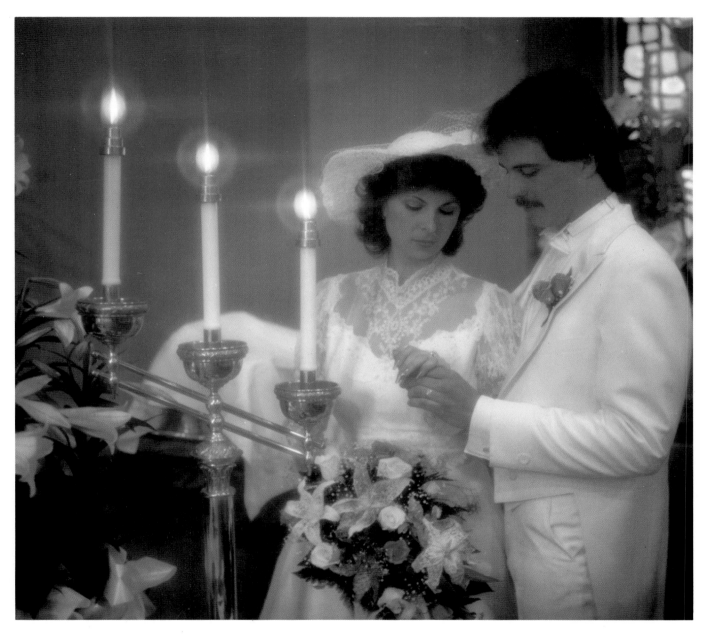

Flowers, candles, stained glass, and a soft light combine to make this church portrait of the couple effective. A light cross star filter has made the candles glow. The fact that the photographer exposed the scene at 1/15 second also helped. When shooting in a church, use the props available to best advantage. (Photo: Ken Sklute)

Using the Architecture of the Church

Though not every church in which you shoot will have the gem-like quality of a Chartres or the magnificence of a Notre Dame, most will have unique architecture that should become part of your photographic "set." Whether it be stained glass windows, graceful archways, or the perspective gained by shooting along aisles, the church or sanctuary has great potential as a photo studio. Use the architecture as an element in your pictures, and allow your photographer's eye to play when seeking compositions.

Some churches have large supporting columns of wood or stone, many with carved designs. These can be used for vertical accents in your pictures, plus serve as wonderful posing props. Vestibules and anterooms may have more intimate columns, and these curving lines can be used as vignettes or "frame within a frame" in your pictures.

While the larger forms are of interest, the textures that cover and enhance these forms should be given equal attention. Note any cloth or tapestries that are hung on the walls, and make use of them as backdrops or design elements within your pictures. Wood and stone carving, statuary and other icons, and objects of veneration can also be used as forms within your compositions. You can use them to interplay with the prime subjects of your portraiture.

The exterior of the church may have stonework or landscaped areas that can be utilized in posing. Small gardens and chapels may be a part of the grounds, and once you gain permission to photograph in these areas, you can handle many of your outdoor portraits, or environmentals, there. These places are generally designed for meditative purposes, and their peaceful nature should be respected. All in all, though, they do make excellent posing areas.

Even if the church is of simple wooden design, with no ornamentation whatsoever, it can still be an excellent place to take pictures. Imagine having a studio over 100 feet long, with light spilling in on both sides, and you'll get the idea. You can use the perspective afforded by the aisle, and have the pews as posing benches, in order to make many good portraits.

So give yourself time to scout the church before and during the ceremony, and open your eyes to the building's potential. Allow yourself time for a number of shots, and use the architecture to enhance your pictures.

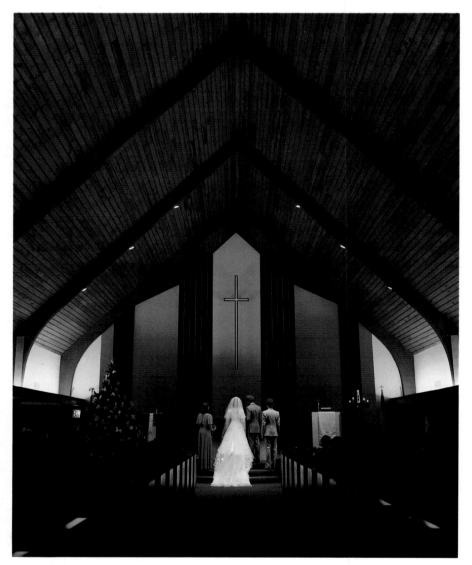

The lines in the roof of this church lead the eye toward the altar. Though the architecture here is not dramatic, its very simplicity is effectively used by the photographer. Also the available light is used to spotlight the events. (Photo: Glen Davis, Legendary Portraits)

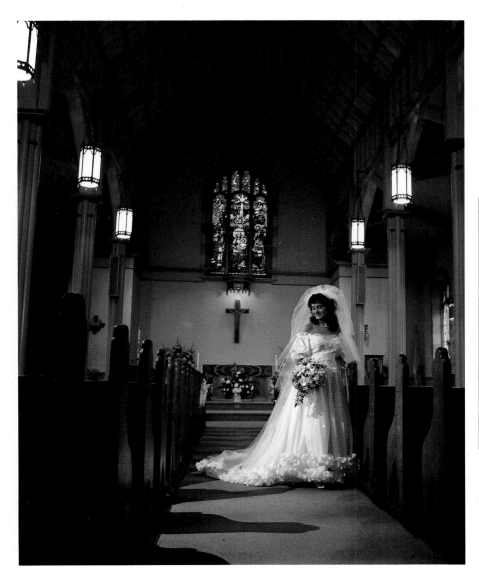

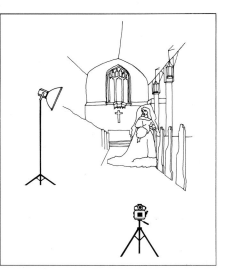

This portrait of the bride in church was made with a 50mm wide-angle lens, at a setting of 2 seconds at f/8. The slow shutter speed was used to pick up the ambient light. A fill strobe was placed off in the corner to bring a highlight into the dress and onto the face of the bride. The fill strobe was set up to match the direction of the light. (Photo: Ken Sklute)

WORKING WITH ASSISTANTS

There's no question that having an assistant along can help immeasureably during the shooting of a wedding. The helper can assist you with styling, posing, handling film, checking gear, and holding a second light for creative techniques. Though many photographers work solo because of economics or choice, most would agree that the task is made much easier with another pair of hands around. Assistants can be friends, a wife or husband, or a young photographer who's looking to learn the trade. In fact, most photographers have worked as assistants at one time or another in their career.

Coordination between photographer and assistant is very important, and you should work out hand signals, game plans, and go over basic lighting rules with your co-worker. After you've done a number of weddings together, you'll become more coordinated with your assistant. He or she will know when and where you plan to set up certain shots. It's important that your assistant know your "style" of shooting. Spend time to show him or her the range of photographs you take.

While an assistant is certainly a plus, most of the pictures in this book can be made shooting solo. Two light techniques can be done alone, although you will have to work extra hard to get them. So book an assistant, or have a friend or spouse along, and make your life easier. You'll be working hard enough as it is.

Using the Church as a Studio

The place where the wedding is performed has special meaning for couples, and is a good choice of location for their portrait. It also offers many posing opportunities, and usually a good quantity of natural light. You will have to be aware of the background in altar shots, and this includes objects of veneration, such as crucifixes, and the large mass of strong horizontal lines formed by the communion bar, the dais, and the altar itself. Don't cut off flowing lines if you use a shot showing the entire altar because you will interrupt the rhythm of the picture. Let windows, paintings, and statues fully show—a decapitated statue is as disturbing a pictorial element as a cropped hand.

The steps of the altar are good for the display of the bridal gown, particularly those dresses with long trains. When draping a gown, lift it slightly and let it fall naturally—look for gracefulness, not elaborate braiding. You can have the gown flow down the steps like water running over rocks, or have it sweeping along the steps to the side of the bride. Don't cut the bridal gown off at the bottom because this will disturb the encompassing design of the picture.

You can either have the altar sharp in the background or have it go soft through the use of a long lens and narrow depth of field. The textures on cloth and building materials that make up the construction of the altar make for wonderful color combinations, and a soft focus effect can make the area resemble a finely painted backdrop.

If you use flash for the portraits at the altar, shoot at a slow shutter speed so that you'll have the natural illumination and "props" as part of the scene. Shooting at 1/250 second, for example, may light your subjects properly, but it will also close the shutter down too quickly to allow any of the environment, lit by natural or artificial light, to appear on the film. There's really no

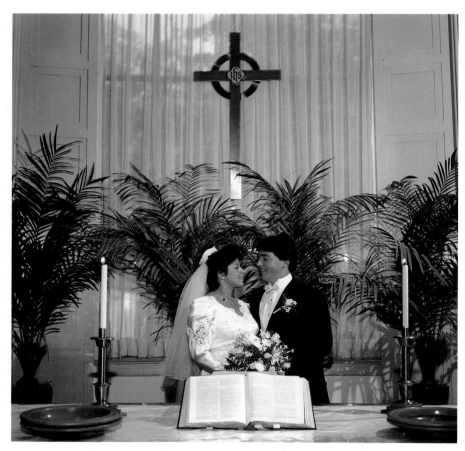

sense to shooting portraits at the altar unless you include the surrounding area in the scene, so use a slow shutter speed to bring them in.

Kneelers are also excellent posing tools you'll find at the altar. Taking the photograph from the back, you can have the couple hand in hand with their faces inclined toward each other in profile, backed up by the entire play of the church. You can also move the kneelers so the bride and groom are facing one another, a picture which can be made close-up for profiles or full length so the color and design of the altar are evident.

It might take days to construct sets that are all part of the natural scene in a church, so use the locations and props available to you to make special portraits of the bride and groom and the wedding party. In this photo, the altar was a "natural" for posing, and the bride and groom became centerpieces in a symmetrically balanced scene. (Photo: Ken Sklute)

Arranging the Bridal Party at the Altar

If you can get the whole bridal party together after the ceremony, use the altar as a posing area for their group picture. Make use of the varying heights of the steps and the wide expanse of the space for the photograph. Why cramp everyone together when you have such a large area in which to work?

The bride and the groom are, quite naturally, the centerpiece of this picture. Have the couple stand together in the middle of the altar, turned slightly toward each other, and be sure to check the flow of the bridal gown. Once they're settled, begin placing the bridal party around them. Watch for a sense of balance in your placement, and notice the overall design taking shape as the picture is being set up.

Balance can be created by having all the men on one side and the women on the other, or you can have the bridal party pose in couples, mimicking the stance of the bride and groom, or paying court by having them turn their attention toward the central couple.

You may wish to set up the bridal party in triangular or diamond groupings on the different levels of the altar. Stand back, and look at the scene before you. Is there a natural flow from group to group? Is there a flow of line from one set of people to the other? See if it continues from one side to the other and then back again.

You'll have to be especially watchful of how background elements interact with each member of the group. Be sure that no objects sprout from behind someone's head, or that strong verticals or horizontals don't break up the overall design of the picture. These details may be small, but

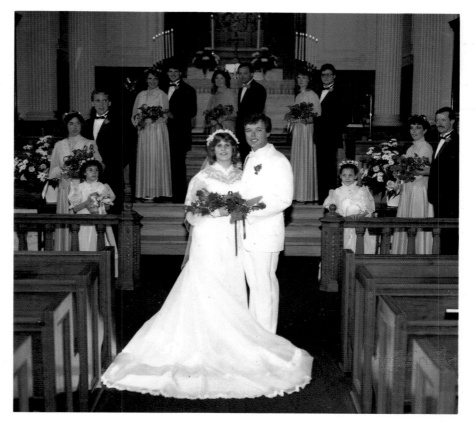

more than one wedding party portrait taken at the altar has featured a best man with flowers growing out of the top of his head.

Once posed, you can take the picture from any distance provided the composition is balanced and the bride and groom are the central characters on the set. Taking the photograph from a lower angle is fine, as long as lines in the altar don't converge; shooting high and from a distance can give you the group and the architecture of the church combined.

This is one example of a wedding party grouping you can use in the context of the church. Note how the photographer made use of the steps of the altar. (Photo: R. Decker, Artography)

Working with Church Light

A church or sanctuary provide a virtual playground of light, whether it be the illumination that spreads through the building or the windows that transmit it. Art historians note that churches were built as temples of light, as in Renaissance paintings where light symbolizes the word of God made manifest. Architects often design churches to enhance this play of light, and as the sun moves through the sky, it highlights different areas and statuary within the structure. So whether it be window light, soft ambient light, or the beauty of stained glass windows, work with the light in the church to create beautiful pictures.

Stained glass windows can be utilized in a number of ways, including using the colored light transmitted or having the design of the window itself as an element in the scene. In some churches, stained glass panels are independent of windows and are illuminated by artificial light. Although this lacks some of the qualities of sunlit windows, the panels should still be used if at all possible.

The first step in using the church light is taking an accurate exposure reading. Walk around the church with your meter right before you plan to make the pictures. Doing this earlier might not be helpful because the light may shift in the interim. Note if the light falls from a high or middle angle, and how deep the shadows are—in most cases the light will be soft and diffused, perfect for portraiture.

Once you've picked your spots, place a model or your subject in the posing area and make highlight and shadow readings on their face and clothes. The light may be too strong, resulting in too contrasty a picture. If you're working with a bride and groom, place the bride away from the source of light, as her gown will be reflective and serve as a natural fill card onto the groom.

If you're working with stained glass windows and the light they transmit, there's a likelihood that there'll be dappled colors falling on your subjects. Capturing this effect will require exposure with natural light or long exposure times with a flash burst to fill in detail. You can enhance this transmitted light by putting a soft, light vignetter on the lens, or diffusing the entire subject. Watch out for splotchy colors, and move your subjects around so that the light plays over them in a refined manner. Having a blue ear and a red spot on the nose won't help the sale of the picture.

For a silhouette effect with stained glass windows, move in close to your subjects and have them give you their profiles, but make sure their noses and chins don't overlap. Take a reading of the light coming through the stained glass and expose for that reading. The white of the bridal gown may throw some detail into the couple's faces, but don't count on the features to be apparent. You can bring up some detail with a fill card, or let the faces go black and have the light from the window rim the hair with a soft halo.

You'll have to use flash for shots where you want the light from the stained glass to serve as background and still have full detail in your subject's faces. Taking a flash only shot will probably result in the stained glass going too dark, so use a time exposure with a burst of flash. Take a reading on the stained glass, then take a meter reading of the flash strength needed for the couple's faces. With camera mounted on a tripod, set your shutter for the glass reading and hit the flash while the exposure is being made.

This shot can be made even more effective if you take the strobe off the camera and burst it from a high side angle. Keep the direction of flash in line with the natural direction of the light from the window, thus strengthening the illusion that the whole scene is lit with ambient light.

You must always be aware of angles when using flash toward or near glass. Even the most studied pose can suffer if there are harsh light reflections in the scene. Posing the couple to one side of the window, and using a directional flash, can eliminate this problem.

Many churches have large, high windows that let in great shafts of light. During bright days the light streams in as if the clouds have parted over the ocean or prairies. Use this light as if it's a spotlight in a theater, and take advantage of its potentially dramatic effects. When making your light readings in a church, be sure to include these "hot spots" in your calculations. You can have the bride and groom standing in these "spots," and have the rest of the church recede in the shadows. You can also take long shots using the shafts of light as compositional tools. Make sure the light isn't *too* contrasty. It may be so bright that it knocks all your other exposure values out of the range of the film.

Filters can be used to enhance the beauty of the natural light in the church, and a light diffusion filter can make the light appear as if its falling through a cloud of incense. You can also use low density color compensating filters to shift the light toward warmer hues, or use a blue filter to shift a warm light back toward a more neutral tone.

Approach the play of light in the church as you would the light in a late afternoon landscape shooting. Use your eyes, filters, light meter, and mild fill-flash to enhance the beauty of the scene. Make use of all your photographic skills to bring out the potential of the settings you'll encounter.

Always take advantage of the fall of natural light in the church setting. This picture, taken from the balcony at the rear of the church, is enhanced greatly by the light coming from the stained glass windows behind the altar. (Photo: R&R Creative Photography)

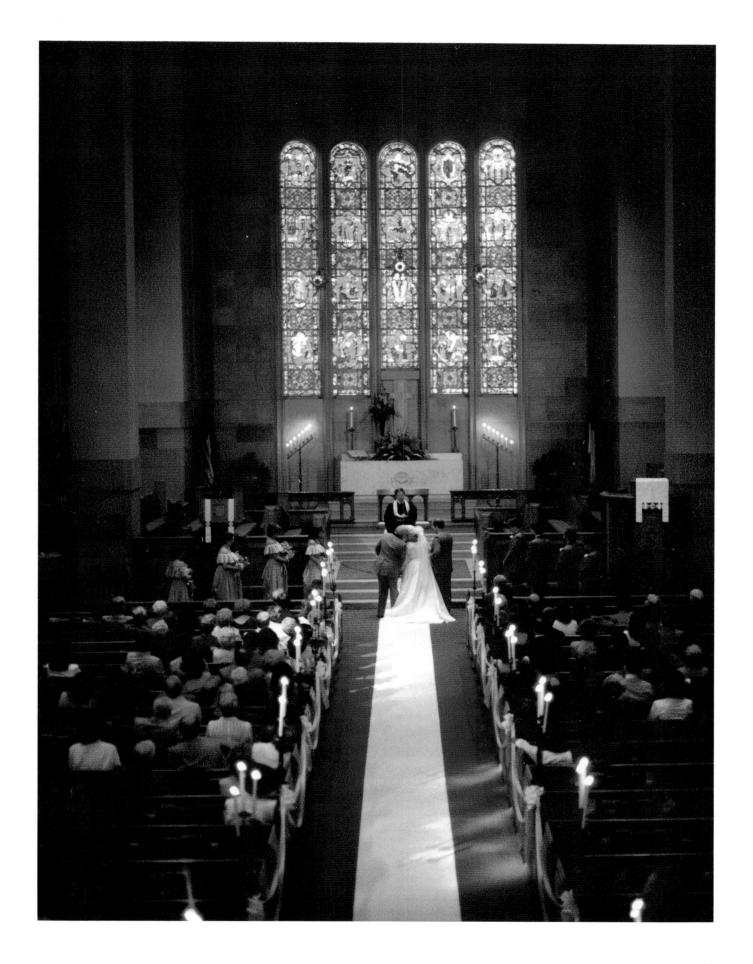

The natural light in a church should be used for dramatic effect as it is here in lighting the bride in a theatrical "spot" effect. Use the interior of the church as a stage within which you set your portraits. (Photo: R&R Creative Photography)

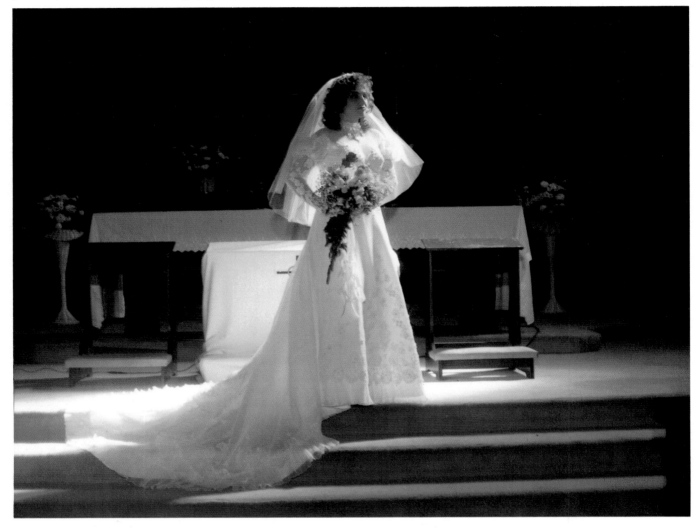

WATCH BACKGROUNDS!

Shots like those taken on the altar, outside the church, at the reception, and other candids often suffer from cluttered, obtrusive, or clashing backgrounds. These problems result from lack of time, failure to use the depth-of-field preview button, and not allowing your eye to roam through the viewfinder before snapping the shutter. Too often, the subject is considered the only area of attention, and there's a failure to see how important background elements are in the picture. Backgrounds are not always obvious in these situations, but they can certainly make or break a picture once it's in print form. That's when these distracting elements become painfully obvious. Regardless of the pose or expression on the subject, the picture is less than what it could have been.

"If onlys" and "what ifs" don't help once an object seems to be sprouting from a groom's head, or if a gilt railing runs horizontally through the frame of an otherwise flowing portrait of the bride. Just as the correct direction of light and the placement of highlights in the center of the frame are important, visualizing how backgrounds will effect the final look of the print carries equal weight. Visualization means that you look at every element in your picture, not just the subject or the foreground. Don't lose a great shot to an awkward background.

The light, pose, and expressions of the couple in the scene are just right, but the ikon in the background seems to be waving to the camera. It makes for an interesting photo, but the figure may be too much of a distraction. (Photo: Ken Sklute)

The Portrait at the Top of the Steps

Before the bride and groom emerge from the church, ask them and the wedding party to wait at the top of the steps for a picture in front of the church door. Have the bride and groom stand in the center and arrange the party around them. The amount of space and the size of the crowd may limit the posing options in this situation, but make the best of it.

Depending on the time of day and the weather, you may have to use fill-flash to open up the faces in the group. Shoot at a low enough shutter speed, say 1/60 second, so that the light has an open feel; too fast a shutter speed will create a well-exposed group with dark surroundings. You'll have to direct your light right into the group, so make sure the strobe isn't tilted up from a previous shot in the church. Also check that all filters have been removed. Take an incident reading to make sure the light is right, and don't use the flash if you have a good natural light available.

Most churches have a series of steps leading to their entrance. Generally you'll be shooting from a lower level than the group. Deaccentuate any tilt you may have by stepping back and leaving room at the sides in the viewfinder. You'll be able to crop tighter in printing. Don't make the mistake of using a very wide-angle lens and getting close; a wide-angle tilted up can distort figures and give your unfortunate subjects long bodies with small heads. You're there to enhance your subjects, not just to fit them into the frame.

Keep an eye out for people leaning into your frame while you're taking the picture. Have the crowd make a *V* on the sides of the steps. It probably would be better if they all stood behind you, but don't expect this to happen. Pose the group on the steps in a triangular fashion, leading the eye towards the center of interest, the bride and groom. Pay particular attention to depth of field, and make use of the depth-of-field

preview button to verify focus. If the camera doesn't have a preview button, use the depth-of-field scale on the lens barrel to check your hyperfocal distance. Focus to the near and far subject and obtain your accurate distances, then set the lens so that the two distances fall between the *f*-stop settings on the scale.

Some photographers carry a step ladder for shots where they want a high angle of view or where perspective is thrown off due to a low shooting angle. Keep one in your car, but don't lug it around with you all day. It's a very cumbersome, but useful tool for some of the shots you'll encounter.

Two or three shots are all that's necessary for this pose. Any more will take too much time in what should only be a transitional moment. Just as you have a shooting rhythm, the wedding day has a pace of its own; get in step and make your work smoother throughout the day.

(Photo: Ken Sklute)

The Traditional Send-Off

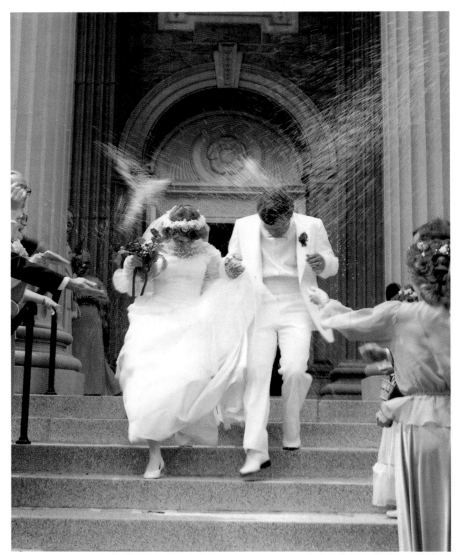

The rice seems to descend from all quarters in this rice-throwing picture. Inclusion of the hands of the celebrants gives context to the picture, plus keeping rice-throwers to the side of the frame guarantees a clear line of vision for the photographer. (Photo: Robert Decker, Artography)

As you're shooting the pictures on the steps of the church, the guests are patiently waiting with rice or confetti in their hands. Throwing rice is a form of release for everyone involved in the wedding, and its the first really active outpouring of emotion in a somewhat controlled environment. As the director of the shooting script on the wedding day, you should take control and orchestrate this ritual, but once it begins don't try to stop it to get another picture.

Once the bride and groom are ready to come down the steps of the church, or are leaving the church door for their car, guests will crowd around and create an aisle for them (more like a gauntlet, according to some couples). At this point, you should already have your spot picked and be ready to shoot. As the bride and groom begin their approach, call out "okay everybody, on the count of three," and when you hit three start shooting. You may have a few enthusiasts in the crowd, ones who throw the rice before everyone else, and this action will usually ignite the rest of the "mob." If that happens, snap a few frames and get what you can. At best, rice throwing shots are candids, and they only sell if you catch a great expression on the couple *and* a lot of action from the guests.

If you'd like to help the bride and groom, suggest to the guests that they loosely toss the rice in the air. Hard-grained rice flung into your face at two feet can be painful. Don't expect or even try to stop-action the rice as it goes through the air; the action and the people will tell the story.

Include as much of the well-wishing crowd in the shot as possible—fill the frame with action. Shooting from a high angle will help this feeling, or you can venture in closer to the action and using a wide-angle lens. Showing just the bride and groom cringing or fleeing doesn't have the story-telling impact as a shot of the two of them engulfed in rice-throwers, or moving toward their car like besieged stars in a Hollywood opening. The action is very fast during this shot, so get off a few frames and hope for the best. The only posing control you really have is in camera angle, so be sure no one obstructs your view and that you have a clear shot of the bride and groom. Have the guests spread out from where you're standing. This will give you a better view, and probably assure that the bride and groom won't be injured by any close-quartered throwing of rice.

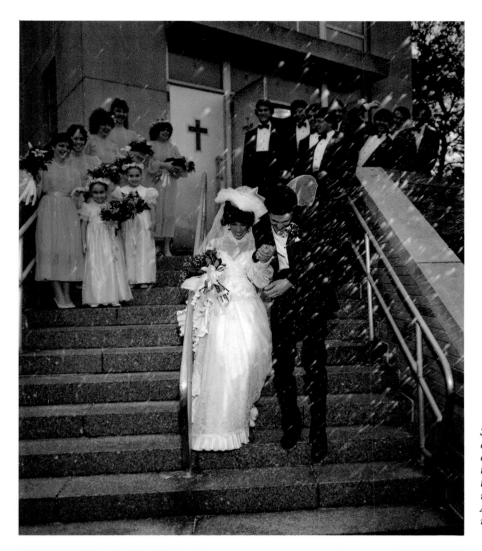

Shots of the tossing of the rice should be made at the bottom of the church steps, far enough away to include some of the wedding party in the photo. Here, the photographer has included the bride and groom, the church door, and the ushers and bridesmaids, plus the rain of rice. Always shoot with the context of the events in mind. (Photo: Ken Sklute)

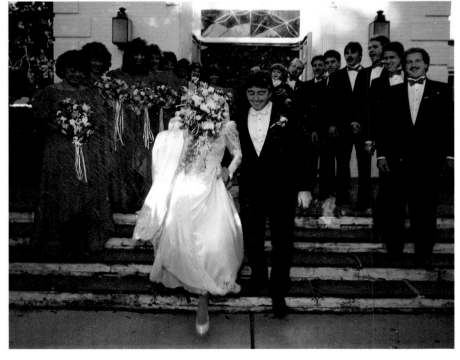

Here's an example of when not to press the shutter. As the photographer was getting ready to shoot, the bride shielded her face from the rice with her bouquet. Although it's an interesting shot, it'll never sell in a wedding album. In some cases, everything will be set up for a shot, but something unexpected will happen to mar the results. (Photo: Ken Sklute)

A Graceful Departure

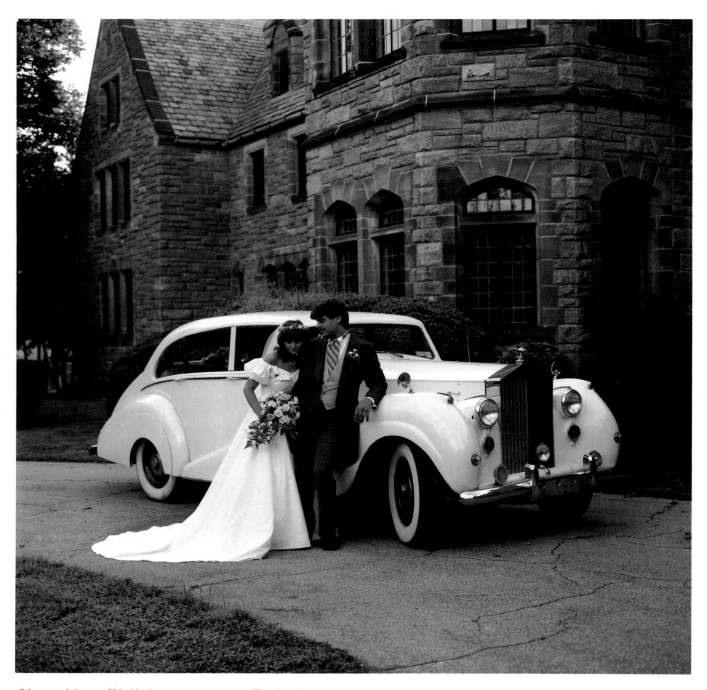

Often, special cars will be hired to transport couples throughout their wedding day. Use the beauty of the design of these cars for arrival and departure shots. (Photo: Ken Sklute)

(Top right) The photographer used the prop of the "surrey with the fringe on top" to create a natural thank-you card pose. Keep your eyes out for setups such as this throughout the wedding day. (Photo: David E. Ross, R&R Creative Photography)

(Bottom right) For this picture of the bride and groom entering the limousine, the photographer sat in the back seat and used on-camera flash to capture the couple as they enter the car. Care should be taken not to overexpose this shot; the light can bounce around the confined space in which you'll be shooting. (Photo: Harold Snedeker)

A favorite shot found in most wedding albums is one of the bride and groom getting into or already in the limousine they've rented. Many times very fancy cars are used, and the couple will want to show off the style in which they were transported on their wedding day. If it's the bride and groom's own car, it may be "decorated" with cans, ribbons, and removable paint; make sure to get a shot of the festooned auto before they hit the road.

The shot of the bride and groom getting into the car can be accomplished in a number of ways. You can set up a simple picture with the groom opening the door of the car for the bride, and a crowd of well-wishers behind them bidding them farewell. Once they're in the car, you can shoot through the back or side window with the couple waving goodbye. If you're shooting from outside the car and the windows are rolled up, make sure to use a polarizing filter to cut down on glare.

You can follow the bride and groom into the car and shoot from the front seat. You'll have to use flash for this shot, so make sure you use bounce to fill the car with light rather than have the bright flash go off directly into their faces. This will prevent a harsh look and will cut down deep shadows to a minimum. The bride and groom should be close together, with their heads touching or kissing. Don't waste a lot of time with this shot, but do look for details like the way the groom's jacket rides onto his collar or a bouquet that is cut off from the frame. Use of a wide-angle lens is necessary here, but don't get too close to the subjects or their features will be distorted.

Although many times the car seems to get more attention than the bride or groom, a fancy limousine can make a great prop for these shots. Rather than have the whole car in the shot, choose some identifying object (such as a fender, name plate, or hood ornament) to establish the fact that the couple traveled in a special vehicle. Chauffeurs are usually understanding souls, but they probably won't drive their cars into odd locations like the edge of cliff or a muddy lawn. Gaining the cooperation of a chauffeur early on can make the difference between an easy setup and one where the owner of the prop makes the shot close to impossible. These drivers are not immune to tipping, so when you see the proper set for the shot have them pull over so you can make the picture.

The Reflective Quality of White

Though the bridal gown is a beautiful dress that can add so much to your portraits of the bride, it can also be a source of problems because of the high reflective quality of white. Most photographers would shrink in horror if they always had to deal with such a large mass of white in their pictures, yet it's an element that is a constant for every wedding photographer. Knowing the pluses and minuses of dealing with the gown is very important in getting quality pictures.

One rule to keep in mind is that the lightest color in the scene should be furthest from the source of light. If the bride were placed nearest the window in a natural light portrait with the groom, the resultant image would be one where the viewer's eye would be pulled toward the side of the print. With the strong reflectivity of the white gown, the meter reading would be inaccurate and the gown would have a burnt-up, harsh appearance. Printing for the gown would result in the rest of the print falling into shadows. Placing the bride, and thus her dress, furthest from the light source not only fills and balances that side with light, but also acts as a natural reflector bouncing light back into the normally darker dressed groom.

The same is true for outdoor shots where the light source is strong, though not as directional as a window shot. In this case, turn the bride slightly away from the light so that her dress falls in the shadow portion of the frame. The dress will be shown to full advantage, and it will still allow you to make effective portraits without harsh highlights. Pick the spot that's right, and choose light that allows for a soft rendition of the gown. Always meter the gown whenever you're in doubt about the light, and don't let the gown become a distracting element in the picture.

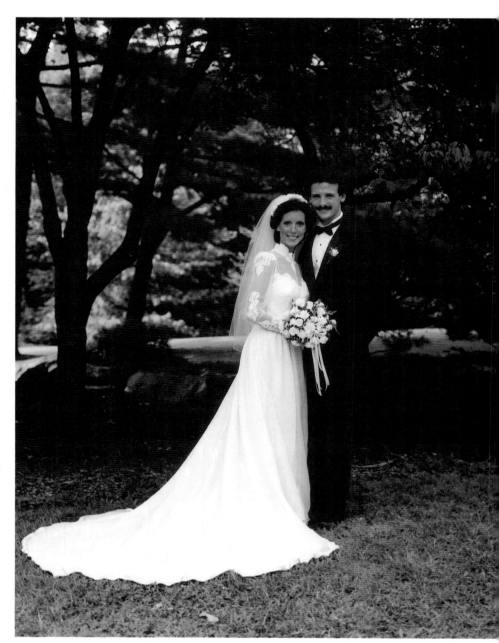

Shooting in bright light is never a good idea for portraits, so the photographer has posed the couple in the shade of some tall trees. Bright sunlight would probably have resulted in an overexposed dress and underexposed faces. (Photo: Ken Sklute)

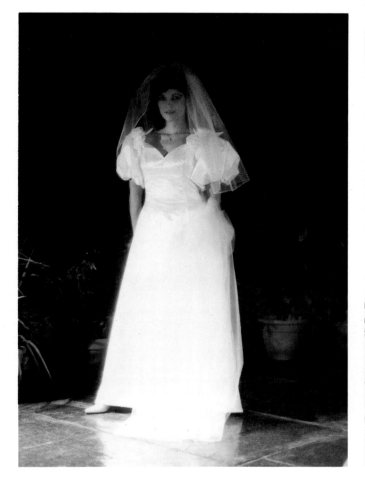

These two examples illustrate the trouble the high reflectivity of the bridal gown can cause you. In the shot of the bride in the limousine, metering for the face causes the rest of the lighted area of the photo to overexpose. In the strobe shot of the bride, the flash was pointed too low resulting in the underexposed face and the overexposed gown. Printing for detail in the dress in both photos would result in a very dark rendition of the bride's face. (Photos: David E. Ross, R&R Creative Photography)

Environmental Portraits

Given the time, temperature, and weather, you should try to make time within the wedding day to make some environmental portraits. What does "environmental" mean? According to some definitions, every portrait made on the wedding day is an environmental one because the portrait is made outside the confines of the studio. For our purposes, an environmental is taken in a park, on the grounds of the church or catering hall, or any other outdoor area where the landscape is used as an integral part of the composition of the photograph.

The choice of location is dependent upon its accessibility and the personal tastes of the couple and/or the photographer. Some couples may want a shot of themselves on the slopes of the Rockies, but this wish would be likely to go unfulfilled if the wedding takes place in Maryland. Of course, this is an exaggeration, but the location should be one that's not too far from the church and the catering hall. Racing to and from the location won't help your pictures or anyone's disposition.

The location should have something to do with the personal tastes and lifestyle of the bride and groom. Confer with the couple before the wedding day, and select areas comfortable for all. Have a map available to pinpoint locations, or even a few snapshots or wedding samples to help them make their selection.

Many times, the couple may have a location in mind that has a special meaning to them, though it may not strike you as a particularly appealing place to shoot. A couple may have met on the edge of a long beach. Be prepared to go trudging across an acre or two of sand. Or they may have met in a diner, and you'll be finding yourself setting up shots amidst the chromed interior, complete with table-side jukeboxes and red cushioned seats. The point is that these pictures should be fun, and meaningful to the couple involved.

If there's only a short break between the ceremony and the reception, and the couple wants environmental shots, you may be able to get pictures on the grounds of the church or the catering hall. Many of the more elaborate halls have picture spots all set up, complete with wooden bridges, gazebos, and small ponds. Posing everyone around shrubbery or on a model bridge doesn't quite fill the bill on environmentals. However, the use of a natural setting and outdoor lighting can become attributes to portraiture, and give a break to the otherwise all-interior pictures of the day. When shooting in these setup areas, take the time to find the light that's right, that's most complementary to the subjects. You can be flexible with your location, but you should be fussy about the type of light you use in the shot.

Generally, the entire bridal party will be subjects in these shots, but if this seems cumbersome, you can just work with the bride and groom and get the shots of the rest of the entourage later during the reception. You may use the break between the service and the reception as a time to "kidnap" the couple to a select location for some very intimate pictures. Don't eliminate the bridal party from consideration, just use your judgement and make sure they don't get in the way of these special moments.

Care must be taken with the bridal gown when working outdoors. Muddy or damp ground and grass will easily stain the material. If conditions are poor in a chosen location, be flexible enough to move to where better environmental conditions exist.

Fill-flash is a useful technique when making outdoor portraits, especially when the sun is high in the sky and shadows form on faces—particularly in the eye sockets. A small burst of light can make the difference between a bleached-out face with dark circles around the eyes and a fully illuminated subject. Also, according to the shutter speed and amount of fill light you use, the background can be balanced with the subject matter or made to go dark.

Timing is also important during this part of the wedding day. You've got to give yourself enough leeway so that you can make the pictures you want and still get the couple to their reception on time. It can be difficult to get environmentals *and* get the couple to the hall for the cocktail hour, so make it clear to the couple that if they put themselves in your hands, you'll get them on their way as quickly as possible. Know the pictures you want to take, and work as best and as quickly you can with the conditions that prevail.

You won't be able to use any major lighting setups in these pictures, so equipment should be limited to main camera, lenses, portable strobe, and vignette and diffusion filters. You might want to bring along a reflector card or two. The card can be held in the couple's lap or by an assistant to help fill in light as needed. All in all, hauling too much equipment just slows down the job, especially if you have to walk some distance to get the shot.

Keep in mind that environmental portraits are an option to be used when time and location allow. Don't feel that they have to be part of wedding coverage, although they can add a nice touch to any couple's wedding album.

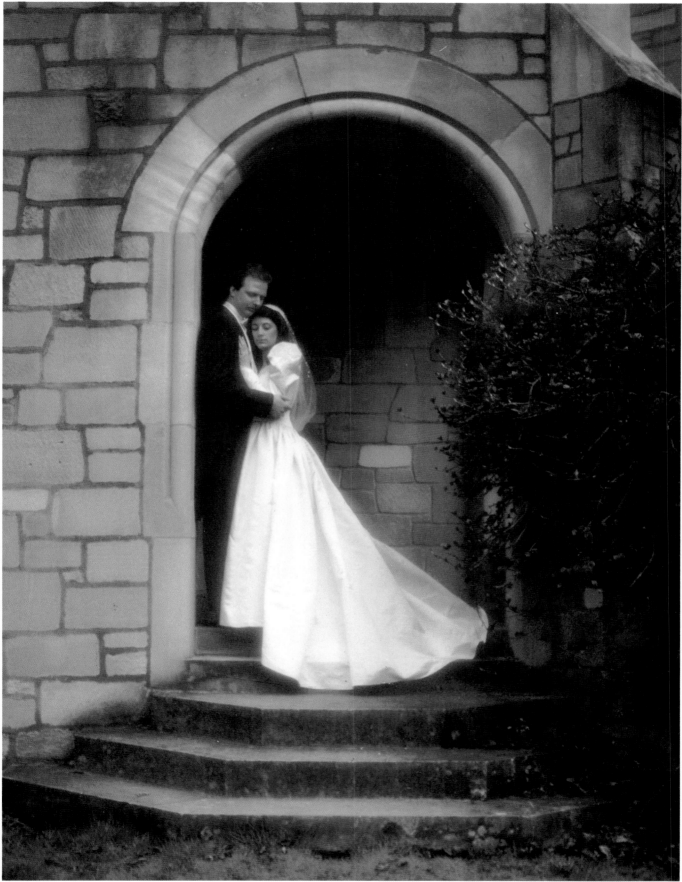

(Photo: Ken Sklute)

Choosing the Appropriate Surroundings

Finding that special place with the bride and groom, setting up the pictures, and using all your photographic skills can yield some great pictures for the album, plus be one of the most enjoyable times of the day. In comparison, much of the other portraiture in the day may seem "functional." The environmentals should be evocative of the mood and feelings of the couple and a challenge to your eye and skill.

Try to treat the location as a set that depicts the feelings of the couple. The beauty of nature or a particular light can communicate tenderness, warmth, hope, and strength. Trees can become symbols of growth; water, of movement and change; and flowers, of beauty and softness.

With all this, it's important that you don't lose the couple in the environment, or make them mere props in a landscape study. Your task is to blend them with the surroundings, and to make the scene an extension of their personalities. Watch form and line, and have the pose of the couple relate directly to the design of the surrounding scene. They can relate to the landscape, or to each other amid the scenery, but they should always be the focal point of the composition.

A failure of many environmentals occurs when the couple stand stock still in the middle of a location, posing as if they're in a studio with a painted backdrop. You needn't have them prancing through the fields, or rowing a boat in a lake, but you should have a sense of involvement depicted in the scene. This can be done by having them contemplating the area together, as well as through effective use of props.

A wooden fence, a park bench, rocks, and trees can all be used as posing tools to help the subjects relate more directly to their environment. There's no end to the poses you can obtain with, say, a beautiful tree. The couple can lean against the trunk, relate to the blossoming flowers, or dawdle under it as if they're characters in a romance novel. Touch their hands to the bark, or the

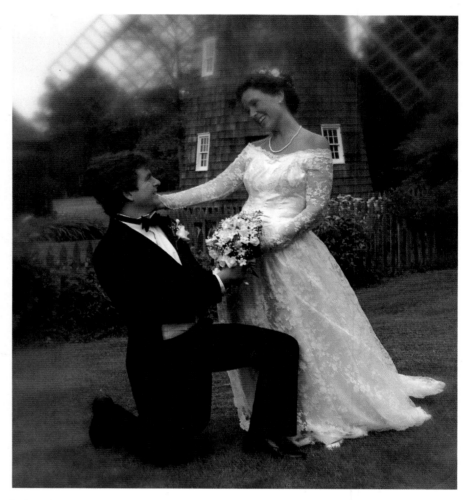

limbs of the tree and use it as a natural vignette for the picture.

Use of auxiliary diffusers and vignetters can add to the beauty of the pictures, and here you'll be enhancing what exists rather than making inappropriate special effects shots. If it's a warm summer day, and the light is hot and steamy, adding a low-density warming (yellow) filter and a light vignette to a closeup will increase the soft, sentimental quality of the image. Don't load up on too many filters, yet keep an eye out for the "tendency" of the light and setting, and accentuate it with the discreet use of accessories.

The use of the windmill in this shot adds an interesting compositional break to the background, yet the photographer has chosen to subdue what might have been an overwhelming series of lines and breaks with a diffuser on the lens. (Photo: David McHugh)

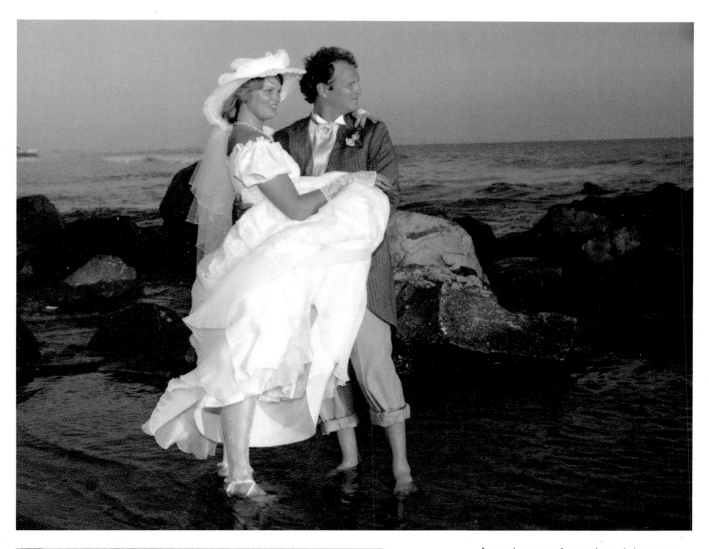

An environmental portrait can bring you to mountaintops, into the woods or, here, to the shore. This picture was made with available light, and the photographer made good use of the "magic hour," right before sunset, to add a warmth and glow to the couple's fleshtones. Saving the dress from the water has also resulted in an interesting flow to the whole picture. (Photo: David E. Ross, R&R Creative Photography)

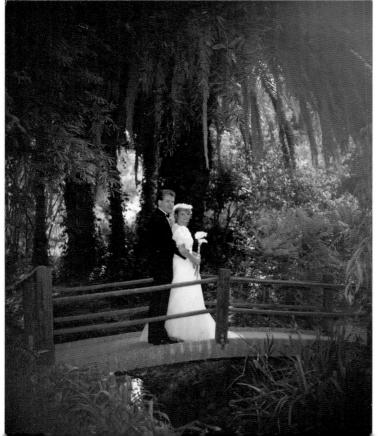

This "picture perfect" setting, plus the use of the available light, resulted in a good outdoor picture. Note how the dark tree in the background is used to help highlight the bride. (Photo: David E. Ross, R&R Creative Photography)

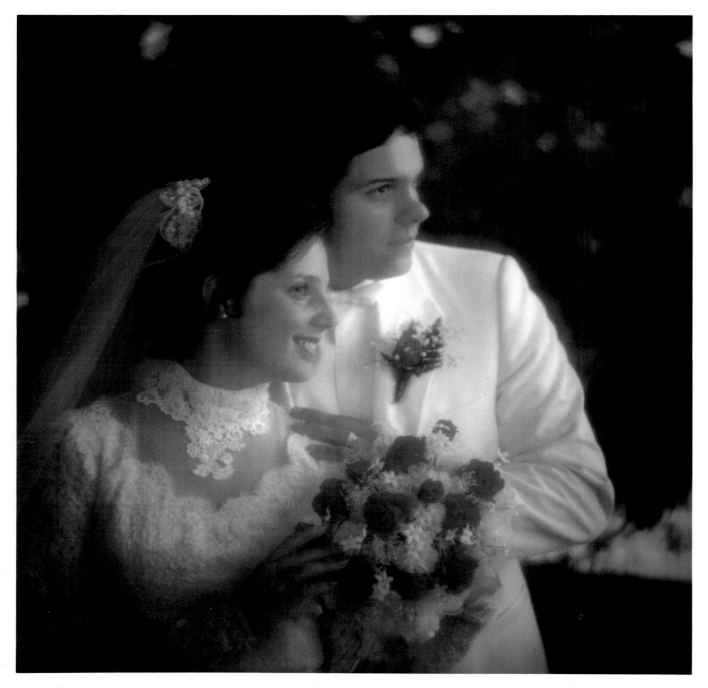

*A strong directional light was used to good
advantage in this shot as was the graceful posing
of the bride and groom. Not every environmental
shot need include the entire forest to have a sense
of presence; often, special use of light will do.
(Photo: Ken Sklute)*

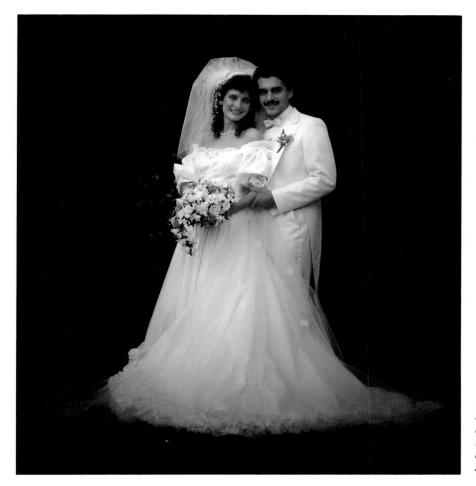

The use of a dark vignetter has turned this outdoor shot (made with available light) into one that resembles a studio portrait. The extra lean of the bride's head towards the groom adds a sense of intimacy to the picture. (Photo: Ken Sklute)

CONTROLLING THE "FRAME" OF THE PHOTOGRAPH

There are basic rules of composition intended to keep the viewer's eye in the picture and have the eye travel to the main subject matter. You should not have a bright highlight, or mass of white, leading out of the borders of the print. When this is unavoidable, many printers will burn down the edges of the print in order to make them darker than the center.

The chief source of highlights and masses of white in wedding photography is, of course, the bridal gown. The aim of many of your light readings and setups is to maintain detail in the white gown, and not to have it distract the eye by being a source of excessive highlights.

In posing, you should be aware of the effect the gown has on pictures, and make sure that the entire gown stays within the frame. Always leave room for some darker area on the border to ensure that the viewer's eye stays within the frame. Having a gown cut off at the bottom makes the picture unbalanced and hurts the overall composition.

Naturally, this doesn't apply to closeups or medium shots, but even here you should make sure that the highlights fall toward the center of the frame, and that an overexposed patch of white doesn't distract the eye.

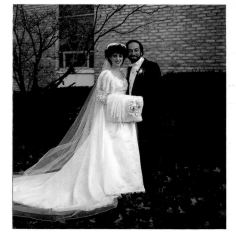

Though the lighting on this shot makes the most out of the setting sun, the fact that the bride's dress is cut off and leads the eye out of the frame serves as a distracting element. When doing full-length shots of the bride, don't cut off the gown or let it lead the viewer out of the frame. (Photo: Ken Sklute)

Dealing with Changeable Light

Photographers are worse than vacationers—as the time of the trip approaches, the weather report becomes the most important item on the news. Long-range forecasts are eagerly watched, and the dreaded rainstorm is wished away with offerings, invocations, and prayers. If there's one factor that can't be controlled on the wedding day, it's the weather. You'll have to make the best of whatever light, and conditions exist. You might even have to dance between the raindrops.

Though rain certainly poses a problem, harsh, open sunlight can be just as difficult. Too much sunlight, particularly in the middle of the day, can create havoc with shadows on faces and squinting eyes. Too much light is often more of a problem than too little light in effective outdoor portraiture.

If you could choose the conditions and/or time of day to shoot environmentals, it would be smart to go for a light, overcast day or one where billowy clouds pass over the sun, and shoot the pictures in the late afternoon. No light is quite so complementary to skin tones, or any other subject, as that thrown in the "magic hour," the last hour or two before sunset. Shadows are soft and the long rays of the sun make the world, and your subjects, glisten. In fact, given a choice, many photographers simply won't pick up their camera between the hours of ten in the morning and four in the afternoon.

A slightly overcast day, similar to those so frequent in the Northwestern coastal regions of America, is the perfect light for outdoor portraiture. This light was made famous by Dutch painters and early masters of natural-light photographic portraiture. Quiet light is perfect for color film, where too harsh a light often goes beyond the contrast range of the film itself. So if you're praying for certain weather for the wedding day, don't necessarily wish for a bright, sunny day.

Given that you can't control the weather,

it's important that once you arrive at the chosen location you scout areas for the best possible lighting situation. Open fields will cause a problem if the light is too harsh, so the positioning of your subjects is very important. When you've set up a shot, look very carefully at the way shadows fall on faces and whether the subjects are squinting when they look in the direction of the lens. Sidelighting is best, though backlighting can certainly be used.

If possible, pose your subjects in open shade, and have them covered by a tree or other natural umbrella. Open shade on bright days is perfect because you avoid harsh light plus have enough fill light from the surroundings to bring a pleasant look to your subjects. There are two things to look for in open shade. One is hot spots in the background. You may get a reading of $f/5.6$ under a tree, but the greenery or lawn in the open area of light may read as high as $f/16$. Watch for those hot spots, and pose and shoot from an angle that eliminates them from the scene. The other problem can be dappled shadows from the leaves falling on your subjects, causing an uneven, blotchy look. Take care to avoid those odd patches of light that can ruin the picture.

Groves of trees are good locations because they provide ample coverage for outdoor portraits. If none is to be found, and you have no choice other than shooting in open light, a fill card mounted on a light stand or held by an assistant can provide a certain amount of illumination to help balance out the light. Tilt the reflector toward the subject to bring the light reading to an even, modeled look. Fill flash may be necessary to balance out the foreground, background, or shadow areas of the picture.

Even with its occasional problems, natural light still provides a wealth of beauty for making pictures. No amount of filtered strobes can provide the warmth and depth of natural light, and if natural light is used correctly it can add much to the wedding

coverage. Keep an eye out for tunnels of light, where the light moves through a defined space and plays on your subjects, or broad streams of illumination, where light enters into the picture as if all the spotlights in a theater were shining on the couple.

Light has an inherent color and tone, and this property affects the picture as much as the intensity of the light. It can be cool, warm, or neutral gray; light can be filled with moisture or crisp and dry. You can enhance or change these properties with the subtle use of filters, and even darken skies when they appear too bright with the use of gradient filters. Gradients have a higher to lower density range from top to bottom, and there are even types available that yield a density range in a halo effect. When using these gradients, take care that the horizon line of the filter is even with the horizon line in the photograph.

Meter readings are critical for outdoor, natural-light shooting, and you can manipulate the look of the final print by the way you utilize the readings you obtain. For "normal" shots, make sure all the elements in the scene fall within a three-stop range, and that you average the readings so all the elements will fall within the proper printing range. Natural light also allows you to make interpretive pictures, and you can take backlit pictures or create special effects by overexposing certain elements within the scene. Your negative will determine how the print will look, so manipulate the meter readings to get the negative you want.

The point is to first find the light that's right, to eliminate inherent problems by posing and making correct light readings for the type of picture you want to make, and then to enhance the beauty of the light through proper exposure and subtle use of filters. Location, the time of day, and the feelings you want to communicate are all factors that go into making effective environmental portraits.

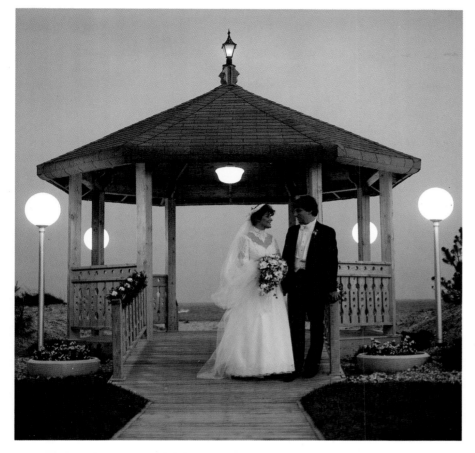

A natural light shot taken right before sunset shows the importance of taking a correct light reading. If this shot was overexposed, the globe lights may have overcome the rest of the print. If underexposed, the subjects of the scene would have been too dark. The balance of natural and artificial light can even be a challenge outdoors. (Photo: Ken Sklute)

Here, lighting, setting, posing, and placement combine to yield an excellent environmental portrait. The use of a dark vignette has added to the center of light falling on the couple. (Photo: Ken Sklute)

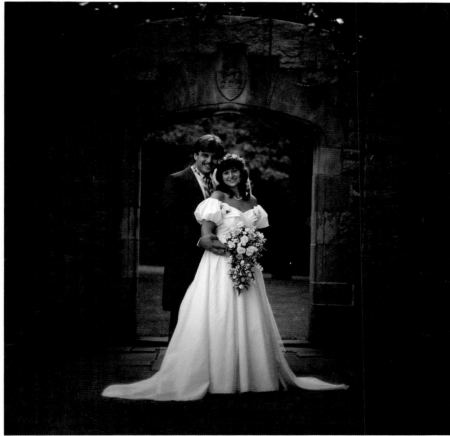

Photographing the Bride Outdoors

The scene is a rockbound shoreline, with waves crashing in while the sun is slipping below a mountainous horizon. A woman stands alone on the rocks, the wind sweeping through her hair, her dress flowing in the breeze. She looks out over the sea; the camera sees her in profile and her eyes glint in the day's last light. She's looking for an answer to her future in the endless seas, and the glow of love and hope surrounds her. If this sounds like a scene from a mini-series, or a book jacket on some romantic novel, you're wrong—it's typical of what's being done today in bridal environmental portraiture.

Following the current fashion in romantic portraiture, many photographers have let their fantasies run wild. While it may seem overdone, or even corny, it's all a part of this business. Whether your tastes run to the dramatic, or you're just interested in getting a good shot of the bride in a nice setting, you should pay attention to feelings and moods in all your pictures. Don't be content with a picture of a woman in a white dress on a lawn. You needn't construct elaborate story lines, but you should pay attention to lines, light, and expression. If you choose to go for a "novella" cover, be sure to know exactly what you're doing and why. Nothing comes off worse than a failed attempt at romantic sensationalism.

Part of all this is knowing the character of the bride and what's natural to her. If she's a poetic type, you can pose her contemplating a flower or looking out to sea. But if she's more of a pragmatic person, these shots will be phony, and the people involved will recognize them as such. All they will be are ego games that you're playing.

Posing is very important because of the gown, and this element will both suggest some stances and eliminate others. Never pose the bride standing flat on both feet squarely facing the camera; have her turned slightly to the side with her weight on one foot or the other. If you're using a posing prop such as a park bench, spread the dress gracefully and use the bouquet as a hand

prop. Take care when spreading or draping the gown; stains can mar the material and cause problems in your pictures.

The bride's hair and veil may blow around in the breeze, and although this can be used to good effect, don't let them get out of control. Carry bobby pins in your camera bag just in case the bride's left her kit back in the car. In all the poses, look for gracefulness and simplicity, and have the dress and figure flow with all the other elements in the picture.

There's no rule that says you have to pose the bride in the center of the frame. In fact, keeping her slightly to one side can aid in the balance of the composition, particularly if the location is one that contains strong emotional content. Have your subject and setting complement one another, and make the outdoor bridal portrait a little different than the one you'd make in the confines of a studio.

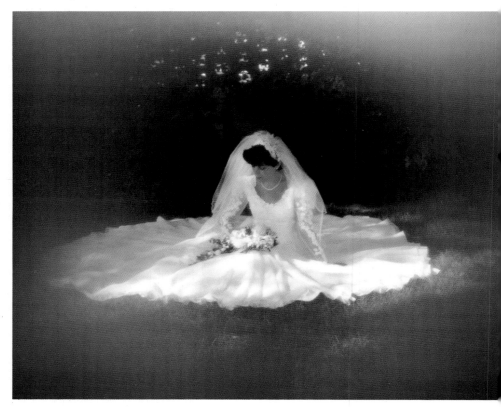

A soft, vignetting mask helps make this picture of a bride in repose one of serenity. The dappled shadows actually add to the variety of tones in the shot. The absence of shadows from her face eliminates any deep lines that may have caused problems. (Photo: R&R Creative Photography)

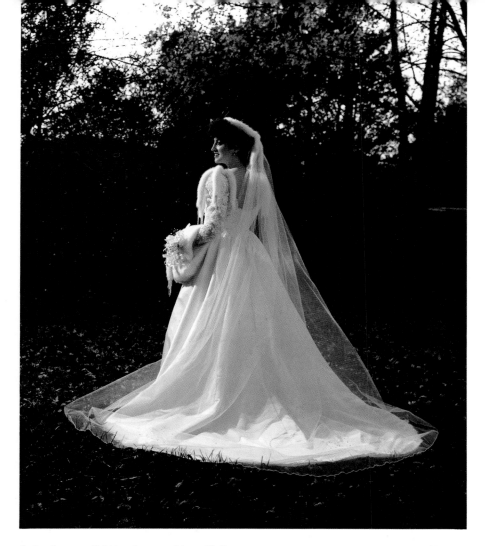

Late afternoon light has been used beautifully here to add a touch of highlight to the bride's face. The whole gown and train is exposed perfectly, enough to show detail yet still allow all the attention to be focused on the face of the bride. (Photo: Ken Sklute)

USING FILL FLASH OUTDOORS

Fill flash is one of the most effective ways of balancing foreground and background light outdoors, especially when the subject is strongly backlit or when heavy shadows are cast on faces. Along with balancing light, the fill can also make a subject stand out "three-dimensionally" from the background by allowing you to shoot at a reading that is stopped down more than what the natural light indicates. Some wedding photographers use fill for *all* their outdoor shots, although this may be overcompensating or just habit.

How you use the fill light depends on the strobe model you own, so check the instruction booklet for "auto-fill," "calcu-flash" or whatever name the manufacturer has given this technique. Generally, you'll start with a reading of the light in the general scene or, for backlighting, a reading of the light behind the subject. You then take a camera-to-subject distance check and set the flash to the power called for to illuminate the subject in the foreground. You can fill a scene totally or partially. You can also underexpose the background (by stopping the camera one or two stops below the light reading) and fill the subject with flash so that a bright subject stands out against a

darkened surround. This can be effective if you're shooting against a distracting background.

Experiment with your strobe prior to taking it into the field, and you'll begin to appreciate how this technique can add just the touch of light that makes the difference between shadows in the eye sockets and a perfectly balanced picture.

Photographing the Groom Outdoors

Posing aids can be very useful when doing environmentals of the groom because he doesn't have the adornment of a gown to add to the grace of his stance. Don't have the groom standing alone, hands in pockets and looking into the distance as if he's waiting for a bus. Use trees, benches, and rocks to add some movement to his body, and take special care to pose his hands and arms with care. Though the environmental should feature a pose that's more casual than a studio setup, don't just have the groom standing in the woods unsure of what he's doing there—have a reason for the picture, and seek some involvement between the man and the location.

Natural light can be used effectively in the portrait of the groom, and you'll have somewhat more leeway in using strong light to get your picture. Don't be afraid of having a contrasty or shadow-producing light in these shots. The strength of light can help produce a more masculine "image." This won't apply to all the men you take pictures of, so use your judgement as to which men will benefit, and enjoy, this type of shot.

There's nothing wrong with having the man contemplate flowers in the same manner you posed the bride, as long as the particular male ego allows for such feelings. In some cases, men may have a problem with this "ego-image," so you may have to resort to a more traditional stance. This includes posing the groom with his foot on a bench or rock, with one arm resting across his knee. You can also get a picture with the groom leaning against a tree, or a closeup with his arm resting on a boulder used as a posing bench.

Utilize the location to the best of your ability. If you're photographing in a marina, you can have the man posing on or near a boat. If you're in a field with a wooden fence, use the texture and direction of the wood as a counterpoint to his stance. Use whatever's handy to involve your subject, and keep it in line with what's he's comfortable with, and the sensibilities he's allowing himself to show.

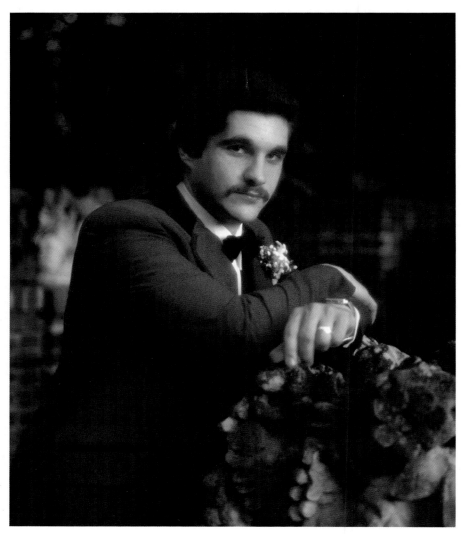

Although diffusing filters are rarely used when making portraits of the groom, you might consider them if the individul has a particularly ruddy face or a blemished complexion. This form of visual makeup can complement the subject without being overdone. A dark vignette can also be used since this filter will go along with the generally dark clothes the groom wears. Vignettes also help center the light on the groom's face in closeups, and can help remove any distracting elements in the background.

(Above) This close shot of the groom makes excellent use of a posing prop. The foreground rock is allowed to go out of focus; and a dark vignette has focused the center of light on the groom's face. Also, the hand with the ring has been positioned to show right into the camera. (Photo: Ken Sklute)

(Right) Though this shot of the groom alone makes good use of available light and a soft vignette mask, the tree appears to be a posing prop that was not well used. (Photo: Ken Sklute)

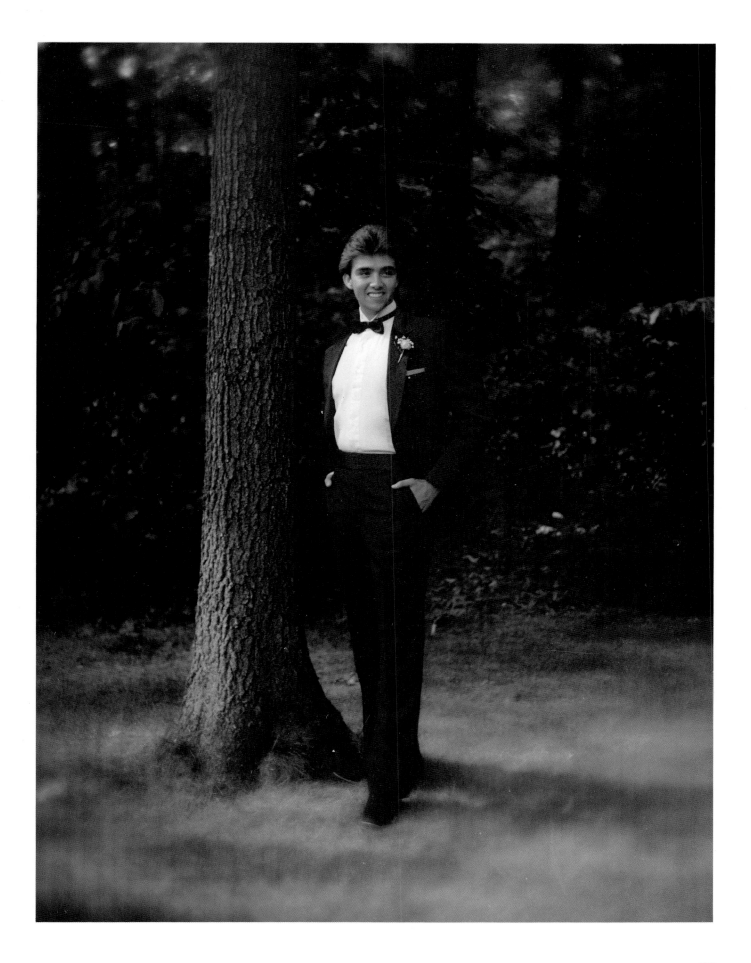

Arranging a Large Group Portrait

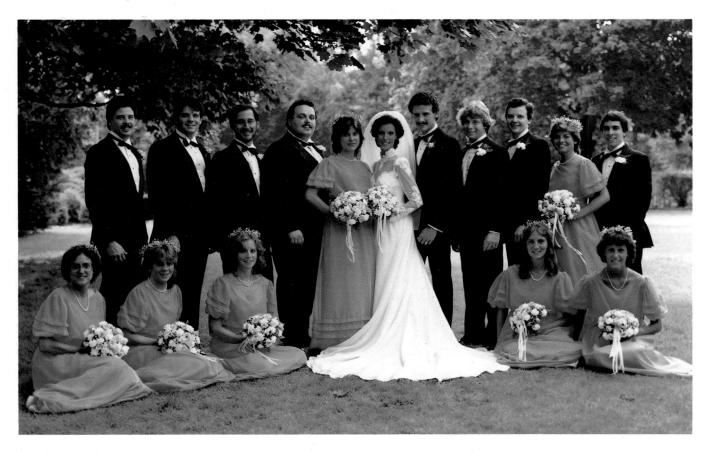

The shot of the entire wedding party might mean that you'll be doing a group portrait of a substantial number of people. The tendency is to line everyone up to get a picture of record, and you may be forced to do this if the group is of ten or more people. This doesn't mean, however, that you have to get a stiff, formal pose; you can make this picture express intimacy and feeling among the people involved.

The wedding party may be composed of people who've never met before, or it may be a tight bunch of close friends. Whatever the makeup on the day of the wedding, the people involved are bound by their connection to the bride and groom. It's your task to communicate that bond, and to do it in a way that shows everyone to their best advantage.

One way to accomplish this is by photo-

graphing the group in a number of different situations. Involve the group in an activity, or photograph them in a pose or location they suggest. One possible pose is a "walking" shot, where the group links arms and walks toward the camera. As they walk, back up and shoot on the move; as the group picks up steam there'll be more expression in their faces and body motions. The bride will have some trouble moving too fast in her dress, so don't have them plummeting down a hillside.

Pictures of the group relaxing together can also be good for communicating a group togetherness, so have your camera ready for candids between the formal takes. Don't be afraid to refine their pose once you see a shot, although too much interference may spoil the mood. You can encourage this type of shot by having them sit and talk

together, perhaps reminiscing about their time together. Have some of the group standing, some seated, but make sure everyone in the group is involved in what's happening. The point is to use your instincts with these group shots, and to mix formals with a more casual, relaxed approach.

Although you may have taken the wedding party on the altar, and may plan to take a few shots at the reception, the outdoor location gives you many opportunities to pose the group in a less straightforward manner. Use whatever props are available, such as benches, trees, gardens, and other natural elements. Intertwine the group with the environment, and then with each other. Find those moments of intimacy, and bring it all together when you snap the shutter.

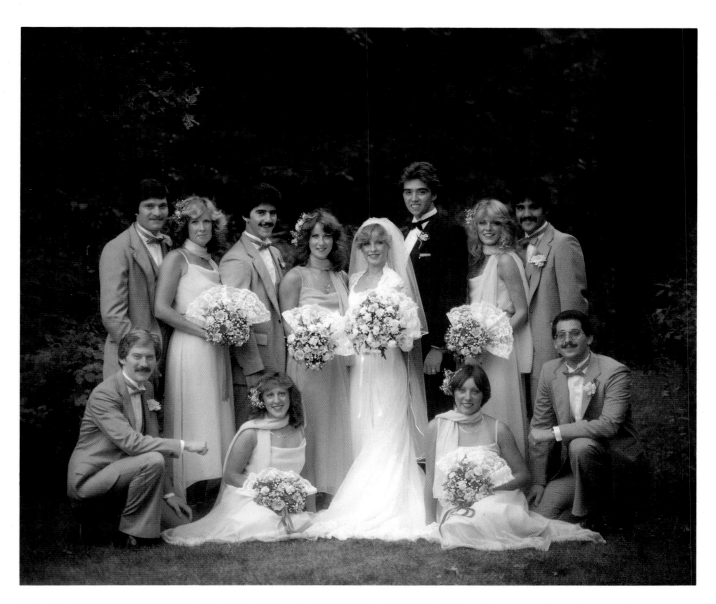

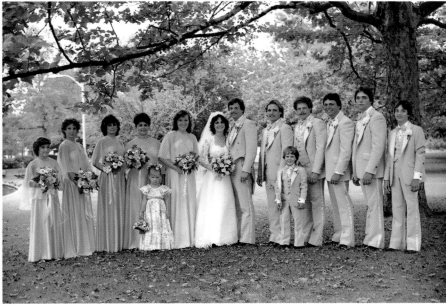

(Above) Attention to detail, excellent use of background and natural light, active and involved posing, and the use of a soft diffusing vignette make this a sure seller and a study print for wedding party environmental portaits. (Photo: Ken Sklute)

(Left) Group shots outdoors should be more than lining up the wedding party. This shot certainly is a record of the people assembled for the wedding day. The tree limb is a natural vignette, and the bouquets are held at all different heights. However, the group seems split down the middle. (Photos: David E. Ross, R&R Creative Photography)

(Opposite page) This is a "classic" group shot, where some care has been taken in setting the groups. The placement of the bride's dress, and the waiting for the full attention of the whole bridal party creates a pleasing photograph. The angle on the bride and maid of honor's arms could have been a little less severe, but the photograph still works. (Photo: Ken Sklute)

At the Reception

The reception is the time when all your instincts and talents will be called upon; you'll have to be a portraitist, photojournalist, candidman, designer, and director in an environment where events are happening quickly, and people are moving in and out of the scene. Discretion is very important at this time. You'll be involved in a situation where most everyone is there to have a good time—and you're there to work. Keep a sense of balance, get your shots, but don't intrude on the flow of events or impose too much on the people involved in them.

Try to maintain a sense of control by being knowledgeable of the course of events. Some receptions may have their own whimsical plan. Don't get caught napping or changing film when some event is about to occur. Confer with the bride and groom beforehand, or make contact with the bandleader or maitre d' at the reception hall. One or all of these people can fill you in on the reception "script," and cue you when an event is about to take place.

The maitre d' is also important in that he or she often controls the pace of events as they unfold. If there's to be an extended toast by a number of people, or a time when a few wedding guests gather for a blessing, the maitre d' can make sure that each person holds for a picture, or that a group stays in position as you reload film.

This liaison can also let you know where and how the bridal party will enter, when the first dance is to commence, and where the cake will be placed for the cutting ceremony. Most of these people have experience with photographers, and handle weddings all the time, so you can expect them to be helpful and cooperative. Remember, however, that the hall is their domain, so don't stride in expecting to tell them how to run their show. The right attitude can make things go very smoothly—the wrong one

will make problems for you throughout the day. Establish your rapport early, and work with the maitre d', not against him or her. If the maitre d' wants, he or she can really make your life miserable.

There are a number of shots that are almost obligatory during the reception, including the entry procession, the toast, the first dances, the garter and bouquet rituals, and the cutting of the cake. Most weddings share these events, though there are exceptions and variations on the theme.

Aside from the setup shots, you should keep your eye out for interesting candids. Here, you roam about the room as you would at a public relations event and seek interesting small groups and situations. These can include pictures of small children with grandparents, couples and groups dancing, people enjoying conversation with one another, and especially, quiet shots of the bride and groom alone or with friends. You might even want to occasionally "kidnap" the couple from the main room for some portraits using the decor of the reception hall. Most of all, get shots of people having a good time.

Shots you shouldn't take include people eating, large groups where half the people have their backs turned to you, and too many pictures of nebulous groups on the dance floor. These rarely, if ever, sell, and they don't serve to highlight particular people or events. You can get lost in candids and waste a lot of film and energy. Make the pictures specific, a part of the wedding story.

During the course of the reception, you may be approached by any number of people to take pictures of themselves or their relatives. "Please get a shot of my aunt and uncle," one may say, "they're here from across the country and we never see them." Make the shot if you have the time, but don't interrupt your own schedule to do

it. Some photographers carry small order booklets with them, and have people sign mini-contracts to buy the picture on the spot. Don't exchange money at the reception, but make sure these pictures count and that they'll result in an actual sale.

One way to handle all requests of this nature is to make time during the reception when all formal shots can be handled. Have the maitre d' announce that, say, during dinner and dessert, or after the cake cutting, you'll have a small studio set up in an area of the hall and that anyone who wants an individual or group portrait can report to have their pictures made. This is a good way to handle family groups; you won't have to chase people down or send out scouts to get them all assembled. Put the responsibility of getting people together on the people who want their pictures taken. This will avoid endless hassles and time-wasting; put a time limit on the operation of the "studio." If people don't show up, you can't be faulted for shirking your duty.

Some couples want table shots of select groups or of all the invited guests. This is a troublesome task, and it's recommended that you make these pictures on a sales-guaranteed only basis. People are forever roaming during the reception, and you'll often have to wait around for everyone to assemble. One good technique is to insist that the bride and groom be with you when you make the rounds, and that they appear in every shot. This usually guarantees the cooperation of the sometimes recalcitrant guests.

A reception can be a harried affair, but if you follow a script, set up a specific time for formals, and shoot only those candids that are important in the context of the overall affair, you can possibly relax enough to enjoy what's going on *and* get good pictures. You'll work hard, but all your energy will be directed to the task at hand.

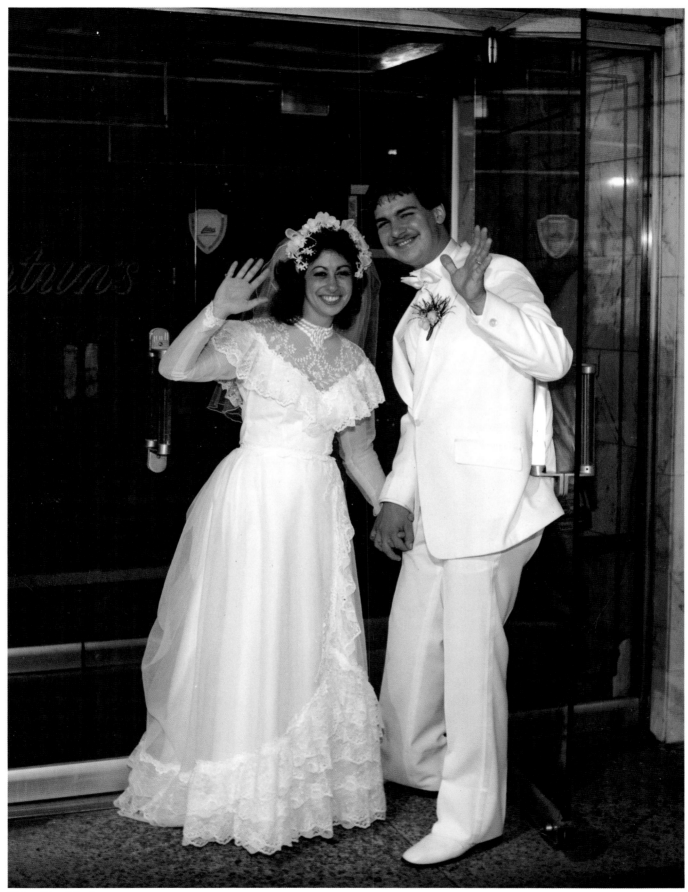

(Photo: Ken Sklute)

The Introduction of the Newlyweds

Most receptions begin with a formal entry of the bridal party, with the band leader or maitre d' making the announcements of the names prior to each couples' entrance. It all takes on the character of stars being introduced at a gala, and is accompanied by fanfares and applauding guests. Find out where the group is to enter and stand, and then set yourself up for a number of action and group shots.

It isn't always necessary to photograph each couple as they enter, especially if you already got them in the procession down the aisle at the church, but you might want to make an establishing shot or two of the guests applauding the entering group. The bride and groom, however, are another matter. Take a shot when they first enter (with the guests in the corner of the frame) and then move into position for a picture of the whole bridal party together.

Some entourages line up in rows, as if they're about to dance a reel, and then the bride and groom walk down the aisle they have formed. This can be a great shot for candid expressions. Be sure that none of the bridal party is blocking your view, and that the flash doesn't bounce off an intruding shoulder or gown. Also, place any children at the front of the rows so they won't be lost in the crowd.

This procession may be more formalized, and the bride and groom will walk between crossed swords, raised arms with hands linked together, or some other type of person-formed enclosure. Get down low for this shot, and include the special formation with the couple going through it.

Once the bride and groom have come through the group, have the party stand together for a quick group shot, and back up enough so that you include some of the hall, and especially the standing guests, in the picture. This should be a quick pose, and it serves to show the presentation of the bridal party in the context of being received by the guests.

These shots come very fast, so be sure to have a fresh set of batteries, or flash set on fast recycling time, for the whole series. You can't interrupt the flow of events by asking the group to hold up or the maitre d' to slow his pace of announcing them just because your flash decides to lose power on you. This is true for many events during the reception, so be ready for the action.

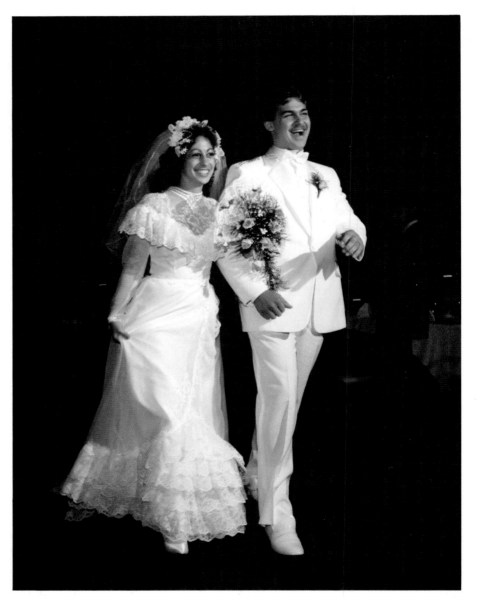

The entrance of the bride and groom is the high point of the reception processional. Here, the photographer used an off-camera light to isolate the couple in their entrance, and waited for the moment when the couple showed the happiness and excitement of their wedding day. (Photo: Ken Sklute)

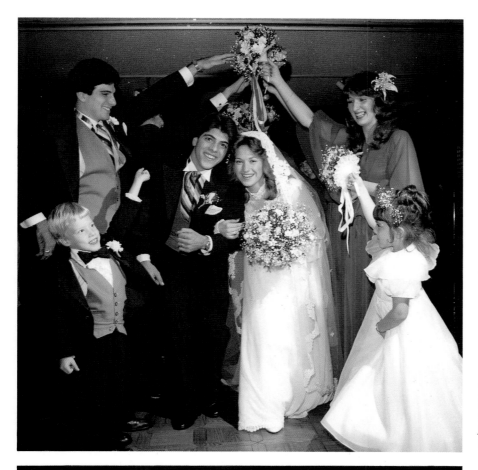

When posing the processional shot with the bride and groom, place the children up front so they don't get caught in the crowd. Also, shoot from a low camera angle to help dramatize the scene. (Photo: Ken Sklute)

A matte box was used to create a different view of the standard wedding party processional shot. Shots of individual couples entering the reception may not sell as well as those that include two sets of couples in the same frame. (Photo: Ken Sklute)

The Celebration Toast

(Photo: Ken Sklute)

When everyone is settled at the dais or wedding party table, it's usually time for the toast to be made. If it's a large hall, the toaster will have to come to the microphone on the bandstand, but more often than not the toast will be made right from the table. You can get a shot of the person making the small speech, glass raised in hand, but proper positioning can yield a much more effective photograph.

Move around the table until you have the person giving the toast, and the bride and groom, in the viewfinder. Don't be overly concerned with depth of field if you can't get the bride and groom in the background in crisp focus, just keep them in the frame so the connection is made. While the toast is being given, the bride and groom will be sitting close together, eyes on the speechmaker. Take a few shots of this pose, and establish giver and receiver with your camera angle.

Right after the toast, move in close to the bride and groom seated at the table and get a few shots of them with glasses in hand. Have them toast one another, or get some pictures of them with glasses in hand, heads leaning in toward one another. You can get a few smiles out of them by asking them to intertwine arms and drink from each other's glasses. Unless they're practiced at this technique they'll fumble a bit, and once they get it right you can get a few images of them laughing about it.

A wide-angle shot of the whole wedding party table toasting the bride and groom can also be gotten at this time. Just step back, set up the shot quickly and make your exposure. Watch out for centerpieces and table decorations, making sure they don't block the view or reflect light back into the lens. There won't be much time to rearrange these setups now, so just find the proper camera angle that gives a full view.

A variation on the toast is the blessing which, in Jewish affairs, takes the form of the cutting of the challah bread. A favorite uncle, grandfather, or other male elder comes forward and says a blessing while he cuts into the bread. This is an important shot in the reception sequence, and you should get one shot of the man performing the blessing alone, and then a group shot of him with the bride and groom.

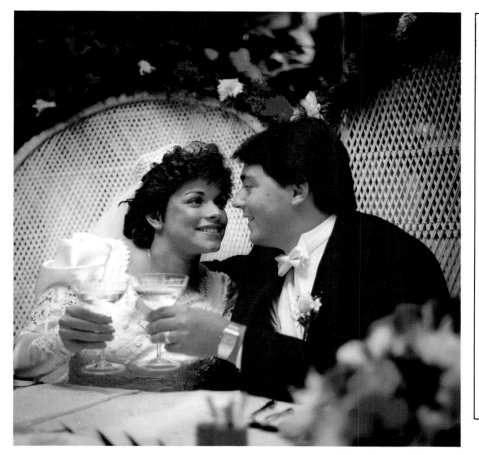

ELIMINATING GLASS REFLECTIONS

For some reason, people who design some catering halls do it with the sole purpose of causing problems for photographers. While placing mirrors all around the walls certainly makes the place look bigger, it can create havoc with reflections from strobes. You must be conscious of these mirrored halls throughout your shooting and avoid the hot spots that can mar even the most perfectly posed photograph. Such rooms keep legions of airbrushers at work.

Shooting on an angle is really the only way to get around this obstacle, unless the ceiling is so low that you can use bounce flash. Although this technique is fine, you should realize that it will really cause a drain on your batteries. Angle shooting deflects the light away from returning to the lens, thus helps to avoid problems.

If you're doing tables, and they're against a mirrored wall, either move the group to the other side of the table or locate them in such a way that the reflection will deflect elsewhere. Keep in mind that strobes and mirrors are a deadly combination, so use your skill and keep your eyes open.

(Above) Right after the toast is made, move in for a shot of the bride and groom while they still have the glasses in their hands. Have them related directly to each other rather than to the camera. Here, the photographer has used the floral arrangement on the table as a way to frame the picture with color. (Photo: Ken Sklute)

(Left) An important point in the reception in a Jewish affair is the cutting of the challah bread. Always check with the maitre d' as to scheduling of events so you don't miss any of the important rituals. Even though the "floating" head in the background mars this picture, the expression on the father's face more than makes up for it. (Photo: Ken Sklute)

The First Dance

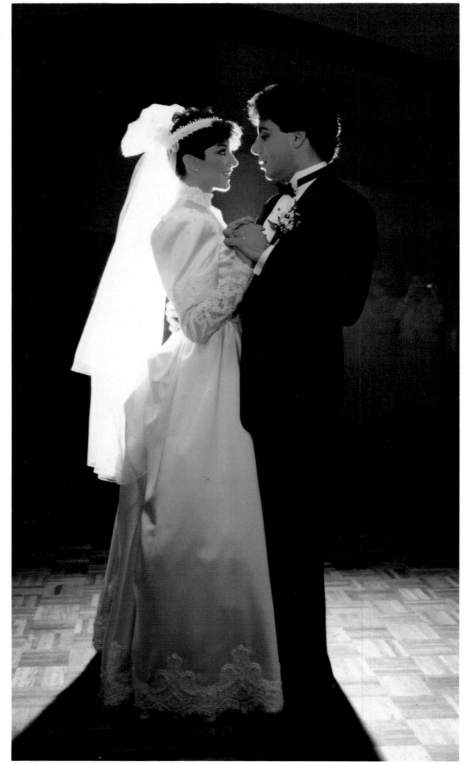

As soon as everyone's seated after the toast, the bandleader or maitre d' may call for the first dance. This sequence of events involves a number of couples, the bride and her father, bride and groom, groom and mother, and so forth. These dancing partners may change often and quickly, so move in and get the shots at the first opportunity. The most important shots are the bride and her father, and the bride and groom.

The "first dance" pictures are ones that exemplify the need for discretion in wedding coverage. These are very intimate, and touching moments where you can't be rushing in and posing people just because you need the picture. When the bride is dancing with her father, for example, take a few shots in their natural stance. This may mean the couple are facing in opposite directions. If you're lucky, they may look at each other once or twice during the dance, and then you'll take the pictures.

If you haven't gotten the shot you want by the time the song is reaching its end, approach the couple and quietly ask them to look at the camera. Shoot one or two close-ups and then move away and leave them to their moments together. Don't circle them about the floor, jutting in and out pointing your camera in their faces. Get the shot you want, but don't intrude on their intimacy. The same holds true for other dancers.

When the bride and groom get to dance together you can be a little more forward in your posing, though you should also be discreet in your movements and directions at this time. Be aware that soon after the couple come on the floor the rest of the guests are invited to join, so don't dawdle too long waiting for the right shot. Pose the wedding couple so their hands are up and close to their faces, and compose the shot as if it's going to be placed in an oval mat.

You can get a few good dancing candids of the rest of the party at this time, but it might be better to get these shots as the affair goes on and the crowd gets looser. Avoid shooting general scenes of various couples dancing. An overall shot of the group on the dance floor can be effective, though be forewarned that these pictures rarely sell.

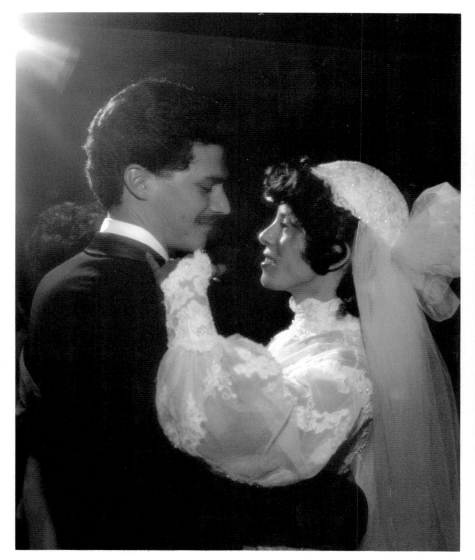

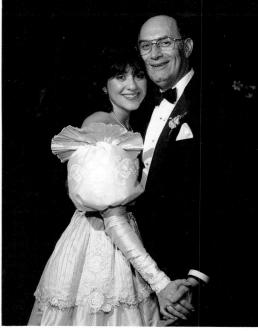

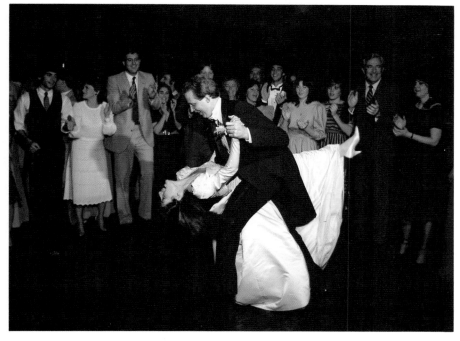

(Opposite page) The first dance shot is done a little differently. Here, the photographer used an off-camera light as a backlight to emphasize the bride's veil and an on-camera flash to give detail to the couple's faces. Though the pose is standard for these shots, the lighting made it much more effective. (Photo: Ken Sklute)

(Top, left) Although the first dance photos may need to be posed, this couple happened to present a perfect picture without any intervention on the part of the photographer. The result is a warm picture projecting a real connection between the bride and the groom. (Photo: Ken Sklute)

(Top, right) The first dance with the father and the bride can be a very emotional moment, and here the happiness of the two people project right into the camera. At one point during the dance, approach the couple and ask them to look into the camera; take the shot and then move away. (Photo: Ken Sklute)

(Left) Many first dance shots are closeups of the bride and groom. Effective shots can be made by stepping back and including the reception party in the picture. Here, the "dramatic" dance is best portrayed by an overall shot; the picture shows how the families and friends of the couple share in the day's events. (Photo: Ken Sklute)

Honesty Captured Through Expression

When posing shots or doing candids, you'll find that the best pictures are those where the subjects project an honest expression of their feelings. The emotions felt are those portrayed. Making everyone smile, or always look as if they're in a fever pitch of enthusiasm, may be false to what's really going on at the wedding. It would be a dishonest way to cover the event.

Not only are gleeful smiles sometimes false, they are also less likely to be good sellers. There are ways of having a subject look happy without their having a full grin on their faces. The eyes, as the cliché goes, are the windows on the soul, and more is projected through these orbs than any toothy grin. People are less likely to hang a smiling portrait in their homes than one that shows warmth and love through the projection from the eyes and the positioning of the head and body.

You can help evoke an honest expression through verbal communication with your subjects. To a certain extent, you control what your subjects project by the thoughts you plant in their minds. If every time you take a picture you have everyone say "cheese," you're merely fulfilling the role of a snapshooter. But if you say "show me the love you feel at this moment" you'll get an entirely different response.

If your subject feels contemplative, tender, or caring, show that in your pictures. If they seem far away, bring them back with a few words, or snap the picture and see how others read the scene. You may have captured a real characteristic of that individual, something others will immediately recognize in the portrait.

Be honest in the way you interpret what's going on around you, and don't play false with the depth of emotions your subjects are capable of feeling. You needn't eliminate wide smiles from your subjects, but don't force them or act the fool just to make everyone appear jolly. Very touching moments do occur during the course of the wedding day, and not to cover them would be neglecting your job.

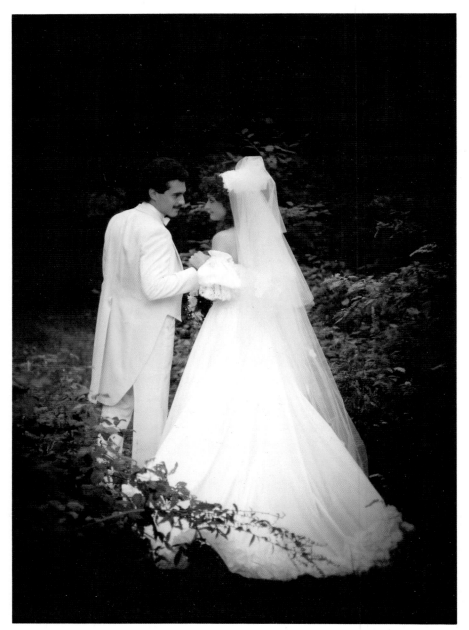

Warmth, caring, and togetherness are all expressed in this photo. Though these expressions could be coaxed through a great deal of talk/posing, the photographer has stepped back a bit and let the natural and honest feelings present themselves thorough this couple. (Photo: Ken Sklute)

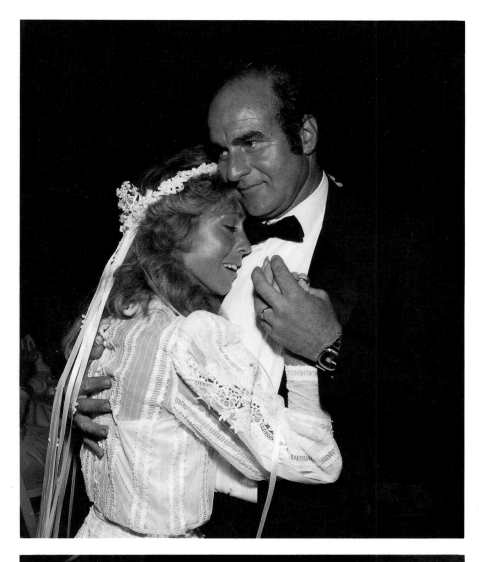

The wedding day reveals the whole gamut of emotions, and here the photographer has captured a touching moment during the bride and father's first dance. Shots like this can never be posed, and the feelings of both people expressed here have no need for words. (Photo: David McHugh)

Emotions run strong during the wedding day, and you shouldn't hestitate to photograph peoples' interactions. A candid shot like this one tells a great deal about what these two people share. (Photo: Rhonda Wolfe Vernon, Artography)

The Traditional "Garter" Shot

Every wedding has its rituals, and the garter scene is one of them. What may have once been a slightly titillating show has now become a bit of a cliché, but somehow many couples still get involved with it. Here, the groom removes the garter from high on the bride's leg, tosses it like a bouquet to a crowd of eager bachelors, and then the catcher goes through the same sequence—only this time he *places* it on the leg of another woman, usually the catcher of the bouquet. It's all a bit silly, but seems to be done in good fun.

The first part of the scene occurs when all the single men are called onto the dance floor. They assemble around a chair on which the bride sits. The groom then kneels down and slowly raises the bride's dress until the garter is revealed. This is the time to begin taking pictures.

Position yourself to the side of the bride and groom, and have the crowd of men a few feet behind them. This will give you a profile shot of the wedding couple and include the action around them. Get a shot when the groom reaches the garter (some brides wear it low on their leg, others quite high). Usually there'll be some good expression on both faces, as well as raised eyebrows among the bachelors.

You needn't motor drive the sequence as the groom removes the garter, just wait for the peak of action when expressions are the best. Once the garter is removed, the groom may twirl it a bit, and you might get a shot of that. He then positions himself with his back to the crowd and throws the garter over his shoulder. Time the shot so you get the garter floating through the air and the men reaching for it.

These shots will be popular only if there's some good action and expression on the part of all concerned. Get a general shot of the ritual, but concentrate your lens on the faces to get some good candids.

When the catcher places the garter on the leg of the bouquet-catching woman, you can take the shot or not. Only take the picture if both people are good friends of the bride and groom. Otherwise you may make one for the record, but don't count on it to make a sale.

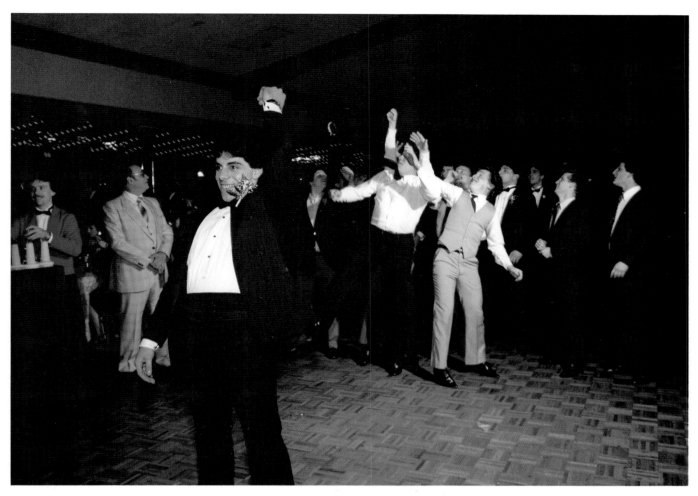

(Opposite page, top) The garter ritual takes place near the end of the reception's festivities, and it's simply enough posed with the bride and groom in profile to the camera. The background here shows the involvement of the people in the wedding party, although a better timing might have led to a more effective grouping. (Photo: Ken Sklute)

(Opposite page, bottom) After the bouquet and garter are tossed, the "winners" repeat the same actions of the bride and groom in the ritual. Here, the photographer has posed a tight foreground group with a balancing group in the background. (Photo: Ken Sklute)

(Above) Using two lights, the photographer illuminates the groom tossing the garter as well as the group in the background vying for the prize. Off-camera lights triggered by a slave can add depth to shots such as this. (Photo: Ken Sklute)

(Left) A wedding photographer should always be on the lookout for candids during the reception. Here, in preparation for the garter toss, the groom takes a playful pose that results in a good grab shot. (Photo: Robert Decker, Artography)

The Bride Tosses the Bouquet

A classic scene near the end of most receptions is the tossing of the bouquet; the bride flings her wedding flowers over her shoulder into a crowd of assembled single women. The idea is that the woman who catches it will be the next to be escorted down the aisle, and there can be quite a scramble for the flowers. This shot is best set up with either the bride in the foreground and the group behind her, or with the bride on the right side of the frame and the group on the left. If you have a second light with you, play it on the women behind the crowd. If not, be careful not to overexpose the bride and have the group go into the shadows. If you have a single light, have the bride stand so that equal light falls on her and the group.

Unlike the garter shot where the removal is a more popular picture than the toss, the moment the bride lets loose of the bouquet is considered the decisive one. Many photographers pride themselves on getting the bouquet in mid-air, with a profile of the bride and the reaching arms of the women behind her. It's much like getting a baseball shot when the ball is just coming off the bat.

Set your shutter speed at 1/250 second in order to freeze the bouquet in mid-air, and count down the toss with the bride. When you hit "one," wait a second and then hit the shutter. You won't get two shots out of this scene, so practice your timing. Gain the cooperation of the bride since you'll be viewing through your finder and won't really have control of when the toss is actually made. Instincts and sound will tell you the right moment.

Once the woman catches the flowers, you may want to wade into the group and have a shot of the catcher with her friends grouped around her, but don't count on selling this shot to the wedding couple.

The bouquet shot will be a seller if there's action, expression, and excitement in the stances of the people involved. Don't kick yourself if every bouquet picture you make isn't a zinger—it can be a difficult shot to get right. Just find the right position, time your picture, and hope for the best.

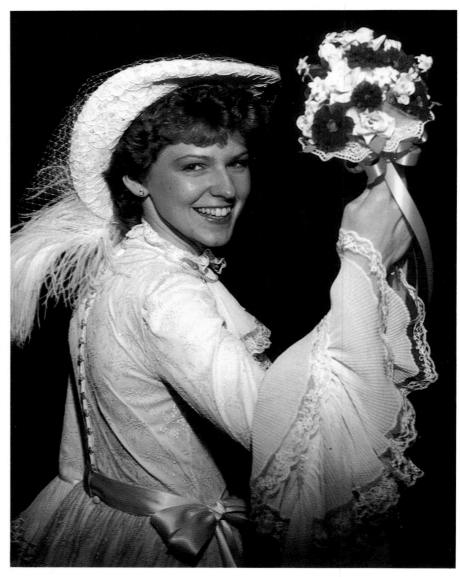

One pose that can be used to portray the bride tossing the bouquet is an action inferred pose, though a shot like this should be followed up by a shot of the toss taking place. Always try to give actions a context, rather than isolate them. (Photo: Robert Decker, Artography)

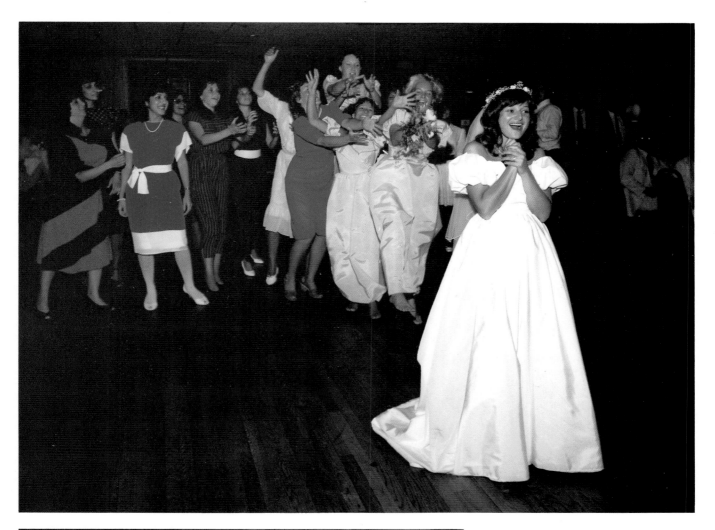

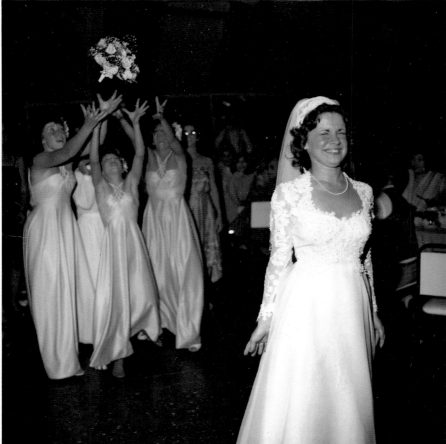

(Above) A successful bouquet-tossing shot results from a combination of expression and spontaneous action. Have your camera ready, and shoot a second after the bouquet is tossed. (Photo: Ken Sklute)

(Left) Here, the look on the bride's face, the reaching of the group behind her, and the balance of light make for a selling picture. (Photo: Harold Snedeker)

The Cake Cutting Ceremony

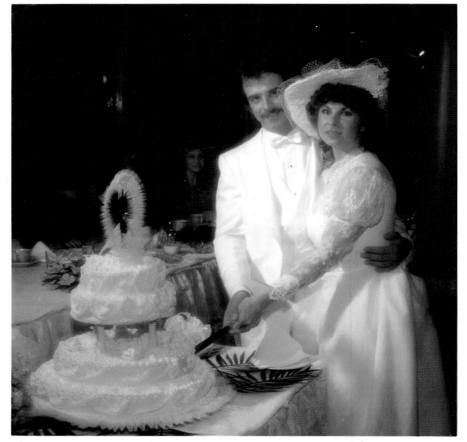

One of the most important ceremonies in the reception, and one that usually signals the near completion of your shooting duties, is the cutting of the cake. Much pomp surrounds this event, and you may have a crowd around the table where it's taking place. Establish your spot, and be sure to mention to the guests who are close at hand that you'll allow pictures after you've taken the shots you need. This is a crucial picture in most albums, so don't let amateurs get in the way of making the best picture you can.

Confer with the maitre d' as to where the cake table will be set up and how the table itself will be arranged. Don't let them set it up next to a mirrored wall or other location that will throw reflections or obstruct your best angle. Arrange the silverware, napkins, candles and other tableware so that they won't get in the way of the picture. Watch for details in how each article lays. Go for simplicity in the table arrangement, and don't be afraid to move things around until they're to your liking.

Set the bride and groom up so they're to the side of the cake, and your camera so that you have the cake to the left. Have the bride stand in front of the groom, and have his arms come around her side so they form a flowing line that runs from the cake through their arms and over their bodies. If this seems awkward, pose them side-by-side, but keep them close together. Have them hold the knife gracefully, with hands intertwined on the handle, and have their arms extended slightly into and toward the cake. Bring motion into the picture by having them lean slightly toward the cake, and get a few shots before they begin the actual cutting. Watch for detail in the way they hold their hands and the angles their bodies and arms create.

This picture presents you with two large masses of white, and that's why it's important to have a camera angle slightly off to the side and not where the cake is dominant in the foreground and the couple behind it. Failure to do this will result in an "overexposed" cake, as well as having the white of the gown blend in with the white of the cake. If the cake does overexpose a bit,

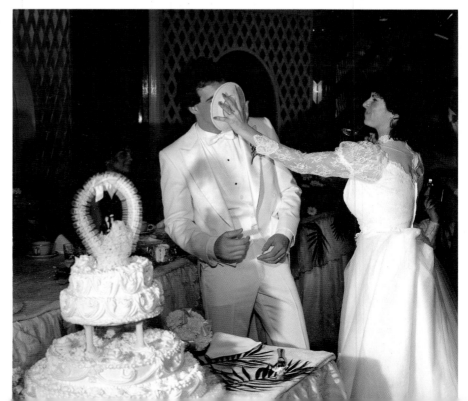

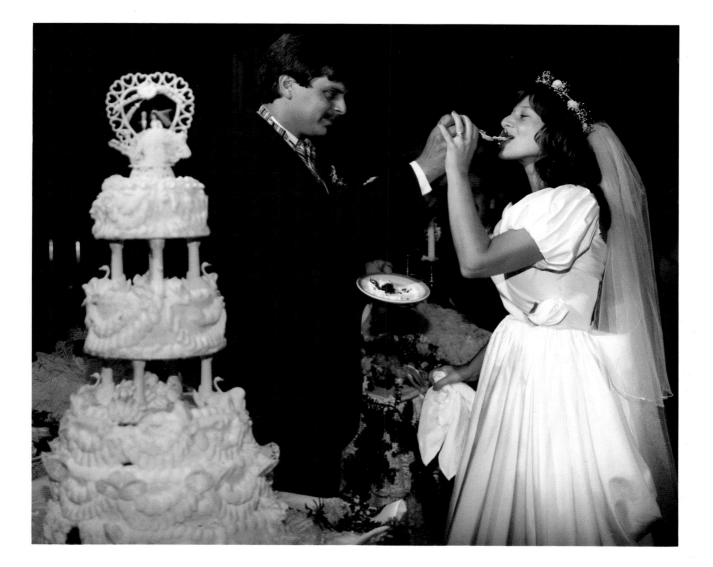

request that your lab "burn it down" in the printing.

After the cake is cut, move in for shots of the bride and groom feeding each other, but don't eliminate the establishing symbol of the cake entirely from the picture. Some people smash the cake into each other's faces; you can't stop them from doing this, but certainly don't encourage it. Hold the pose right before a bite is taken, and then take quick shots during the actual feeding.

Once you've gotten the shots you want, back off and let those with cameras take their snaps. Offer to pose the bride and groom if people so desire, and be cooperative with the guests who want to take pictures. You needn't pose the bride and groom in the same fashion as you did in your shot, and the table may be in a bit of disarray, so don't worry about competition for sale of the pictures. Just be sure that these amateurs don't intrude while you're taking your pictures.

(Above) After the cake is cut, the bride and groom will feed each other. Get ready for a sequence of shots during the cake cutting, and be sure to always have the cake in one part of the frame. (Photo: Ken Sklute)

(Opposite page, top) The start of the cake cutting sequence should be one "formal" of the bride and groom posed with knife in hand ready to cut the cake. Arrange the cake table carefully, and note how to pose the hand-in-hand around the knife. Have the couple relate directly to the camera in this shot. (Photo: Ken Sklute)

(Opposite page, bottom) Always be ready for surprises during a wedding. Minutes before, this couple had posed for a "formal" of the cake cutting. Now a different type of opportunity presents itself. Don't be caught off-guard when this type of event occurs; it's all part of the wedding day fun. (Photo: Ken Sklute)

The Candid Photograph

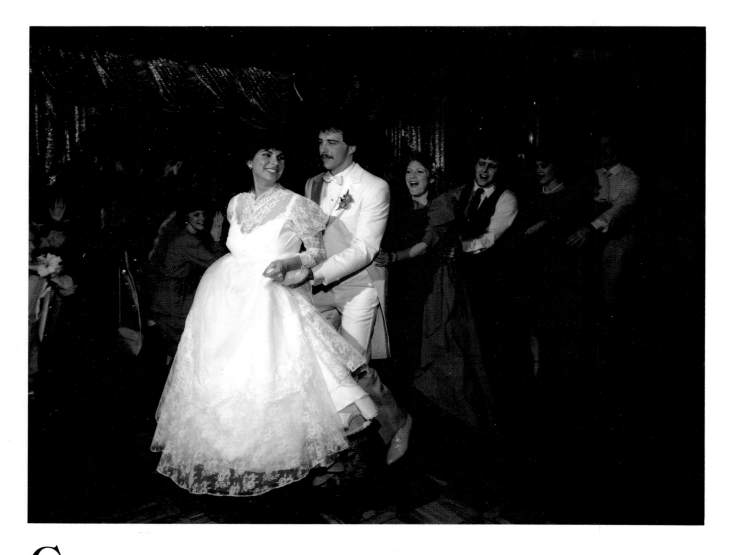

C andids come from two sources during a reception: those that are taken on the spur of the moment and informals that are refinements of naturally occurring situations. Making candid photographs should be a natural process for you, and you should occasionally roam the hall in search of pictures. Look for scenes that tell the story of the wedding and highlight certain individuals who are taking part in the festivities. There may be shots of children sitting on their grandparent's knee, or pictures of the bride and her mother standing hand in hand. You may come across some men sharing a drink and a laugh, or the ringbearer dancing shyly with the flower girl.

No one will object to being the subject of your candids if you ask permission to take the picture; after all, that's what you've been hired to do. What may cause a problem is shoving the camera into people's private moments and shooting without asking. You may get a sneer, but worst of all you'll probably get a poor picture in the bargain. Roam the hall, see the shots, request permission to shoot, refine the pose, shoot, and move on.

After a while people will get used to you being around with a camera, and the greatest compliment you can get is if they consider you "invisible" and a member of the wedding. Keep in mind that people can get

Using an off-camera light to highlight the bride and groom at the front of the dancing line, the photographer gives a different interpretation to a standard picture. Too many group dancing shots merely show a confused group of bodies moving around the floor. (Photo: Ken Sklute)

(Left) Grab shots such as this one are popular in wedding albums, so keep your eye out for potential fun shots. (Photo: Ken Sklute)

(Below) A good time is the order of the day at a reception. Here, the photographer climbed up on a chair to get a group shot of many of the participants. A shot like this communicates so much more of the mood and spirit of the event than a stacked, formal group portrait. (Photo: Ken Sklute)

a little loose at weddings and may do things they look back on with embarrassment later. If they do this in front of everyone, they're fair game for a picture. If they do this privately, or in a small group, just leave them be. Never shoot pictures that will humiliate or embarrass people—as you shoot more weddings you'll understand the distinction.

Spontaneous candids are those you shoot on the run, and these are fun pictures that chronicle the events of the reception. Perhaps an aunt will get up and belt out a few tunes with the band, or an uncle decides to lead a folk dance; these are unplanned happenings that certainly come under the heading of wedding memories. You

can't pose these shots, so just use your best photojournalistic skills to capture the action.

Strike a balance in the number of candids you shoot, and confer with the bride and groom on the type of coverage they desire. Some want lots of candids, others may prefer only a few shots for fillers. Heed their words, but don't miss out on the really fun parts of the day. They may not think they want the pictures before the wedding, but may change their minds when they see the great moments you've captured. Candid shooting can be one of the most enjoyable parts of your day, as the process challenges your eyes and instincts.

(Above) While roaming the hall during a break in the reception's festivities, the photographer grabbed this warm portrait of the bride, groom, and elderly member of the family. Shots like this don't have to be taken in a formal portrait setting, and the feelings communicated in this picture speak for themselves. (Photo: Ken Sklute)

(Opposite page, top) Though this shot probably wouldn't make the first page of the album, the photographer couldn't pass up the opportunity for this takeoff on the traditional cake shot. (Photo: Ken Sklute)

(Opposite page, bottom) While you're roaming the reception for picture opportunities, always keep an eye out for what the children are doing. Here, a future Don Juan dances with two young ladies, and gives the photographer a selling shot. (Photo: Ken Sklute)

DEALING WITH UNRULY INDIVIDUALS

Unfortunately, weddings are sometimes populated by people who overindulge. As a result, they may behave belligerently towards you, refuse to cooperate for pictures, or just cause mischief. Others may have sudden artistic impulses and decide they have to direct every shot you take, while some may be avid photographers and trail you asking constant questions about technique.

You must be very firm with these individuals. Inform them that you're *working*, and ask if they'd like someone to harass them on *their* job. Tell them that the bride and groom want the best pictures you can make of the day's events, and that they're interfering with the process. Be polite. Don't raise your voice, but be firm. Going along with their interference will just encourage them.

If rational approaches don't work, inform the best man what's happening—he's usually the bouncer at these events. Make it clear that the individual is making it impossible to do your job. If that doesn't work, go to the bride and groom. Peer pressure usually works in these situations. Your main task is to isolate the individual and let his or her friends keep the situation under control.

The Guests

Table shots provide the bride and groom with a record of who attended the wedding and ensures that everyone who did attend has their picture taken. Check with the couple if they want these shots beforehand—some do and some don't. In fact, some photographers flatly refuse to even consider doing tables. Although they may seem like simple group setups, they can be among the most bothersome shots of the entire day. Some of the people at the table may be hesitant to have their pictures taken, others have drunk too much and won't cooperate with directions. The greatest headache comes when you try to assemble everyone who's at the table for the picture. An uncle has always wandered off, or the sisters decide to go visiting right before you make the shot. Sending scouts from the group out to gather absentees can be equally frustrating; they'll often get waylaid on their mission and end up missing themselves.

If you're contracted to do tables, the best time to shoot is during open periods in the reception's activities, usually before, or right after, dinner. A good technique to use to gather the forces is to enlist the services of the bride and groom in getting everyone to cooperate. Have them do the table tour with you, and when you arrive at the table say, "The bride and groom asked me to get a shot of this wonderful group with them so they can have a remembrance of sharing the day with you," or something to that effect. This will make the shots so much easier, and place a stronger emphasis on having everyone at the table when needed. Don't let the bride and groom begin to chat while you're posing the picture—a three minute shot could turn into a fifteen minute problem.

Arrange the group around one end of the table, with half sitting and the other half standing behind them. Direct people firmly, and make sure that glasses, bottles, and other debris aren't blocking your angle of

view or throwing reflections back into your lens. Centerpieces can be monstrous affairs, so move the group to the side if necessary.

A wide-angle lens will let you stand fairly close to the group; with large groups and a normal lens you might have to stand in the middle of the next table. Set your flash and depth of field so that you can guarantee that both the front and back of the group are in focus. Setting the lens at $f/8$ should do it for most groups, although a three deep stacking might require $f/11$. Always take two shots. Someone is bound to have their eyes closed in one of the pictures.

For large group table shots, use a wide-angle lens and have one side of the table stand in a stacked group behind the other. Watch out for distracting elements, such as bottles and centerpieces, on the table, and be especially aware of mirrors and other reflective surfaces in the background. (Photo: Bob Salzbank)

The Portable Studio

Pictures of family groups, shots of favorite aunts and uncles, or entire sides of families are often requested at the wedding reception; a wedding is one of the two major events in life when the whole "gang" is together and dressed up. Rather than take these pictures helter-skelter and be distracted from other important pictures of events at the reception, assign a particular time and place where all the pictures can be made. Organize a portable studio and take the groups and couples as they come. You'll save wear and tear on yourself, have better control over the lighting and posing, and keep the requests reasonable.

The location of this studio should be away from the main hall, either in an anteroom or other unused portion of the building. If this is impossible, set up in a corner of the reception room itself, away from the ebb and flow of activities. Choose a background suitable for portraiture. This can be an area with heavy curtains or drapes, or some corner of the place where sittings can be handsomely arranged. Scout the hall when you first arrive, and get permission from the manager to set up. The maitre d' can be very helpful in suggesting locations.

Some photographers haul backgrounds and supporting poles with them, and this may be a good idea when the reception is being held in a paneled building or one that offers poor shooting locations. This isn't usually necessary, but is okay if you *know* the building has severe faults. Large groups may overwhelm the backdrop in any case, so don't carry more than you need.

A portable studio can consist of two self-contained strobe head-umbrella or soft box combinations, although you can get as elaborate with lights as you like. You might even want to include a slave powered strobe for a background light for small groups and close-ups. The lighting can be as simple as an on-camera strobe and an extra slave light on a light stand. Better pictures will be obtained with the two-light setup, but don't feel that you can't make the shots without it.

Assuming you have two lights, for large groups set your lights at a 45 degree angle back from the group to attain full lighting coverage. Take strobe readings from the

front, back, and sides of the group, making sure the light evenly covers the assembled troops. Put the strobes at equal power, and feather the umbrellas or soft boxes so that an even, open light spreads over the group.

Set the strobes so that you have enough power for the lens setting to give you sufficient depth of field, and make sure that everyone from the front to the back of the group will be in focus. If you have a set of stairs, you can stack the group and minimize "lost heads" in the crowd. Use a wide-angle lens for the larger groups, especially if your shooting area is cramped. Small

Scouting the reception hall for a shooting location, the photographer came up with one that had natural light spilling through soft curtains. Though not every hall you work will have such an advantageous location, this shot of the ringbearer and flowergirl took on a soft glow from the special light. (Photo: Ken Sklute)

groups or couples should be taken with a normal or telephoto lens; the wide-angle may distort their faces or bodies. Also, they should have more intimate lighting, so set your lights for a 1:2 lighting ratio, a quarter power less on the fill than the key light. If time is short, and moving lights around is cumbersome, shoot all the groups and couples with the even lighting setup, metering each grouping as you go.

Posing shouldn't be sloppy just because time may be short, although you may have to go into some preset formats in order to get the job done quickly. You may have a number of groups waiting for pictures, so you can't dawdle and fuss with every shot. Shoot very large groups in stacked fashion. Ask for everyone's cooperation, and don't allow your subjects to chat and visit while you're setting up the pose.

Groups of ten or less can be set up around a chair or posing bench, and you'll probably want to have this prop ready in any case for the very elderly people who may be included in the groups. Look for diamonds and triangles, make sure two heads don't lay on the same vertical line, and pose for flow and design.

Couples should be taken in a middle-range or closeup fashion, and you might want to keep the camera and tripod in one setup and switch to a moderate telephoto lens. This avoids having to change lights and camera angle for each shot. Have the couples stand, turned slightly toward each other as if they're dancing, and right before the shutter is snapped have them lean slightly in and toward the lens. While this type of posing may sound "fast and dirty," it's the best way to accomplish the job.

The best time to operate this studio is right before or after dinner, when the courses are slow in coming or being cleared away and there's a break in the schedule of rituals. Have the band announce the fact that the studio is open for business frequently before and during operation. You should also let people know about this when they request that you take a quick portrait earlier in the day.

Keep the "doors" open for about an hour, and let the people who want pictures made organize their own groups. This saves you from the trouble of finding everyone needed for a picture, or waiting around until the group is formed. Shift the responsibility to those interested, and you'll see how effi-

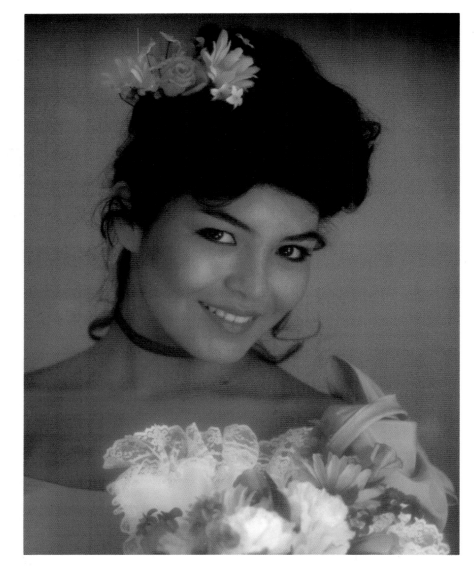

ciently, or not, matters are handled. Once closing time comes to pass, pack your gear and get back to the reception.

Many areas of the reception hall can serve as intimate posing areas for just the bride and groom. Explore the hall, find locations, but remember, only take the bride and groom away from the reception for a few minutes at a time for pictures. Many halls have beautiful waiting areas or decorated corridors—use whatever environments suit your needs, and make use of the light and colors to make strong, informal portraits of the couple. Don't lug around your big lights for this shot. Don't keep the couple away from the party for more than a few minutes at a time.

This lovely portrait of a member of the bridal party was made during the reception in a portable studio away from the main action. Having a space set aside allows you to concentrate on getting shots like this without the distractions of others. It also allows you to get portraits without them appearing to be merely "candid." (Photo: Ken Sklute)

The Completion of the Sale

Now that the photographic portion of your wedding work is completed, you'll have to go about getting the film processed, sorting proofs, selling extra enlargements, and packaging the final selection in albums. Though preparation for and shooting of the wedding was hard work, you'll have to apply yourself equally to the task of completing the sale.

The key ingredient in these final phases is *organization*; having a definite way of going about the next steps will save hours of work and much confusion. Without a plan of action, the final phase of the wedding job will become a nightmare of misplaced negatives and stressful activity. Tailor your system to your own logic, but use the following guidelines to aid you in the process.

FINDING A LAB

Even before you have your first roll processed, you should take the time to find a professional color lab that you can work with—never just send your film out to an untested lab! Go through the phone book, talk to other photographers, and check listings in professional photographic magazines for sources. If you have a lab in your area, visit them and ask to see the workplace and samples. Find out what special services they offer (such as mounting and texturizing prints, special cropping, and rush service). Note if they have custom and candid divisions. Make sure they have a distinct customer service department, one that will work directly with you and can give you prompt answers about the progress and problems with your work.

While on your visit, see how they do the work coming through; note how organized the facility is and the care with which orders are handled. Most importantly, make contact with a steady employee or manager. This person will be your inside contact, your lab troubleshooter. Communication is key to every photographer/lab relationship.

Keep this in mind when choosing a lab: you may have shot the greatest wedding pictures ever taken, but a inefficient lab will always give you poor results.

Most professional labs have in-house salespeople who can sit down with you to discuss terms and details of the relationship. They'll lay out the costs and advantages of different levels of service, and let you know the best way that you can get the type of work you want. That's what makes them custom labs. Each professional is treated like an individual, and their likes and dislikes are catered to. It's in the lab's best interest to keep you as a customer, and in your best interest to know how they work, so listen to what they have to say and submit your orders accordingly.

Prior to shooting your first job, submit a number of rolls to three or four labs for testing. Upon return of the film, note the turnaround time, care in processing, and how the film is packaged. Submit cut negatives with special cropping and custom printing instructions and see how that work is handled. There can be a great difference between labs and this testing should help you find the right one for your needs.

Once you've settled on a lab, start testing your equipment and submitting rolls and negatives shot under various lighting conditions. Everyone has a different eye for color, and you might like prints warmer (more to the yellow side) or cooler (more to the blue side) than other photographers. Let the lab know your tastes, and discover the buzz-words that will make them respond to your desire for a certain way of printing. If you've chosen a truly custom lab, they should print to your specifications.

FILING

Before the work orders start piling up, you'll need to set up a system for filing, storage, and retrieval of negatives. Get a filing cabinet and think about what method of filing will work best for you. You can file orders by name, job number, or date. You may even set the whole system up on computer, using a data base program. Each order should have a worksheet that lists customer name, number of proofs shot, date proofs were picked up, albums and enlargements ordered, and so forth. This becomes a quick reference on the status of the job, plus it serves as a holding file should clients want further prints down the road.

As the jobs pile up you'll see your files expand, and that's why it's important to have a cutoff date for eliminating inactive jobs from your collection. You can toss the jobs, or store them somewhere in the caverns of your home or office. Many photographers clear their files by offering proofs for sale a year after the delivery date of albums, and negatives three to five years after the wedding. Better to have some cash coming in than have old orders cluttering up your workspace. Give clients this option, and you'll be surprised at how many of them will be happy to take the old material off your hands.

PROOFS

The first step in having clients select prints is getting a set of proofs made. These are are $3\frac{1}{2} \times 5$, 4×5 or 5×5 prints of every shot you've taken. Most labs will deliver numbered proofs, i.e., prints matched to negatives by a numbered twin check that is attached to the back of the print and the glassine negative holder. If you work with a lab that doesn't supply numbered proofs, find another lab. Matching prints to negatives can be a tedious process, especially if you have taken two or three shots of the same pose.

Proofs should be given a rigorous inspection. Make sure the color is balanced and that faces have proper fleshtone; check for dust marks and sharp focus. Remember, these proofs are essential selling tools, and poorly developed proofs will result in lower sales. If you're unhappy with the quality of the proofs, send them back to the lab for remakes, and be very specific about the reason you're returning them. If you just tell them, "I don't like these," they won't know how to reprint them. Be picky—it's your livelihood that's on the line.

As most labs have different levels of print quality (from custom to candid to economy) you can choose from their service levels for your proofs. Part of your pre-job testing should include discovering which type of proofing service gives you satisfactory results. Most modern labs have video analyzing even for their economy runs, so you may find that the most inexpensive proofs meet your needs. But if the quality difference is appreciable, spend the few extra dollars for candid or even custom proofs and watch your sales increase.

When sorting proofs, always make sure the twin check on the negative mask matches the number on the negative sleeve. This will make ordering and final sorting a much easier process. (Photo: Jon Schaub)

After you receive proofs to your liking, you'll begin the editing process. Undoubtedly there'll be some klunkers and shots where key people have poor expressions or their eyes closed. Remove these from the set you present to clients. Only show prints that you think will sell, but don't limit the number of proofs in your presentation. If you have 200 good shots, show all of them.

Prior to placing prints in a proof album, stamp your copyright notice on the back of each one. The notice should read something like this:

© *(Your Name)*, 19 ___
Unauthorized Reproduction Prohibited

This protects you from clients who attempt to bring proofs to a color copy house for reproduction, thus depriving you of sales. Ethical businesses will refuse to reproduce your copyrighted prints, though you won't have absolute control. Some photographers even stamp PROOF on the front of the print, or hole-punch a corner. Although this detracts from the look of the proof, it does help guarantee that you'll be the only source of enlargements.

Arrange proofs in chronological order and place them in expandable proof albums. These selling tools are laid out so that cli-

ents can write their own orders next to or underneath the actual prints. Many styles actually encourage extra sales by hinting that prints can also be ordered for friends and relatives. Some photographers like to use the cheapest proof albums they can find thinking that it's a way to save a few pennies on the job. Proof presentation books are one of your most important selling tools— go with a quality book with order sheets interleaved between each photo page.

Proof albums are reviewed many times before the final order is made, and friends who attended the affair will be called upon for advice as much as the family. These friends can be as much a source of picture sales as the bridal party, and even if only a few wallets and 5 × 7 print sales results, the purchase of a book with order pages makes it worthwhile.

Another way of presenting proofs that's gained popularity is having slides made of each negative and then giving a "slide-proof" party at your place of business or the client's home. Though these slides rarely match the quality of prints, they represent a dynamic selling tool, especially when projected to large size. This technique allows customers to visualize enlargements, and gives larger groups an opportunity to view the work at the same time. Prices for these slide sets are moderate, and you may want to experiment with them to see if they increase your sales.

When you deliver proof prints to clients, be firm about when you want a decision made and the proofs returned. Although you may have already been paid for the job, it's in your best interest to complete the order and go on to your next client. Also, you'll want to get the extra cash flow generated from enlargement sales. Some clients can hold on to proofs for months, and all this does is drag out the whole process. Quite frankly, most enlargement sales are made when wedding couples are still in their "blushing" stage, and as time goes on their enthusiasm for extra prints wanes.

ENLARGEMENTS

A proof appointment should be a time when you encourage extra print sales. Though there's no set rule, you should try to double the initial price of the wedding with enlargements. If you meet with clients in your home or workspace, have plenty of sample enlargements around to show them examples of how *their* prints can be finished. Have framed and canvassed prints, even some with special printing effects. Photo lacquers on the market can even add effects

like brush stroke or "crackle," giving photos a painterly look.

Most labs will help you get these samples together; some will even offer reduced rates on those that will be used as selling samples. Work with a professional framer for mounting, matting, and framing of your samples. Have a selection of wood and metal frames, as well as special bevel cut and "french" mats. Every print benefits from matting and/or framing, and the more attractive your samples look the higher your sales.

ALBUMS

The same goes for albums. There are more than a dozen companies that offer professional wedding albums, and styles and prices go from budget to custom. As the person who's responsible for taking the pictures, you're in the best position to advise people on how to preserve, protect, and present their valued memories. Although most clients will request the traditional main album and two "parent" albums, they aren't always aware of the scope and variety of albums available. Educate yourself, and have samples and/or brochures ready to show to them.

Some clients might want to put their own albums together, thinking that they'll be able to get away cheaper that way. This might be an option, but remember that an album is as much a calling card as the pictures in it. Emphasize to clients that a wedding album is not just a snapshot folder, and that it's assemblage should be the job of a professional.

Types of Covers. Albums can be divided into a number of categories according to the way they're covered, how they're bound, and the fashion in which photos are placed in the pages. Some albums are covered in synthetic materials that are durable, stain-resistant, and give a quality look at a good price. The main distinction between this style and its amateur counterparts is the amount of padding in the covers and the durability of the stitching or binding glue. Other distinctions include the way in which prints are inserted (some have protective slipcases for each page) and the embossing on the front cover.

The style range on these synthetic covers is very extensive. They approximate leather, suede, or a variety of woven textures and colors. Many of the albums carry logos on the cover, such as "Our Wedding," "Wedding Memories" and *"Nuestra Boda,"* or have embossed scroll

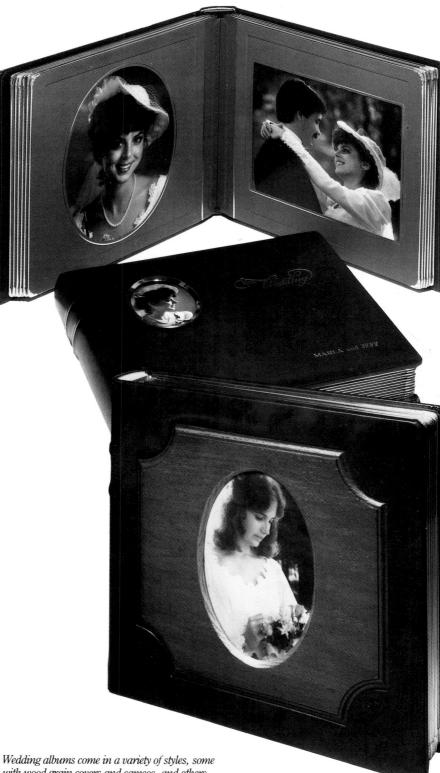

Wedding albums come in a variety of styles, some with wood grain covers and cameos, and others bound in leather covers. Always have a variety of albums to show clients. (Photos Courtesy Art Leather Manufacturing Company)

work. White and brown seem to be the most popular colors. Prices on synthetics vary, and you should check into manufacturers specifications on both their economy and custom lines.

Wood album covers have gained popularity, and most manufacturers now carry lines of this type. Some wood covers are handcrafted, made of hardwoods that are individually rubbed and stained. Some feature a cameo for a front picture, and some of these are decorated with elaborate frame-like carvings. Prices on the wood covers range from economy to custom, with the less expensive styles made of recycled wood fibers and a wood grain veneer, and the more costly composed of natural woods worked by hand. There are even wood cameos offered on synthetic and natural leather album covers.

Natural covers, like leather and suede, are also offered. Many of these albums have library-style bindings, special leaves for holding prints, and carry a prestige and elegance that make them a truly "limited edition." Natural covers come in a variety of colors ranging from ginger to wine to antique black.

Types of Bindings. There are a number of ways to bind, or hold the individual pages in an album. Your choice of bindings will depend on price, ease of assemblage, and the resultant ease of viewing. There are companies that put together the album for you, and these are actual bookbinding operations that lacquer prints and seal them into book form with a special spine. Although these custom operations certainly won't be a part of every sale, they certainly should be a part of offered services.

The main style of bindings in albums you put together yourself are pin (or metal rod), post-bound, and multi-ring. Metal rod bindings are slipped through the edge of each page and then assembled into a receiving spine on the album—each page has metal loops through which the rods slide. These bindings allow for easy page turning and for the pages to lie flat while viewing.

A post-bound book is one with pages that are slipped over two or three expandable posts that rise from holding areas in the album cover. These are quite easy to assemble and are almost infinitely expandable. Multi-ring binders are economical lines that have a series of wire spirals which receive pages, much like a spiral-bound notebook. These are also easy to assemble, and have various trigger mechanisms and snap closings.

Wedding pictures come in both vertical and horizontal formats, and some even benefit from the soft lines of an oval matt. How can these different formats all fit into one album? The question has been answered by multi-format inserts that are a feature of many wedding album pages. The inserts, which serve the purpose of mats, slide into Mylar sleeves that are the actual pages of the album, or cover pictures that are applied through mounting or adhesion in the album. On any leaf of the album you can fit one vertical or horizontal 8 × 10, or two 5 × 7s, or a number of 4 × 5s, or wallets—whatever layout pleases you and the client.

The ability to customize albums with the mat insert system becomes endless and opens up the possibility of very creative designs. The 8 × 10 album page is still the most popular, but it's good to know that there are options available.

CROPPING AND RETOUCHING

An item that should be part of your selling kit is a cropping tool, which can be simply made from four pieces of white matt board. With this you'll be able to show clients how final prints can be enhanced through cropping. Though many of your pictures will be fine as they were shot, some will definitely benefit from having some of the top, bottom, or sides removed in printing. Not everyone is aware that prints can be cropped, and showing and explaining this technique can open clients' eyes to new print possibilities.

For example, a shot of the bride taken from waist up might have the best facial expression of all the bridal portraits you've made. By cropping, and printing a full face, the picture might become more effective. A family grouping may have been done hastily, and one of your light cords may be sticking out in the corner of the print. A simple crop can help "clean up" the picture.

When selling cropped pictures, make sure you're aware of the standard cropping masks of the lab, and print ratios. Don't send them a picture cropped in a 2:5 ratio and expect them to make a full bleed 8 × 10 print. Labs will supply you with acetate sheets with crops masks on them that you can lay right on the negative. Each mask is coded by a number, and when orders are made you supply the lab with the crop number and an idea of where the crop should begin and end on the print. Samples of full frame and cropped prints will help explain all this to clients.

Another service you'll want to make clients aware of is retouching. Acne, scars, and even stray hairs can be removed from prints—you can even open eyes in group pictures! Backgrounds can be cleaned up or made to go soft and lights can be dimmed. There's no end to what a talented retoucher can do. Have samples made of before and after prints and have them at the presentation, particularly if you feel that the pictures could benefit from a little artwork.

Aside from the frames you have on your sample enlargements, you may want to have sample matts and frame corners to show clients. These provide extra options for photo decor. Not everyone will go with the styles you've selected with your stock enlargements. Many times, people will select frames that go with the interiors of their home, so have modern, traditional, Americana, metal, and other frame corners to show. Your local framer will provide you with these samples at a nominal charge.

The last item for your presentation kit is a price sheet listing charges for extra enlargements, framing, retouching, and any other special services you plan to offer. These prices should be made in accordance with prices from suppliers, and the markup you charge depends on your overhead, and the amount of work you'll have to put into getting the services done.

THE PRESENTATION OF PROOFS

Once you have all your selling tools in order, including sample enlargements, proofs, cropping tools, and sample retouched prints, make an appointment with the clients. Try to get all the possible picture buyers assembled at the same time. This usually includes bride and groom, both sets of parents and the bridal party.

Though this may sound like a source of confusion, its function is to be able to educate and to sell everyone at the same time. Outline all the special services mentioned above to everyone and convey the excitement so that print sales generate more print sales.

There's nothing worse than second or third hand information, and having a novice re-explain cropping ratios to another family member can be a real source of headaches for you down the line. So make the appointment a mini-lecture on photography, and go over, as simply as possible, all options available to the clients. Set up your enlargements on easels, or have them on the wall, and have the proofs and selling tools on a central table for all to see. Also, have the initial contract and checklist available, so clients can see what they asked you to shoot and how you've successfully completed their orders.

Most professional lab work-order envelopes guide you through ordering instructions. Always check proofs and finished work carefully upon receipt of order. (Photo: Jon Schaub)

In some album systems, the first step is to place prints into folios before they're positioned on a page. Arrange albums in chronological order, telling a story of the day's events. (Photo: Jon Schaub)

Prior to insertion into the album, make a final check to make sure the print is sleeved properly and that no imperfections mar the print. (Photo: Jon Schaub)

Even before you show proofs, make your enlargement and album presentation. Show the albums they may have chosen for the package deal, but also show albums that may end up costing them a few dollars more. Explain how albums are assembled, and point out that if they want extra prints that an album can easily be expanded.

With enlargements and wall decor, let clients examine your samples and show them how canvassing and texturizing can add a certain painterly feeling to the prints. Then begin an explanation of cropping. Be sure to emphasize how ratios work. Finally, show them airbrushed prints, letting them know that blemishes and other problems can be removed from final prints.

Don't discuss price at this time, but make sure each person has a copy of the price list in their hands. Most labs don't charge for standard crops, so you might want to emphasize that some of the extra services you offer come at no charge.

Once all of that is settled, and you're sure there's a certain understanding of your main points, open up the proof books. Now is not the time to shrink from the crowd. People will have plenty of time to contemplate the proof books on their own later. Walk them through the book, suggesting prints for albums and enlargements as you go. Help them choose a picture for a thank-you card, and recall incidents of the wedding day evoked by particular images.

The people gathered will give you cues as to which pictures they like. Write down their comments on the proof-order page opposite the picture in the album. This will serve to remind the actual buying party as to who wants what prints when they place their final order. It's guaranteed that there won't be agreement on all the pictures—this is human nature. But as the presentation moves along, both you and the clients will get a feel of how the final albums will look, and what enlargements are going to be ordered. Of course, not everyone will want a 30×40 print of the couple for their home, so be prepared to get a number of wallet size and 5×7 orders.

After you've gone through the proof album, wrap up your presentation by reviewing the main points. Assure them that you're available at any time for clarification and questions. Let them know the approximate time you want the proofs returned and order placed, and be firm about the necessity for getting the order back on time.

Remember, sharing the wedding pictures with clients should be an enjoyable experience for all concerned. Though selling has been emphasized here, make your approach subtle and part of the overall event, rather than just a hard-sell affair. Yes, be a salesperson because that pays the rent, but don't use high pressure.

FILLING THE ORDER

After a certain length of time (hopefully no more than a month), you'll get the proofs and order sheets returned to you. Add up the extra print, retouching, and custom enlargement sales and have the client pay 50% on receipt of order. This will cover your lab costs. Let them know the balance due, and request that payment be made on delivery. Before you let them out the door, go over the order with them and verify all prints and services requested. Have them initial the order forms and give them a receipt for their payment.

As you've used a proof book with opposite page order sheets, filling out the order is a simple matter. First, get individual negative order sleeves or bags from your lab. These holders are work order sheets, with areas for size, quantity, and quality standard, plus cropping instructions and a line or two for special instructions. Match the number on each print to the number on the negative. Double check that it's a match, put the negative in your work sleeve, and fill out the order. (Many labs ship negatives in work glassines to start, so you can save this step.) Leave the print in its place in the proof album—this serves as a check when prints are returned from the photo lab.

Pack the whole order together and bring or mail it to the lab. If mailing, insure the package to the maximum and get a return receipt. Enclose any special instructions, and make a note to your inside contact to handle the contents with tender loving care.

While you're waiting for the prints to be returned, place your order for albums and sleeves. Always order a few extra refills just to be sure, and keep them in stock to fill future orders. Sleeves are generally sold in multiples of six or eight per package, so you may have overruns in any case.

Once the prints are returned, examine each one carefully to be sure that they're printed to specs and that the colors are correct. Sometimes, you'll notice that smaller prints and enlargements of the same negative have color mismatches; this is due to the fact that some labs may do different sizes on different enlargers. Also, watch for dust marks, poor flesh tones, and other print faults. *Be very picky.* Your whole day's shooting, your reputation, and the success of the sale rests on your final product, so don't hesitate to return prints for makeovers.

Quality control and keeping on top of your lab are essential. If you let a few poor prints slip through, you're doing the client, the lab, and yourself a disservice. Send prints back, insist on prompt makeovers, and make sure the lab performs as a partner, not an adversary. If the lab won't work with you, find another lab.

Of course, not all the problems in returned orders are the fault of the lab. Poorly phrased cropping instructions and underexposed negatives can't be done to specifications, and there hasn't been an enlarger made yet that can refocus a blurry negative. Be demanding with your work, but don't expect the lab to perform miracles. Set parameters of acceptable quality and stick to them. In this way your lab will know what you will and won't accept.

As time goes on, you might want to consider doing your own album prints. This requires considerable time and money, but it is a way of getting exactly the type of pictures you want. Very busy freelancers and studios often go this route, although most leave proofing to a custom lab. Also, many one and two person custom labs are available, and they usually only accept a limited clientele. If you find an operation like this that suits your needs, you'll find that it results in a very personal relationship. Whatever you have to do to get the right lab for you should be done.

Most labs offer mounting services for large prints, and this is fine as long as prints don't arrive dog-eared in the mails. If you get too many bent corners, have the lab ship the prints unmounted in a tube and find a local framing service that can handle your needs.

Before you even begin putting prints in the wedding albums, double-check that what you have in your hands matches the client's order. Use the proof books as your checking system. Assemble the prints in the albums according to instructions enclosed with the books, and paste your business card on the back page. This becomes a reference card for friends of the couple looking through the album at a later date.

Keep the prints in chronological order, or in a fashion agreed upon by you and the client. Once you begin to sort the prints out the marching order should become apparent. The first print is very important, as this is the first image people will see when they open the book. You can have a portrait of the couple, a ring shot, or even a shot of the invitation surrounded by flowers in this place. From there, start with the house

shots, the groom's pre-ceremony shot, coming down the aisle, reception, candids, cake-cutting, and so forth. While there are no hard and fast rules about album design, keep in mind that the book should "read" like a story of the wedding day.

When that's done, place the negatives together with the proof book in the customer file. Some photographers recycle their proof books, and this is fine as long as they're not too marred. Don't dismantle the whole affair, however, until the order is in your client's hands and everything is satisfactory. If there are any questions, you have the order sheet next to the prints for confirmation.

By this time, prints should be returned from the framer, and they should be subject to the same scrutiny you give to work from the lab. Make sure mats are even and that no stray dust has settled under the glass. Check the surface of the prints to make sure no marks occurred during mounting. You should have agreed in advance on a damaged print policy.

When you deliver the order to the client, they may offer to buy the full set of proofs. You may opt to do this, but it might be better to wait six months to a year before you let them go. Waiting may result in further print sales; at that time they'll see the pictures anew and may order more.

Even later on, perhaps a year or so, you might want to send a follow-up letter and offer to sell clients the full set of negatives. Though this eliminates the possibility of any further print sales, it does clear out your file and bring a little cash flow into your operation. Besides, after two years it's unlikely they'll be ordering more wedding pictures, although the follow-up letter might get you some offers for baby pictures.

Handling Mishaps. There is a possibility that the lab may mangle, scratch, or even lose your order. Though it's rare with reputable labs (that's why it's *so* important to thoroughly check out a lab before you send an order), it does happen. If these mishaps occur during the proofing stage, you're in trouble. Though some pictures can be retaken, most can not—the whole wedding party can't be reassembled and made to act as if they're having a good time.

Wedding insurance policies are offered by professional associations that cover this possibility, and they help pay for film, processing, cost of re-renting formal wear, and even a wedding cake. Though you can go through the motions, most clients will be very unhappy. Yet, some pictures can be salvaged (such as bridal portraits) to save the whole deal from going sour.

It's important that you cover yourself against this possibility, and that's why it's essential to have a release from liability clause in your wedding contract. You won't make any money on the deal (in fact, you'll lose money, time, and reputation), but at least you won't have a lawsuit on your hands. It's very unfortunate when proofing disasters strike since both the photographer and the client suffer.

You may want to drag the guilty lab into court if this happens, but they do have a release from liability clause in their contract with you. Cases have been made when labs lose photographers' films, but as of yet no definitive ruling has been handed down. There are ways to nullify their escape clause, but in the final result all of the wrangling and aggravation doesn't get your film back. It's a situation where nobody wins.

If negatives are lost or mishandled on your final print order it's still bad news, but at least you have proofs in your hands which can be used for copy negatives. Though quality will suffer, you'll at least have something to give to clients. In this case, the lab should cover all copy and printing costs, plus any artwork needed to enhance the final job. Be sure to check out the lab's lost and damaged negative policy before you work with them, and at least be assured that they'll cover copy negative and print work should final negatives be lost or get damaged.

In both of these cases, let the client know what's happening as soon as you find out, and spell out the options very carefully. It probably would be best to return their money if disaster strikes, but you'll see what's necessary when you deal with each individual case. Don't try to fool or conceal from the client what's going on—you'll just create more trouble for yourself down the line. The situation is sure to create grief for all concerned. Just be direct and honest and hope for some understanding.

Though the above is a worst-case scenario, it's all a part of the experience of being a wedding photographer. In a way, it's what makes the trade so real, so much a part of life. Hopefully, you'll be able to share in the love and happiness of all concerned, and contribute something to the most important events in people's lives.

The Equipment for Wedding Photography

Wedding photography requires equipment that is mobile and portable, plus has the quality and durability to handle heavy-duty professional use. It also must be capable of producing salable photographs, ones that meet high standards of sharpness and color rendition. Many manufacturers produce cameras, lenses, lights, and accessories for the demanding wedding trade, and although no specific brand name recommendations will be made here, there are certain features you should consider before you purchase equipment. Certain special items should be included in your work inventory; an equipment checklist, included in this section, should be helpful in filling your needs.

If there's one cardinal rule that pertains to wedding equipment, it's always have a spare. That goes for camera bodies, film backs, strobes, and particularly, cords and connectors. There seems to be an unwritten law that at every wedding a flash sync cord has to malfunction, or that film must get jammed in mid-roll. Some of these problems can be prevented by maintenance, others result from the hectic nature of the job. For camera and strobe maintenance, check your instruction manuals; for pressure on the job, relax in the confidence of your instincts and knowledge. A watchword for weddings is: unless you have a spare, or know how to fix equipment on the spot, be prepared to find yourself at a wedding with no way of taking pictures. And most of those shots can never be repeated.

CAMERAS

With the phenomenal growth and popularity of the 35mm format, there have been an increasing number of weekenders using it for wedding coverage. While a 35mm camera may be fine for certain candids, or for advanced amateur coverage, medium format is still the preferred format for wedding professionals.

There are just too many points favoring 2¼"-square over 35mm. The larger size of the medium-format negative allows for cropping, retouching, and yields tonal detail the 35mm can't match. True, present 35mm optics are excellent, and 35mm is certainly gaining more acceptance in the fashion and glamour fields, but the bottom line is that medium format simply yields more workable negatives.

Also, most custom labs are geared to handling wedding work from 120 and 220 film, and have their cropping masks and enlargers set for those sizes. Unfortunately, cropping too tight off a 35mm negative yields poor, grainy enlargements, and retouching is next to impossible on the miniature negative. Blemishes are easy to remove from a 2¼"-square negative, and fairly substantial cropping still allows for quality enlargements. With the rapid advances in film technology, there may be a day when 35mm can be readily used for wedding work, but that day has yet to arrive.

A number of medium-format cameras on today's market are ideal for wedding coverage. The differences between them are in the ratio of the height to width of negatives and the number of extra features they have built-in. Some cameras yield a 6 × 4.5 cm negative, others a 6 × 6 cm negative, and some even a 6 × 7 cm one. Some units have interchangeable backs which cover all these formats, including the ability to handle 35mm film and Polaroid backs for testing. The 6 × 4.5 cm cameras tend to be the most lightweight; 6 × 6 cm cameras are the traditional workhorses. The 6 × 7 cm units are often a good choice for studio and tripod-only work, although many sturdy individuals have been known to carry them around for an entire wedding.

Aside from dependability, two other features are important for wedding work. One is the ability of the cameras to sync with a flash up to speeds of 1/250 second. The need for high-speed flash sync is a creative and a necessary one. Your subjects will often be on the move; you will need a fast shutter speed to "freeze" the action. This feature is also useful for interior shots where you want to add to the mood, and exterior shots where daylight and flash has to be balanced.

Another important feature is interchangeable backs. These are pre-loaded film cassettes that slip neatly onto the back of the camera. They're necessary because you can't always stop the action in order to reload film. Even though you'll get 30 exposures on a roll of 220 film with a 6 × 4.5 cm format camera, you may still be confronted with sequences of action where you'll run out of film just as the event is reaching its peak. Though you'll often be able to plan shooting by counting frames as you go along, many times you may lose track. With interchangeable backs, you'll be able to clip another loaded film back on with no "break in the action."

An "optional necessity" for most wedding work is a motor drive with a remote cable release. Pros have gotten on for years without these units, but they do make portrait sessions smoother, especially if you like to roam while posing and setting up shots. Being able to walk away from the camera can also be a technique for relaxing subjects. They won't feel they're being examined under a microscope every time you shoot a picture. Motor drives are also useful for candid and action sequences, although winding film between shots is a mechanical function for most photographers.

Twin-lens, medium-format cameras are still available, although their popularity has declined with the widespread use of the more modern, eye-level viewing reflex cameras. If you choose one of the twin-lens models for your work (and their price, particularly on the used market, is quite attractive) make sure you get a model that can take interchangeable lenses, rather than one that relies on screw-on optics for wide-angle or telephoto shooting.

Universal, or press cameras can also be used for wedding work. These cameras feature rangefinder focusing systems and are known for their solid construction and

simple design. Often, pros will glue their settings into place, choosing to shoot the entire wedding at f/5.6 or f/8, thus making the press camera into a "point and shoot" system.

A new breed of medium-format cameras, incorporating many of the features of advanced, electronic 35mms, is beginning to come out on the market. These cameras have multi-mode automatic exposure, micro-processor-controlled functions, LED readouts, and integral motorized advance. All of these marvels can be fun to play with, but they don't necessarily improve the results. As you'll see, wedding work doesn't require all the "bells and whistles"—it just requires a photographer with a sense of what makes a good picture behind a dependable camera.

LENSES

Three lenses are necessary for wedding work, with a fourth "special effects" lens that can be added as an option. The first is the "normal" lens, the one ordinarily supplied with the camera, usually an 80mm lens which yields an angle-of-view equivalent to the 50mm on a 35mm format. You'll be using this for the majority of your wedding work.

The second most-used lens is the wide-angle (usually around a 50mm), which helps if the room is too small to get a full view with a normal lens and when taking large groups. You might be called upon to shoot very large family groupings at a wedding, and without the wide-angle you might have to go into the next room to get the shot. The wide-angle lens also aids in covering overall shots (such as a full picture of the church) and wherever movement is confined but you need to get in a lot of the action, such as the cake-cutting shots. Wide-angle lenses are among the greatest problem solvers in the wedding trade, but they shouldn't be overused, particularly with close-up portraits. You might inflate noses or enlarge hands more than you, and the bride, want.

Moderate telephoto lenses, such as 135mm, are also useful at weddings. They can be used for candids, portraits, and for shots around the altar while the ceremony is in progress. With a telephoto, all of your pictures can be taken without being obtrusive. By the way, always check with the presiding priest, minister, or rabbi to make sure shots around the altar during the ceremony are allowed—some ministers have been known to stop the service because of a photographer's movements around the altar.

An optional lens for your wedding kit is a soft-focus portrait lens, sometimes referred to as a "softar." These lenses come in ranges of 100–150mm and are made with a built-in diffusion effect that yields a "gauze-covered" feeling to every shot made through it. Some lenses even have variable softeners, which allow you to preview the effect, and are best when exposed at around f/5.6. A soft-focus lens is useful for bridal and couple portraits, or dreamy environmental shots, but don't go and take every picture with it. For those with the budget, this lens can be a good investment, although add-on filters can be used in its stead.

Lens Accessories. Almost every experienced professional wedding photographer has a series of filters, diffusers, and vignetters in his or her bag of tricks. While some are best bought ready-made, others can be made from recycled filters that are floating around gadget bags of the past. If you're not in a do-it-yourself mood, you can buy all these effects filters in most camera stores.

Vignetters are used to give a soft edge to pictures and disperse the light around the edge of the frame. You can make a vignetter by taking an old UV or skylight filter and putting clear nail polish around the edge. A dark vignetter, suitable for pictures of the groom and small groups of men, can be made by cutting out neutral density filter material and attaching it to the edges of the filter. Different densities will yield lighter and darker effects.

Similarly, diffusers can be made of any number of translucent materials, including gauze, Scotch tape, stockings, or even by dispersing beads of nail polish over an old glass filter. Experiment, and you'll find an amazing array of effects available with different types of translucent diffusers.

Other filters you might consider for your gadget bag are cross-stars, prisms, and diffractors, as well as any you see in the large filter catalogs available from various manufacturers. One word of caution: over the years, many of these filters have been overused, with the result that many of the pictures taken with them look like worn-out clichés. Have filters available for the occasional shot, but don't make their use a tiresome habit.

In the last few years, the matte box system has become popular as a way of engaging and changing filters. With this system, a bellows attached to the front of the lens allows quick insertion of color-correcting, diffusing, and special-effects filters, as well as block-out screens for in-camera

double exposures and montages. You can also get block-out mattes in different shapes (such as keyholes and hearts), and give the resultant negatives to a custom lab for special print-in effects, such as sheet music or champagne glass montages. While still in demand in some areas, these effects may have seen their day. Montages *can* be interesting, but overuse is boring.

It's best to start with a few vignetters and diffusers and add from there. Although kits with hundreds of types of filters are available, the "straight" photo should be the heart of the wedding album. Just have the filters along should the right picture opportunity present itself.

LIGHTING EQUIPMENT

While the ideal situation would be to shoot every picture with natural light, many wedding shots must be taken indoors, often under poor or difficult ambient lighting conditions. Even on sunny days, outdoor shots may need fill-in flash, and few churches have the illumination necessary for a good exposure—even if you use the higher speed films.

Natural light shooting should be your first choice, but when this is impossible strobes, power packs, cords, meters, stands, brackets, and all the other artificial light paraphenalia that adds so much weight to a wedding photographer's kit must be included in your day's baggage.

Two types of lighting conditions will present themselves: formal, or off-camera lighting, and candid, or on-camera lighting. Off-camera lighting should be used for formal portraits of the bride, groom and family groups, and actually represents a mini-studio location lighting system. On-camera lighting is the unit that is attached to your candid, ceremony, and reception camera, and may also include a slave-powered second light placed on a stand or carried by an assistant.

The off-camera, or mini-studio setup should consist of a key light, a fill light, and an optional background kicker powered by a slave mechanism. The key light is the main light source, and consists of a flash tube powered by a power pack, or a flash tube power pack combined in one head. The light is mounted in an umbrella reflector or soft light box, which serves to disperse the light over the subject. Because of the high reflectance of most bridal gowns it's best to use a muted, rather than a super silver reflector.

The fill light is of similar design, but the reflector should be smaller and the power

output about half that of the key light. Most strobe heads have variable power output, and the settings should be verified by the use of a flash meter. For example, if the key, or main light, reads at $f/8$, the fill should read at $f/5.6$ for all other than special effects shots. This means that the fill is one stop darker than the key. Some lighting effects will call for a 1:3 lighting ratio, while effects like Rembrandt lighting may call for the elimination of the fill light altogether.

A slave-powered strobe mounted on a small stand behind subjects can be used to even out backgrounds, give a glowing edge to subjects, or to eliminate shadows thrown by the other light sources. While the fill light and key lights are charged by power packs, the slave is usually a battery-powered unit that is set off by a light sensitive switch. Slave units come in very handy, and cut down on the cords needed for a job.

Reflector boards, flash diffuser heads, and soft boxes simplify and refine the lighting process, keeping the formal lighting setup to a minimum. Many photographers over-light and use too many light sources for their work. This is fine if you have the luxury of a studio space, but location shooting equipment should be kept to a bare minimum.

Reflector boards fill in shadow areas and bounce light wherever directed. They can be used when shooting in natural light as well, and will help to correct lighting ratios that might otherwise result in dark, un-toned areas. Reflector boards range in size from 11×14 to 30×40 inches, and consist of aluminum foil or reflective material mounted on a cardboard or other light-weight material. Reflectors can be clamped to light stands, leaned against furniture, or even held in people's laps during shooting.

Diffuser heads, and especially soft boxes, have created a revolution in strobe photography. Many manufacturers are offering portable, snap together units that make electronic light a soft, caressing type of illumination. Soft boxes come in squares, stars, and hexagonals, and they certainly improve upon strobe that formerly only came from a silver umbrella reflector. These strobe units lend themselves to wedding photography, just as the umbrella reflector is perfect for commercial work.

Along with lighting equipment, the mini-studio will require a sturdy, versatile tripod, cable releases (short and long), optional background paper, and paper stands, lighting stands, and any other accessories you've come to rely upon in your formal shooting setup.

On-camera lighting consists of a portable strobe with an independent power supply. You can choose from one of two power supplies: one is to connect the strobe to a battery pack worn on a shoulder strap or a belt case; the other is to use NiCad, or rechargeable batteries that fit into the neck of the strobe itself. Some photographers prefer the NiCad setup because it eliminates another cord to get twisted, while others like the battery pack because they know they'll always have power for their flash. With NiCads you'll have to keep a charger going to constantly freshen your batteries, or carry enough spares to get you through the day. They're usually good for about seventy full-power shots.

Lightweight strobes, and those that mount directly on the hot shoe of the camera usually don't have the staying power of pro units. In addition, a strobe mounted too close to the lens yields too flat and direct a light, not the type of illumination we look for in wedding work. For that reason, the strobe is usually mounted on a bracket up and away from the lens. Some strobe mounts allow the flash to "move around" the lens, while others are fixed or can be moved slightly. Be careful of connecting cords on those navigable brackets.

Wedding strobes must have the capability to give bounce lighting—this means that the flash head tilts up and down from straight ahead to a 90 degree angle. The strobe also should have a dispersing card—a rigid, reflective piece of material that throws the light from the flash to the card to the subject matter. This card helps yield a broader, more even and diffuse light. Getting away from direct flash is always a good idea, especially with the highly reflective wedding dress that will be present in many of your shots.

Though many professionals still work with manual, dial-setting strobes, a whole new crop of high-tech flashes are now on the market. Many have auto-exposure features, green go-lights, and even LCD read-outs of exposure calculations. You should definitely take advantage of this new technology, and use it to make more subtle pictures. Half of your battle is working with and manipulating light, and the new strobes certainly aid in this situation.

The same slave-powered kicker light that's used in the off-camera setup can be used as a second light during procession and reception shots. The unit can be mounted on a light stand, or any long handle, and can be used to add dimension to many shots.

Light Meters. With all this light bouncing around, there has to be a way to measure and balance it. Although many strobes are made with auto-exposure features, it's still a good idea to carry along a professional light meter. Most meters are made to read both

ambient and strobe light, and many have the capability to read cumulative flashes. Use the light meter to check strobe power, to take outdoor and natural light readings, and to help you control lighting ratios. Used in conjunction with auto-strobes, light meters add an extra measure of safety to your essential light reading work.

ADDITIONAL ACCESSORIES

With the lights, cameras, and action of wedding photography, a lot of equipment gets banged around and twisted up during a job. That sort of treatment necessitates two things: a sturdy set of bags and cases to protect the equipment, *and* two sets of everything that might snap, crackle, or pop.

Aluminum reinforced cases are excellent for carrying equipment to and fro, including the attaché case sized ones for cameras and the "stage hand" models for all the other gear. Wheeled caddies, like those used by veteran air travelers for their luggage, are recommended for saving the neck and back muscles. Soft cases, made with the newest synthetic fibers, are excellent for on-the-job handling of lenses, film and cords. In addition, it's not a bad idea to have clothing with lots of pockets.

Always have extra batteries on hand, as well as modeling lights for strobes and even an extension cord with a grounded junction box outlet. (Somehow, they never have grounded outlets in catering halls.) Bring extra flash cords and slave-triggering mechanisms, and one or two extra on-camera strobes. Weddings are tough on equipment, so be prepared!

How much film is enough? That depends on the type of job you've booked and the extent of the wedding itself. The average wedding requires between 125 and 200 pictures, which gives room for bracketed and blown shots. Use of 220 Vericolor III (or other professional quality color negative films) will require less film changing, but you should have a few rolls of 120 handy for those end-of-the-day shots. A 6 × 6 cm camera will yield 24 shots per 220 roll, so ten rolls should be sufficient for the job.

The main reason professional color films are recommended is that these films are made to give optimum color balance at the time they're produced, and this should give you less variable results. Amateur films are meant to age, and their results can change greatly over time. When buying film, try to buy the same batch number, make sure the shop has them refrigerated; keep them in your cooler up until the day of your shoot, and have them processed immediately after exposure. Letting them sit around, or keeping them in the glove compartment until you get to the lab, will have dire consequences.

Negative film is the only way to go for weddings. Prints from negatives are still vastly superior to prints from slides, and the negative film captures a much higher tonal range than slide film. In addition, negatives allow a certain leeway in exposure; even if you're off a stop, you can still salvage a good print. Black-and-white, alas, has fallen into disuse in the wedding trade, (except for newspaper announcements) even though its expressive qualities are perhaps more evocative than color.

THE CHECKLIST

Packing for a wedding is like packing for a trip—you always seem to get to the hotel without a toothbrush. The following check-list will help keep track of the day's inventory. This list may evoke a number of reactions, the first being "How can I carry all that stuff around?", and the second being (if you're just starting out) "How can I afford all that gear?"

As to hauling gear around, this rather extensive checklist covers almost every situation you'll encounter at a wedding. As time goes on, you'll make up your own list, and add and subtract items as you see fit. Yes, there can be a lot of equipment at a wedding, and being organized will make a major difference in how it all works for you.

As to the second question, you don't need *all* the equipment listed to shoot a wedding, so don't despair if you can't go out and put down a few thousand dollars. You *will* need a medium-format camera with a normal lens, a portable strobe with bounce capability, a few filters, and film. This, plus a light meter, should handle most of the situations pictured in this book. You can always rent equipment (such as a mini-portrait location kit) from dealers, and this might help you fill your equipment gaps when just starting out.

In other words, start with what you've got and build your equipment by reinvesting money earned. When buying equipment, don't get seduced by fancy hardware; wedding photography is not a high-tech scene. It's more about seeing and caring, and being able to make the best of the light and the settings, than it is about gizmos and fancy gear. The beauty is in your vision.

You do need basic, dependable tools, and the knowledge of their capabilities and limitations. Wedding work can be pressured and hectic, and mastering your tools allows technique to give way to seeing and manifesting your vision.

EQUIPMENT CHECKLIST

CAMERAS
- ☐ First Camera _____
- ☐ Second Camera _____
- ☐ 3 220 backs _____
- ☐ 1 120 back _____
- ☐ 1 50mm lens _____
- ☐ 1 80mm lens _____
- ☐ 1 100mm lens _____
- ☐ 1 100mm soft-focus lens _____
- ☐ 1 135mm lens _____
- ☐ 1 motor drive _____
- ☐ Lens and body caps _____
- ☐ 1 standard cable release _____
- ☐ 1 short cable release _____
- ☐ 1 long cable release _____

LIGHTING
- ☐ 1 light meter _____
- ☐ 2 power packs _____
- ☐ 3 strobe heads _____
- ☐ key light accessories _____
- ☐ fill light accessories _____
- ☐ umbrellas _____
- ☐ soft boxes _____
- ☐ diffusion screens _____
- ☐ 2 spare flash tubes _____
- ☐ 4 modeling lights _____
- ☐ 2 slave lights _____
- ☐ 2 slave triggers _____
- ☐ 4 light stands _____
- ☐ various reflector boards _____
 - Sizes: _____ _____ _____
- ☐ 2 portable strobes _____
- ☐ kicker cards _____
- ☐ 2 strobe brackets _____
- ☐ 2 extra long sync cords _____
- ☐ 4 standard sync cords _____
- ☐ 3 sets batteries _____
 - ☐ NiCads _____
 - ☐ other _____
- ☐ 2 belt battery packs _____
- ☐ 1 extension cord _____
- ☐ 2 NiCad chargers _____
- ☐ 1 extension cord with grounded outlets _____
- ☐ 2 pole stands _____

FILM
- ☐ 120 rolls _____
- ☐ 220 rolls _____

FILTERS
- ☐ Diffusers
 - ☐ 50mm _____
 - ☐ 80mm _____
 - ☐ 100mm _____
 - ☐ 135mm _____
- ☐ Vignetters
 - ☐ 50mm _____
 - ☐ 80mm _____
 - ☐ 100mm _____
 - ☐ 135mm _____
- ☐ Special
 - ☐ 50mm _____
 - ☐ 80mm _____
 - ☐ 100mm _____
 - ☐ 135mm _____
- ☐ Matte box with adaptors _____
- ☐ Block-out masks _____

OTHER ACCESSORIES
- ☐ Background paper _____
- ☐ Grip clamps _____
- ☐ Pinch clamps _____
- ☐ Tripod _____
- ☐ Lens cleaning tissue _____
- ☐ Air blower _____
- ☐ Step ladder _____
- ☐ Camera bag _____
- ☐ Cases _____
- ☐ Airport caddy _____
- ☐ Wedding contract and shooting checklist _____

ADDITIONAL ITEMS*

*You may want to include safety pins, a needle and thread, hairpins, brush and comb, and other necessary "repair kit" items.

Index